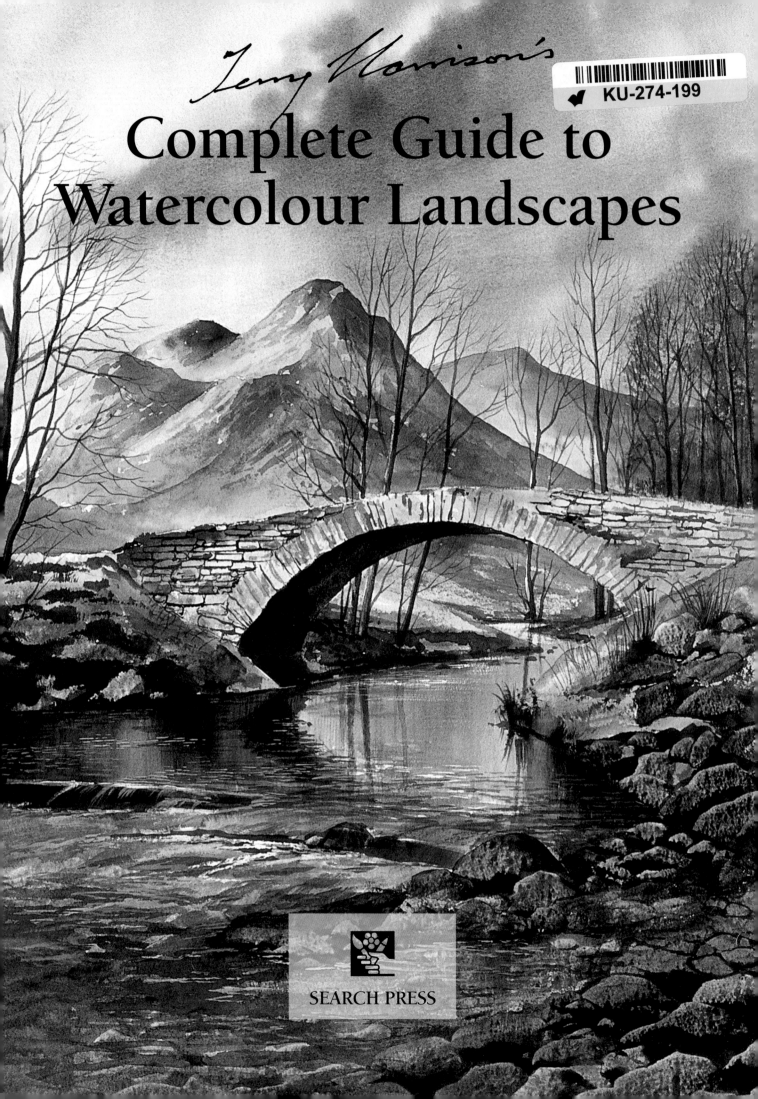

Terry Harrison's

Complete Guide to
Watercolour Landscapes

SEARCH PRESS

First published in Great Britain 2008

Search Press Limited, Wellwood, North Farm Road,
Tunbridge Wells, Kent TN2 3DR

Text copyright © Terry Harrison

Photographs by Roddy Paine Photographic Studios

Photographs and design copyright © Search Press 2008

ISBN-13: 978-1-84448-320-4

Suppliers

If you have any difficulty obtaining any of the materials and
equipment mentioned in this book, please contact Terry
Harrison at:

Telephone: +44 (0)1386 584840

Website: www.terryharrisonart.com

Based on the following books published by
Search Press:

Terry Harrison's Watercolour Trees (2005)
Terry Harrison's Watercolour Flowers (2006)
*Terry Harrison's Watercolour Mountains, Valleys
and Streams* (2006)
Terry Harrison's Sea & Sky in Watercolour (2007)

Page 1
Chatting in the lane
380 × 510mm (15 × 20in)

Page 3
The Packhorse Bridge
500 × 670mm (19¾ × 26½in)

Opposite
The Winepress
180 × 470mm (7 × 8¼in)

Publishers' note

All the step-by-step photographs in this book feature
the author, Terry Harrison, demonstrating his
watercolour painting techniques. No models have
been used.

Printed in Malaysia

Complete Guide to
Watercolour Landscapes

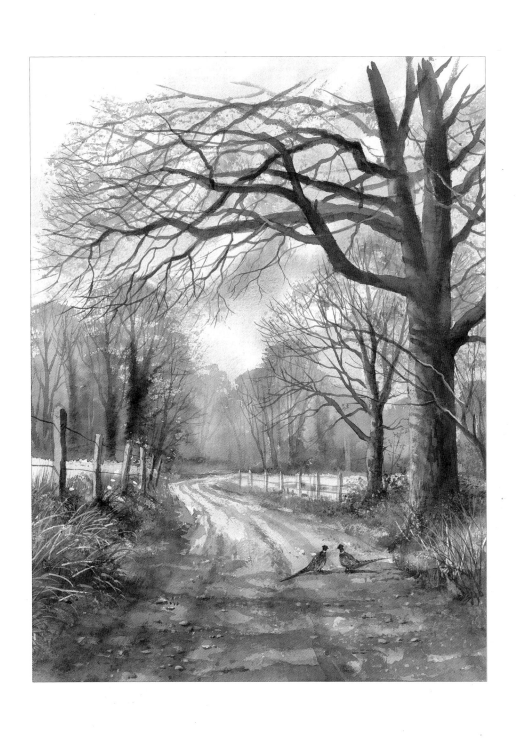

Contents

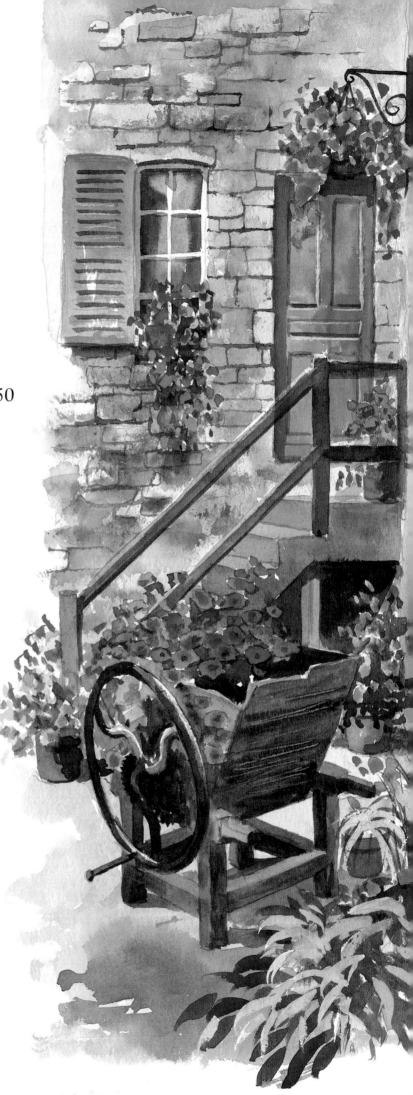

Materials

You will need a range of brushes and a selection of paints. I have used only one type of paper for the projects in this book, but you can use different weights and textures.

Paints

I always use artists' quality watercolours because they flow and mix better than the students' quality paints and give much better results. It is always advisable to buy the best paints you can afford. You can go a long way painting with only primary colours and a limited palette, but you may want to experiment with a wider range as you become more experienced.

Brushes

Some artists adapt brushes to suit their personal requirements. I have gone a step further than this and designed my own range of brushes, specially made to make good results easily achievable, and these are used throughout this book. Pages 14–15, 58–60, 100–101 and 154–155 show how each of these brushes can be used to create a range of effects when painting various types of landscape.

Paper

Watercolour paper comes in different weights and in three surfaces: smooth (called hot-pressed or HP), semi-smooth (called Not) and rough. I usually use 300gsm (140lb) rough paper, because the texture is useful for many of my techniques. You can use Not paper of the same weight if you need a smoother surface for detailed work.

I never bother to stretch paper before painting. If a painting cockles as it dries, turn it face down on a smooth, clean surface and wipe the back all over with a damp cloth. Place a drawing board over it and weigh it down. Leave it to dry overnight and the cockling will disappear.

Other materials

Hairdryer
This can be used to speed up the drying process if you are short of time.

Masking fluid
This is applied to keep the paper white where you want to achieve effects such as ripples or foam in seascapes or highlights in landscapes.

Soap
A bar of soap is useful to protect your brushes from masking fluid. Wet the brush and coat it in soap before dipping it in the masking fluid. When you have finished applying the masking fluid, it washes out of the brush with the soap.

Ruling pen
This can be used with masking fluid to create fine, straight lines.

Masking tape
I use this to tape paintings to my drawing board, and to create a straight horizon.

Pencil and sharpener
A 2B pencil is best for sketching and drawing, and you should always keep it sharp.

Eraser
A hard eraser is useful for correcting mistakes and removing masking fluid.

Credit card
Use an old plastic card for scraping out texture when painting rocks and cliffs.

Kitchen paper
This is used to lift out wet paint, for instance when painting clouds.

Easel
This is my ancient box easel. You can stand at it, as I do, or fold the legs away and use it on a table top. There is a slide-out shelf that holds your palette. This particular one collapsed shortly after we photographed it, after twenty years' service, but I have used the good bits, together with another easel, to rebuild it.

Bucket
Your brushes need to be rinsed regularly. This trusty bucket goes with me on the painting demonstration circuit so that I am never short of water.

Watercolour Trees

Trees are my favourite subject and I love painting them. They are an important part of the landscape and interesting trees can make a big difference to a scene. A twisted, wind-blasted oak or a shimmering grey-green beech can add atmosphere and life to a mediocre view, so I frequently use artistic licence to add a tree to an otherwise bland picture. I prefer to paint an impression rather than slavishly reproduce each detail, but it is still important to learn about the different shapes and the way the foliage changes with the seasons. A good knowledge of a subject is essential if you want to produce believable paintings.

I would advise anyone interested in painting to look at the work of other artists and to understand their methods, then go on to develop a style of their own. When I first started to paint, I was inspired by the artist Rowland Hilder and it gave me the desire and enthusiasm to paint my own pictures. The demonstrations in this section show how easy it is to build up your skills with a few tricks and the right brushes. I have included some really easy trees, which will, I hope, give you the confidence to progress through the section before moving on to tackle more detailed impressions. Watercolour is a wonderful medium with translucent qualities. Dry brush, simple washes and wet-into-wet techniques can be used with great effect to capture trunks, branches and foliage, so practise these techniques and you will soon be enjoying the challenge of creating your own paintings.

Wherever I go I take a camera and sketchbook with me. Photographs and sketches are useful and I often refer to them when I am working back in the studio. It is also interesting to revisit the trees at different times of the year. The changing seasons have dramatic effects on deciduous trees, which can be splendid in their summer raiment, stunning in autumn sun, magnificent in their winter habitat or beautiful bedecked in spring foliage.

It is impossible to cover everything in this section. I have managed to include my favourite trees, although I must confess that recognising unusual varieties is not my strong point. I am far more interested in capturing the effect than in relaying botanical accuracy. I am a great fan of botanical gardens and arboretums because trees and plants are usually labelled! So, I apologise in advance if I have identified something wrongly. The important thing is to enjoy the painting, which I am glad to say I still do.

Terry Harrison

Short cut
430 x 535mm (17 x 21in)
The tree is the dominant feature in this painting, but the stile invites you to travel across the fields and explore the countryside beyond. The foreground grasses are masked out with masking fluid first, then washed over with different tones of green.

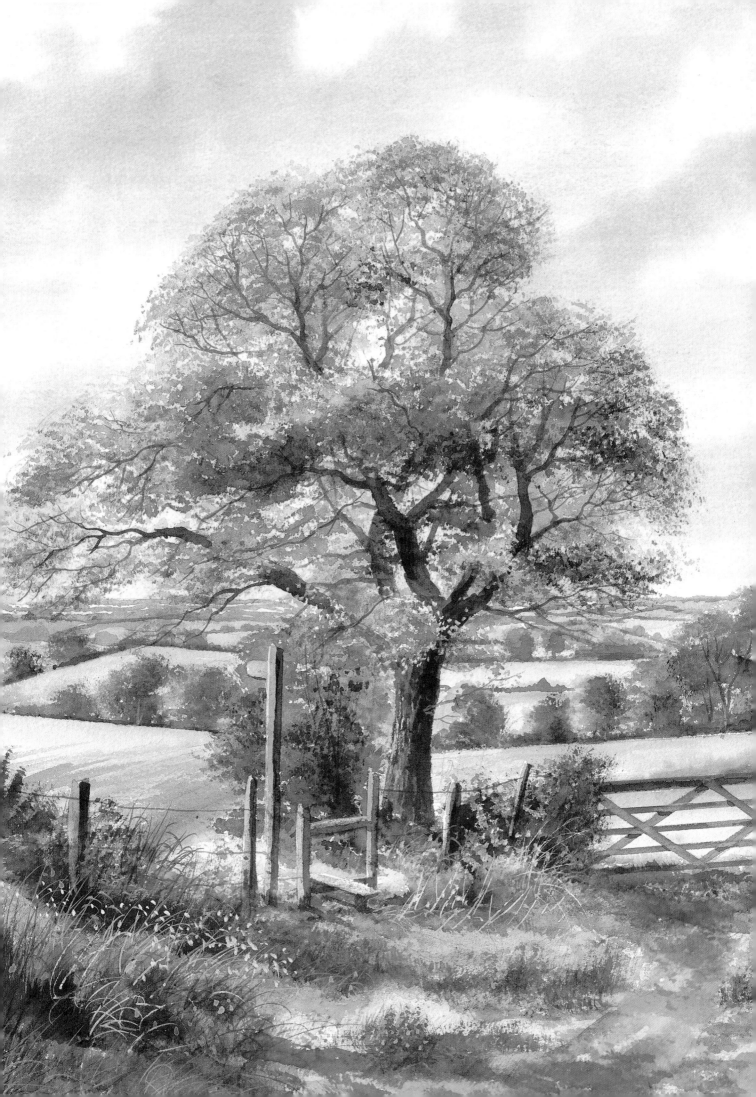

My palette

I use all the colours shown on this page and squeeze them into the pans in my palette. I am then able to mix them in the wells. Also, I am able to use them again because the palette has a lid and the paints do not deteriorate between painting sessions.

Foliage and grasses

Foliage and grasses can be many colours, but they are predominantly green, and greens are used extensively in landscape and tree painting. I have developed my own range of tube colours, including three greens: sunlit green, country olive and midnight green. Below, I show these greens on their own, mixed with cadmium yellow, and mixed with cobalt blue.

Sunlit green

This warm light green can be used straight from the tube or it can be mixed with cadmium yellow to give a richer light green. For a more acid green use lemon yellow. For a cool distant green, mix sunlit green with cobalt blue.

sunlit green

sunlit green +
cadmium yellow

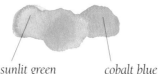
sunlit green *cobalt blue*

Country olive

This is a warm mid-green. Country olive mixed with cadmium yellow will give you a warmer green. For a cooler green, mix it with cobalt blue.

country olive

country olive +
cadmium yellow

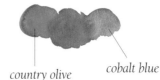
country olive *cobalt blue*

Midnight green

This dark green tends towards blue and is therefore cooler in shade. Mix it with cadmium yellow for a warmer colour, or mix it with cobalt blue for cooler shades.

midnight green

midnight green +
cadmium yellow

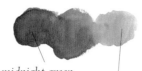
midnight green *cobalt blue*

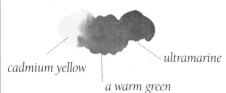

Alternative mixes for greens

cadmium yellow *ultramarine* *cadmium* *cobalt blue*
 a warm green *yellow* *a cool green*

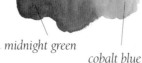

The colours I use

With this range you can mix most colours.

cadmium red

alizarin crimson

ultramarine

cobalt blue

yellow ochre

raw sienna

burnt sienna

burnt umber

cadmium yellow

Autumn colours

I have developed these colours specifically to capture the tones of autumn. It is difficult to mix them from my basic palette, and much easier to use these tube colours. With their transparent qualities they are ideal for autumn foliage.

Sunlit gold

Autumn gold

Shadow colours

I have developed these unique colours that are ideal for painting shadows!

Shadow

Burnt shadow

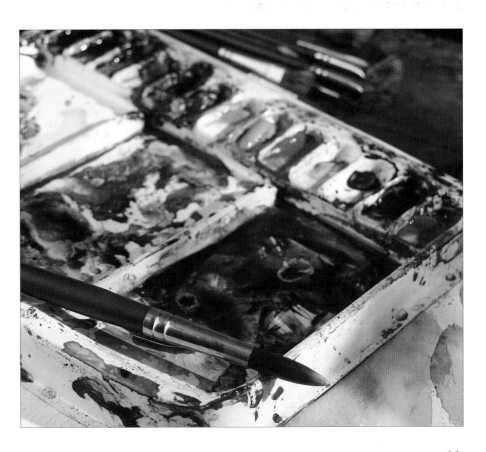

My palette looks a complete mess, but I know where all my colours are, which helps me to find the right one when I need it without interrupting my painting flow. It is a good idea to keep the colours in the same sequence each time you paint. It is so much easier to work in this way.

I group my colours in sections.

Section 1: midnight green, country olive, sunlit green

Section 2: earth colours, which are burnt umber, burnt sienna, raw sienna, yellow ochre

Section 3: reds and yellows

Section 4: blues

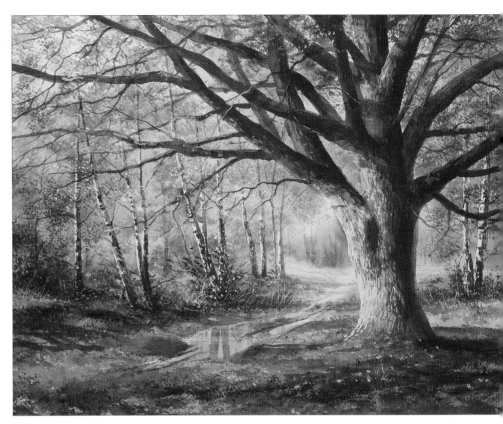

Shades of autumn

The colours sunlit gold and autumn gold capture the beauty of a fresh autumn day in this painting of an oak and a silver birch wood. The shadow colours are worked into the foreground, creating a contrast with the light areas on the tree trunk and in the sunlit glade.

Using photographs

In theory, it would be good if we could all set out with our easels and painting kits and spend a lovely day in the open, painting a charming scene. In practice this is rarely possible. I always seem to see something I want to paint when I am on my way somewhere and have no time to paint a picture. This is when I find my camera invaluable.

The camera is an excellent way to capture the silhouettes of trees – as with the photograph of the pine on the right – which really helps to understand their shape. If you are armed with a good set of photographs, it does not matter if the heavens open, or the light changes, or some other crisis occurs – nothing need stop you from finishing your painting. Best of all, your library of photographs will help you to paint any tree at any time of the year.

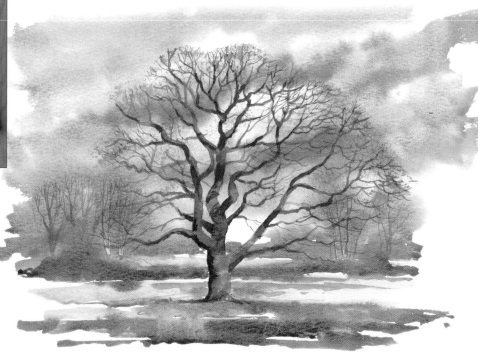

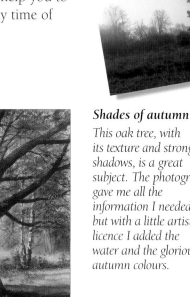

Shades of autumn
This oak tree, with its texture and strong shadows, is a great subject. The photograph gave me all the information I needed, but with a little artistic licence I added the water and the glorious autumn colours.

Scots pine sunset
The silhouetted Scots pine in the photograph is good reference material, with the shape of the tree clearly outlined against a bright sky. I painted it against a soft wet-into-wet background, creating a scene full of misty light and atmosphere.

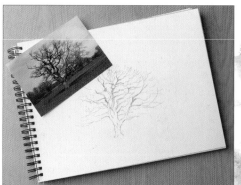

Winter oak
After taking the photograph, I decided to do a sketch of this tree beause of its complex structure. This helped me when I started the painting, because I was then able to capture the interesting twists and turns of the branches.

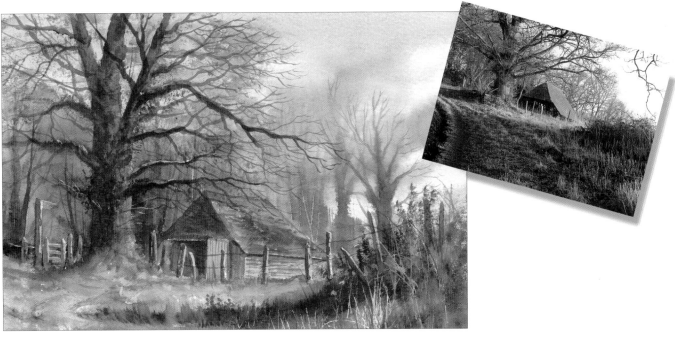

Caught in the afternoon sunlight, this country barn is an excellent subject for a painting. I copied the elements almost exactly, but lightened the foreground in areas and softened the background trees.

Combining photographs

Sometimes, one photograph is not enough, so I combine two or three to produce the effect I want. Elements from the two photographs below have been combined to create this painting: the tree (top), and the signpost, fence and stile (below).

Short cut

Very little has changed in the composition of the elements taken from the stile photograph above, apart from adding the foreground tree and changing the dimensions of the picture. However, the painting is more interesting with the tree as the focal point.

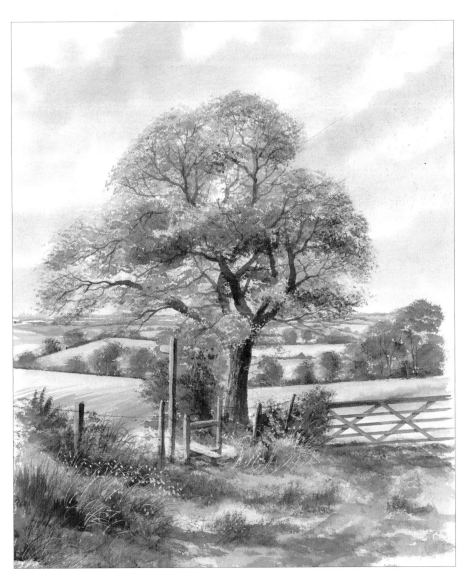

Techniques

Using the brushes

You do not need a huge range of brushes when painting trees. You can create wonderfully realistic effects with the ones shown here.

Large detail

This brush holds a lot of paint, but it still goes to quite a fine point. This is ideal for tree trunks and washes.

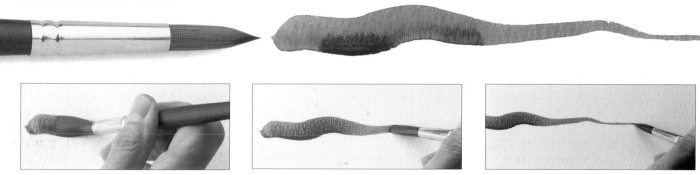

This is an important stroke to master when you are painting tree trunks or branches. Load the brush and press it firmly on the paper, then draw it smoothly along, gradually decreasing the pressure until it tapers to a fine point.

Medium detail

This is ideal for painting more delicate trunks and branches.

Small detail

This is useful for really delicate trees and twigs.

Half-rigger

This goes to a really fine point, so is ideal for very tiny branches. The hair is long, but not as long as a rigger. This brush holds a lot of paint, reducing the need to reload in mid-flow.

Golden leaf

Use this to stipple foliage, and to flick up grasses. This is a stiff bristle brush with a blend of soft hair. When the hair is wet, it curls and separates the bristles, making it an ideal brush for painting texture.

Use a fairly dry brush to create this effect.

A slightly wetter mix produces a denser result.

Foliage brush

This is a smaller version of the golden leaf brush, and it is good for stippling on foliage and creating texture.

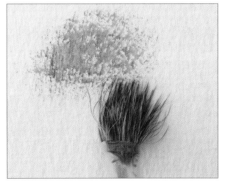

Load one side of the brush with light green and the other with dark green.

Stipple the colour on to create realistic foliage.

Fan stippler

This is a fan version of the foliage brush. Its curved top echoes the shape of trees and it is ideal for all kinds of varieties.

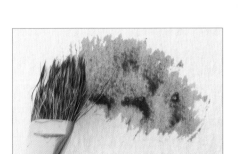

This wet-on-dry effect is ideal for dense foliage.

Wizard

Twenty per cent of the hair is longer than the rest. Paint is held by the body of the brush and released through the longer hair, which produces some interesting effects.

Gently stippling the brush will create a good effect.

Fan gogh

This is thicker than many other fan brushes. It holds lots of paint and can be used for a wide range of trees, including firs and willows.

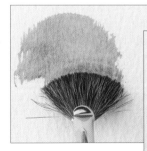

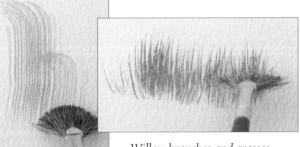

A fairly wet mix of paint is used here for the tree shape.

Willow branches and grasses are easily created with fairly dry brush strokes.

Fan gogh px

This slightly larger version of the fan gogh has an angled, clear acrylic resin handle that is great for scraping out trunks.

Different effects

These examples show the results of painting the same tree with the same brush but using different techniques.

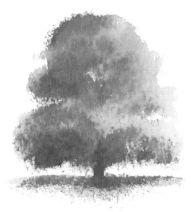

Wet-into-wet: sunlit green, then country olive are applied on to a wet surface with the foliage brush to create subtle blended effects.

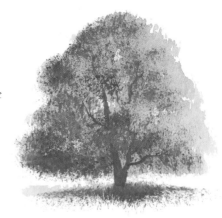

The shape of the foliage is painted first with sunlit green. When dry, country olive is stippled on to define the mass of leaves. The tree trunk and branches are added with a half-rigger.

Using a plastic card

I could not resist including this fun technique for 'painting' the trunks of silver birches. Apply a dark grey paint mix to the edge of an old credit or store card.

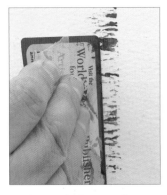

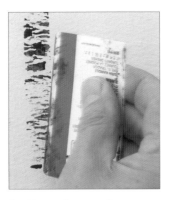

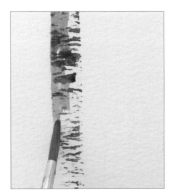

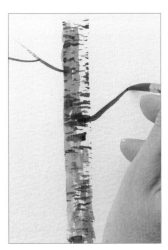

1. Scrape the card across the paper, move it down and repeat to create the trunk.

2. Turn the card over and scrape it the other way to create an uneven texture and bark effect.

3. Use a small detail brush and a mix of cobalt blue and raw sienna, for the shadow.

4. Paint the branches emerging from the knots using a mix of burnt umber and ultramarine.

Using a sponge

Colour can be sponged on to a painting to create an impression of foliage. A sponge can also be used to apply masking fluid when painting trunks, branches and highlights.

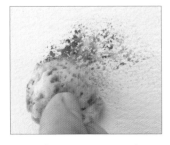

Dip a damp sponge into the paint and stipple it on to the paper to create foliage.

Place a dry sponge on a masking fluid bottle. Tip the bottle gently: the sponge will absorb the liquid.

Apply the masking fluid to the areas where you want to retain the white of the paper.

Tip
Tinted masking fluid is easier to see on white paper. You can add a few drops of paint to the plain variety – the colour will rub off with the dry masking fluid.

Using masking fluid

Masking fluid is ideal for retaining areas of white paper for foliage or lighter effects. Here it is used to create trunks and branches. I have developed a brush specifically for applying masking fluid, or you could use a brush coated with soap (see page 7).

My masking fluid brush

1. Draw outlines of the tree with a 2B pencil. Mask the trunks and branches.

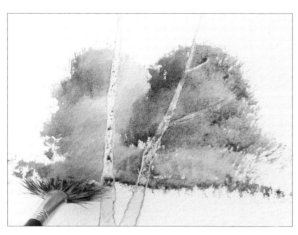

2. With the fan gogh brush and mixes of sunlit green and country olive, paint in the background foliage.

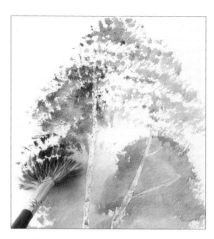

3. Using country olive, dab in the tree foliage.

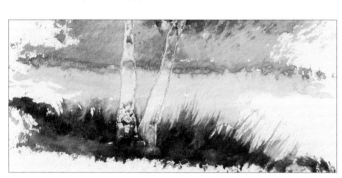

4. Add the grass behind the tree using cadmium yellow and sunlit green, then flick up darker grass under the tree using the fan gogh and midnight green.

5. Rub away the masking fluid with a fingertip.

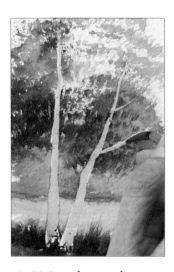

6. Using the medium detail brush and a wash of sunlit green and raw sienna, paint in the trunks and branches.

7. Using a mix of country olive and burnt umber add shadows to the trunks and branches.

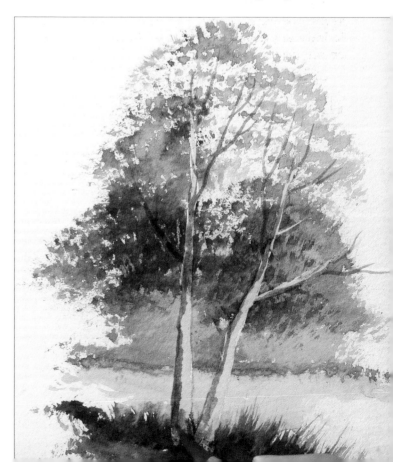

Painting snow-covered branches

Masking fluid can be used to produce a convincing snow effect on wintry trees. The dark areas of the trunk are painted in later.

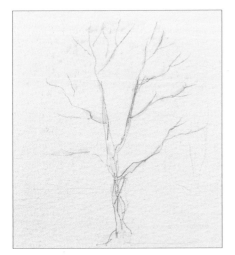

1. Draw an outline using a 2B pencil. Mask snow areas with masking fluid using a brush and sponge.

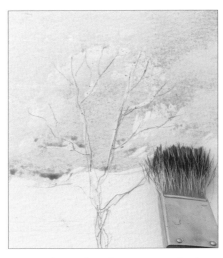

2. Wash in the sky using cobalt blue and the golden leaf brush.

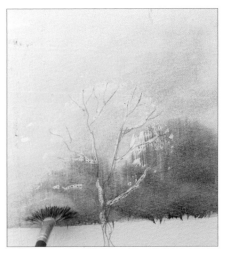

3. With the fan gogh and my shadow colour, paint in the misty background.

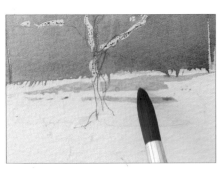

4. Change to the medium detail brush and add cobalt blue highlights to the snowy bank.

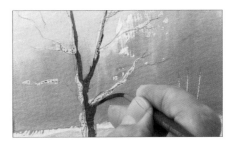

5. Using the half-rigger and a mix of burnt umber and ultramarine, paint in the trunk shadows and undersides of the branches under the masked areas (snow).

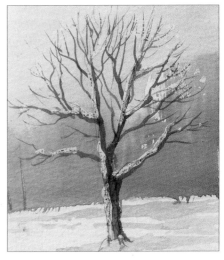

6. Complete all the branches and twigs.

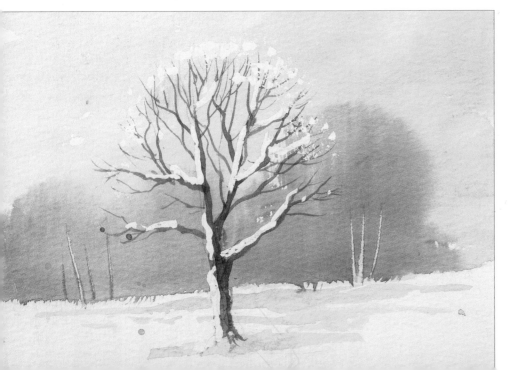

7. Now remove the masking fluid with your fingertip to reveal the snow areas.

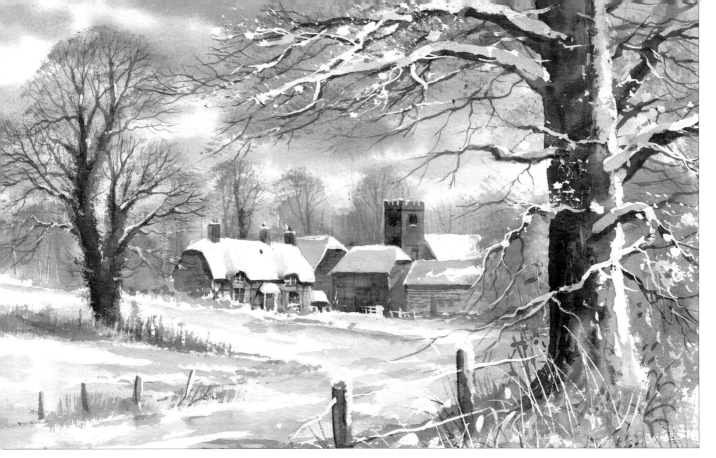

Winter's day
535 x 355mm (21 x 14in)
Masking fluid is used to great effect to depict the snow laying on the overhanging branches of the trees and the foreground grasses. Cobalt blue and shadow colour are added to some of the snow areas after the fluid is removed.

Using a paper mask

This masking technique produces the effect of a patchwork of fields with hedgerows. If you use various greens, and make them progressively warmer as you come forward, you will create a feeling of distance.

1. Using the foliage brush and a cool green mix of cobalt blue and sunlit green, stipple along one straight edge of the paper.

2. Change the angle of the paper, resting it against the right hand side of the first row. Add country olive to the mix and stipple along the edge as before.

3. Adjust the paper again. Deepen and warm the green mix with more country olive, and stipple in the foreground hedgerow.

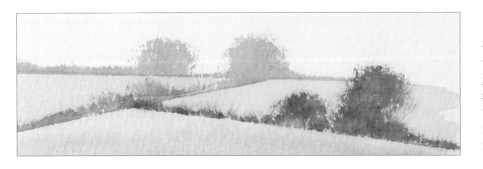

4. Finally, paint in the fields using diluted washes of sunlit green, country olive and raw sienna. With very little effort, this simple technique gives an impression of a landscape, and it is very effective.

19

Painting trunks and branches

Different techniques can be used when painting trunks and branches depending on the type of tree, the season and the effect you want to create. Remember that they are almost never brown. I nearly always use green toned down with shades of brown.

country olive + burnt umber

country olive + burnt umber + ultramarine

These mixes are ideal for trunks and branches.

If you use the colour mixes shown here, your trees will look more realistic. A flat brown creates a tree that is dull and unnatural. Mix it with green and the tree immediately looks much better.

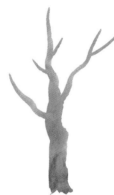

burnt umber

burnt umber and country olive

Wet-into-wet using a mix of country olive and burnt umber.

Wet-into-wet using a mix of country olive and burnt umber, with ultramarine added on the shaded side while still wet.

Wet-into-wet with a mix of country olive and burnt umber. Ultramarine is added for the darker areas.

Wet-into-wet using a mix of country olive and burnt umber. When dry, detail is added with a small detail brush.

Wet-on-dry using a mix of country olive and burnt umber. When dry, detail is added using a small detail brush and a stronger mix of country olive and burnt umber.

Dry brush on a white background using a mix of country olive and burnt umber.

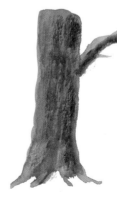

Dry brush on a dry country olive background using a mix of country olive and burnt umber.

Painting foliage

Different effects can be used to create an impression of leaves and foliage using a range of brushes or a sponge. Burnt umber and country olive are used to paint the branch, and country olive is used for the foliage, which is painted on a dry background (wet-on-dry).

(a) Country olive is stippled on with a fairly dry foliage brush, then midnight green.

(b) Diluted country olive is stippled on sparingly with a foliage brush. The colour is slightly wetter than (a).

(c) The golden leaf brush is excellent for leaves: a fairly dry brush is used to stipple the foliage over the branch.

(d) This is the same technique as (c) using the golden leaf. Then individual leaves are added with the large detail brush.

(e) The wizard brush has a ragged edge which is ideal for creating a softer texture. Use a dry brush to create this effect.

(f) The leaves are dabbed on using a damp natural sponge. You will lose the texture if the sponge is too wet, so keep it fairly dry.

(g) The medium detail brush is used when a tree is close up. Each leaf is dabbed on for a more controlled texture.

(h) The large detail brush is used for a denser effect. The brush strokes are larger and closer together, but gaps are left in the foliage.

Simple trees

It is usually assumed that in order to paint convincing trees you have to know a lot about them. The good news is that you don't! Even after years of painting trees, I am pretty hopeless at identifying anything but the most common types, although I do refer to my sketchbook notes if I need to. On the following pages you will find trees that are remarkably easy to paint, with no name in sight. I am aiming to create impressions of trees, rather than trees with detail.

Painting skies

Learning a few useful techniques will make all the difference to your paintings. As this is primarily a book about trees, I am not attempting to tackle skies (it would be impossible in such a short book to cover all the tricks I have picked up over the years); however, it is useful to understand how to paint a simple sky like the one below.

Laying a wash

A basic blue wash is a useful background if you plan to cover a painting with trees. If you want to create a feeling of distance in the sky, use a graded wash so that the colour fades away towards the horizon.

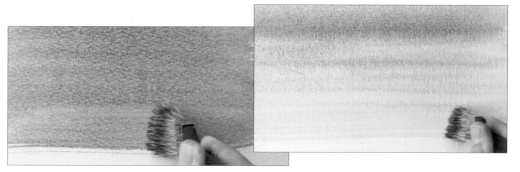

A graded wash can be applied to create a feeling of distance. Wet the paper first, then load the brush with ultramarine. Start at the top and move down the paper with horizontal brush strokes. The water on the paper dilutes the colour in the brush and it becomes lighter towards the horizon.

A simple sky can be created with a flat wash on dry watercolour paper using the golden leaf brush.

Wet-into-wet trees

Painting colours wet-into-wet creates interesting effects and it is wonderful for trees. Start by putting on a basic graded ultramarine wash on wet paper using the golden leaf brush. While the wash is still wet, paint in the trees using the fan gogh brush.

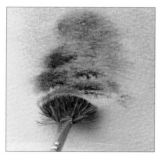

1. Double load the fan gogh brush with sunlit green on one side and midnight green on the other. Start to paint in the first tree...

2. ...angling the brush from side to side as you work downwards to create the feeling of sunlight and shadow.

3. Using the same technique, add the second tree. The paint will spread and blur before it dries to produce a soft, misty effect.

4. Load the brush with country olive, hold it horizontally, and paint in a line beneath the trees.

5. With the tip of the bristles, add the suggestion of the trunks.

Scraping out

The trunks of simple wet-into-wet trees can be 'scraped out' using the handle of a brush or a fingertip. This is a surprisingly effective technique. The outlines will blur as the paint dries, so you should not need to do any more work on the trunks. The handle I use belongs to the fan gogh brush. It has a clear acrylic resin handle which is ideal for scraping out trunks.

6. Use your fingernail or the corner of a credit card to scrape out the shape of the smaller trunk.

7. Use the handle of a brush, preferably made from clear acrylic resin, to scrape out the shape of the trunk on the larger tree.

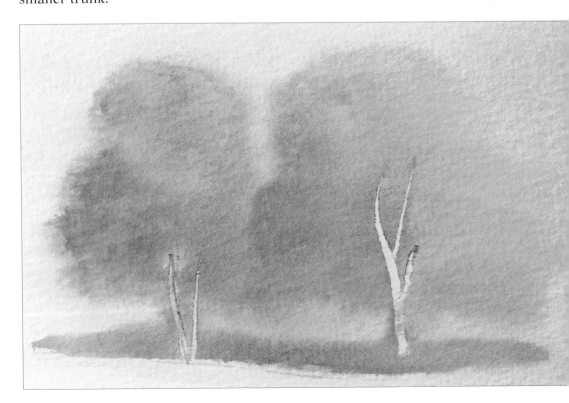

The finished trees.

Look no trunk!

This must be the easiest possible tree to paint. No trunk, no hassle – just a fan stippler brush, double loaded and used to dab on foliage. The effect is finished off with an impression of grass beneath the trees.

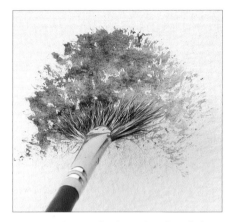

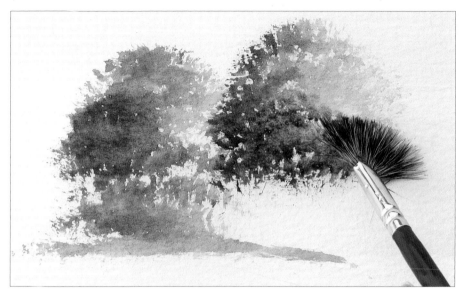

1. Lay the right hand side of the fan stippler in sunlit green, then angle the brush and lay the left hand side in country olive. This is called 'double-loading' and it creates sunlight and shade in foliage. Dab the paint on to the paper, angling the brush from side to side as you do so.

2. Lay the right hand side of the brush in sunlit green and the left hand side in midnight green and paint the second tree as before, with its darker edge overlapping the sunlit side of the first tree.

The finished trees: the same brush is used to dab in the foreground grass.

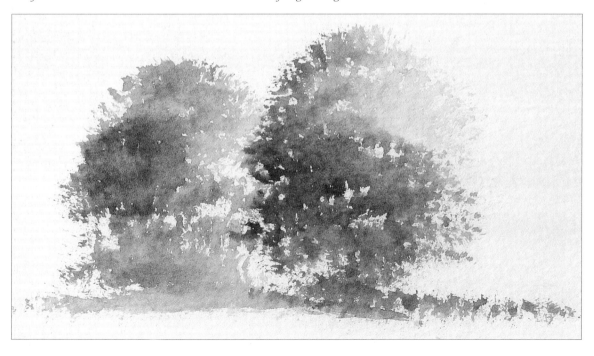

24

Keep it simple

For this basic tree, the trunk and branches are painted first with a half-rigger and the foliage is dabbed in afterwards. One of the most important things to remember is that most trunks are not brown. Use a mix of green toned down with a little burnt umber.

1. Paint in the trunk with one upward stroke.

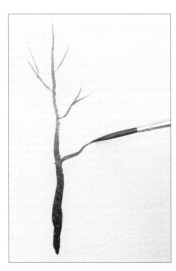

2. Add the branches using the same brush.

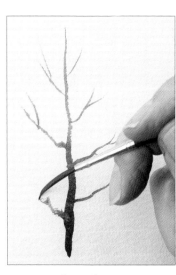

3. Complete the framework of the tree.

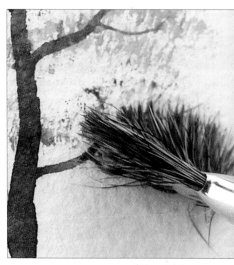

4. Change to the fan stippler and sunlit green, and begin to add the foliage, keeping the effect light.

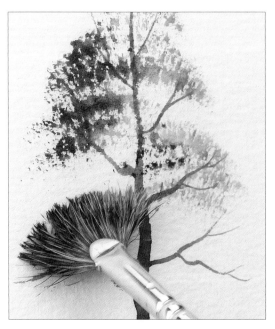

5. Complete the foliage by dabbing on darker tones of country olive.

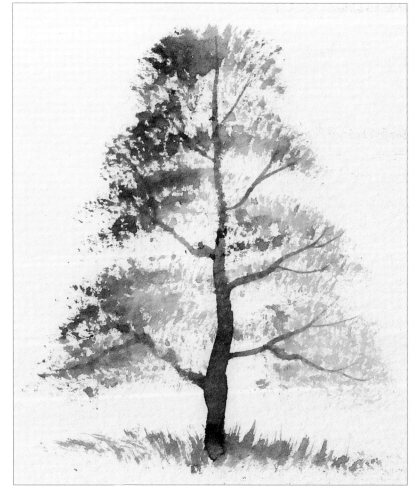

The finished tree: the grass beneath the trunk is created by flicking the same greens upwards with the fan gogh brush.

Thicker foliage

This tree is painted in a similar way to the previous tree, with the trunk and branches painted in before the foliage. This time, the foliage is thicker – use the fan stippler brush as before but load it with more paint so that the colour runs into the textured paper.

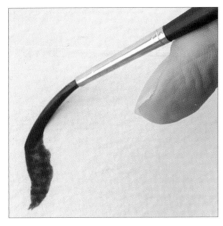

1. Mix green and burnt umber and start painting in the trunk using the half-rigger.

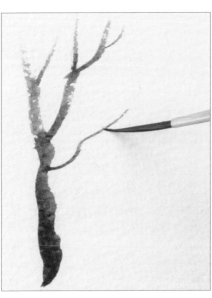

2. Add finer branches, tapering them off towards their ends.

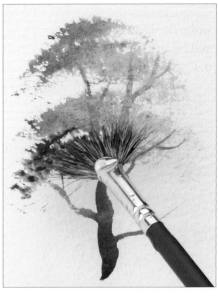

3. While the trunk and branches are still wet, stipple on sunlit green double loaded with a little country olive using the fan stippler. The colours will blend together and the branches will disappear into the foliage.

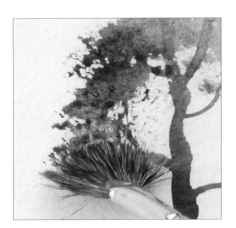

4. Use midnight green under the foliage and for the shadowed side of the tree.

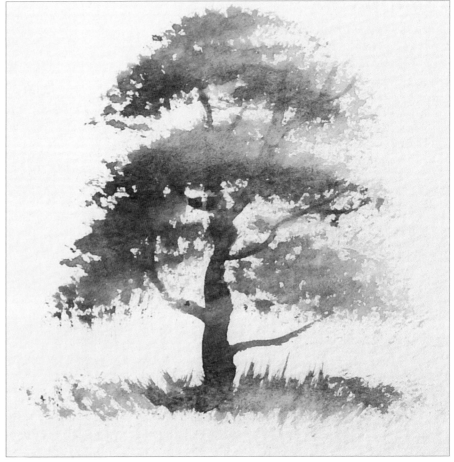

The finished tree: the grass beneath the trunk is created with the fan gogh brush and the same greens.

Foliage first

The foliage on this tree is fairly thick, so it is painted first using the fan stippler brush and a double loading technique. When you are happy with the effect, add the trunk and branches between the clusters of foliage. Do not try to be too precise: remember that you are aiming for an *impression* of a tree.

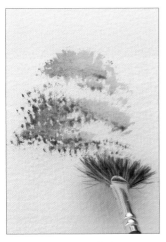

1. Double load the brush with sunlit green and country olive. Begin to dab in areas of foliage leaving gaps.

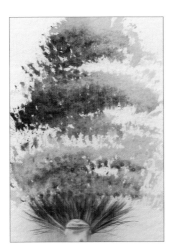

2. Work downwards, varying the angle of the brush to complete the light and dark areas.

3. Hold the brush horizontally and lay in a line beneath the tree.

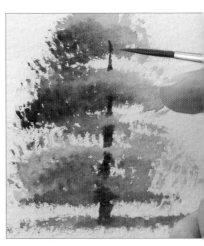

4. With the half-rigger, paint in the trunk where it shows through the foliage, using burnt umber and country olive.

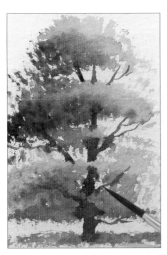

5. Still using the half-rigger, paint in some finer branches.

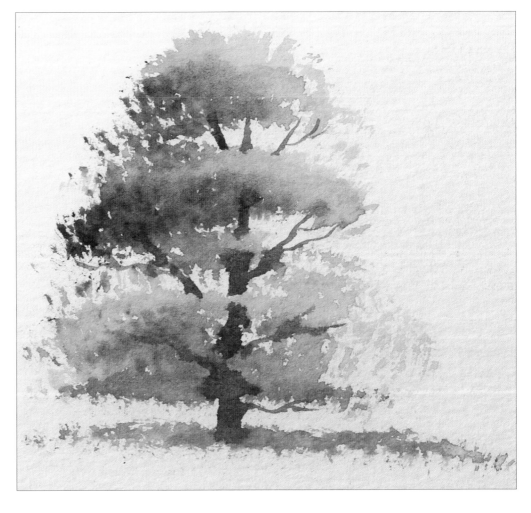

The finished tree.

Spring tree

Spring foliage is easy to paint, with its light, new leaves. This simple tree reflects the freshness of the season.

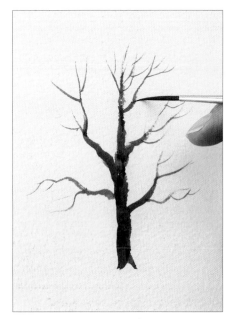

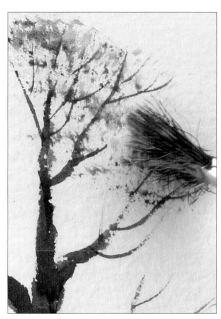

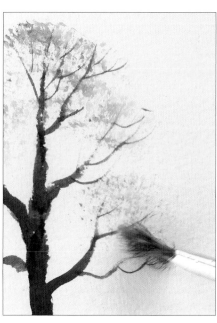

1. Using burnt umber and country olive, sketch in the tree with the medium detail brush, then add finer branches using the half-rigger.

2. Using the fan stippler and sunlit green, start to lightly stipple on the foliage. The brush should not be too wet.

3. Work downwards, keeping the effect light and airy.

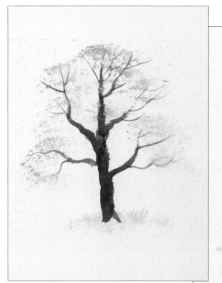

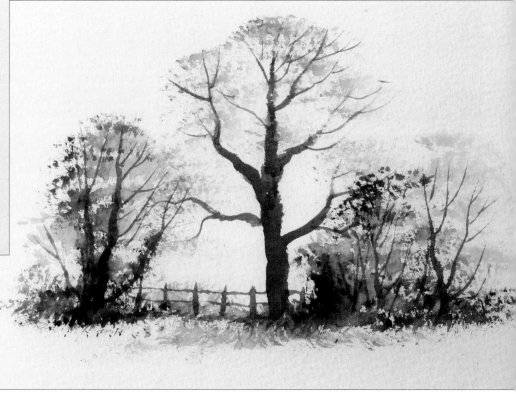

This painting captures the mood and atmosphere of the season. The range of green tones blend together in a harmonious composition that portrays spring.

Summer tree

In the height of summer, when a tree is in full leaf, it is not always easy to tell what type it is. This impression of a tree is very easy to create and can it be used to represent lots of different types of tree, especially when they are massed together.

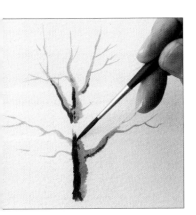

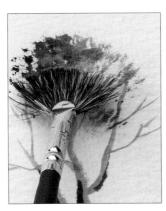

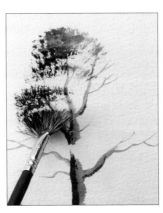

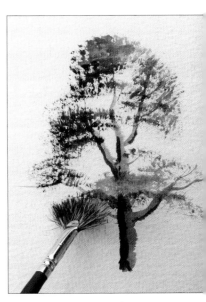

1. Sketch in the tree using a half-rigger and country olive. Add the shadows using country olive and burnt umber. Leave a gap at the front for an area of foliage.

2. Double load the fan gogh brush with sunlit green and country olive and start dabbing on the foliage.

3. Move downwards, angling the brush and stippling on areas of light and dark foliage to create an impression of sunlight and shadows.

4. Fill in the 'hole' at the front of the tree with an area of light green. Stipple the foliage across the trunk.

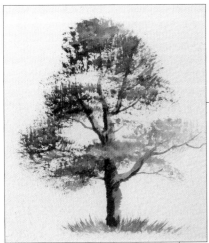

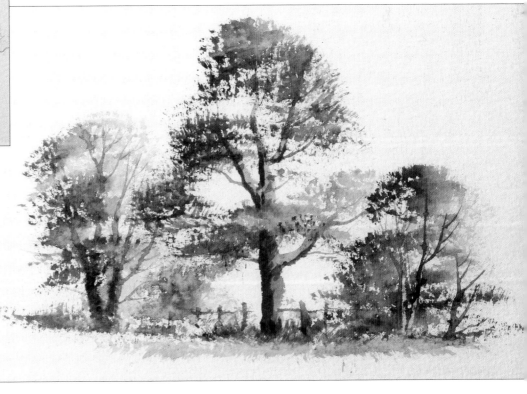

This is the same scene as the painting opposite. The denser summer foliage is darker and richer, and the feeling is warmer. The fence is now covered with thick grasses and bracken and the background is overgrown.

Autumn tree

The rich, vibrant reds and yellows of autumn are wonderful in any wooded landscape. I love painting this time of year. Here, the foliage is stippled in over the tree framework, which is a mix of country olive and burnt umber.

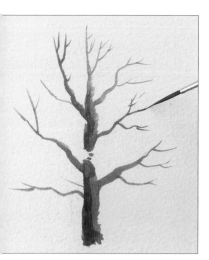 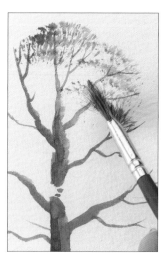

1. Paint the trunk using the medium detail brush, leaving a gap at the front. Add the larger branches, then change to the half-rigger and paint the finer branches.

2. Double load the fan stippler with autumn gold on the left hand side and sunlit gold on the right hand side. Start to stipple in the foliage.

3. Move down the tree to the gap in the trunk. Stipple in an area of foliage, angling the brush from side to side to create the golden autumn shades.

4. Add some burnt shadow to the brush and start building up the darker tones down the left hand side of the tree.

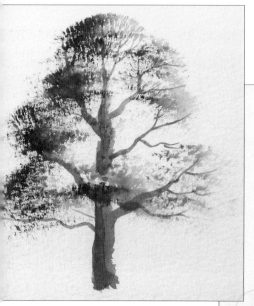

The tree is transformed with its autumn colours. The golden and russet hues create a glorious seasonal painting.

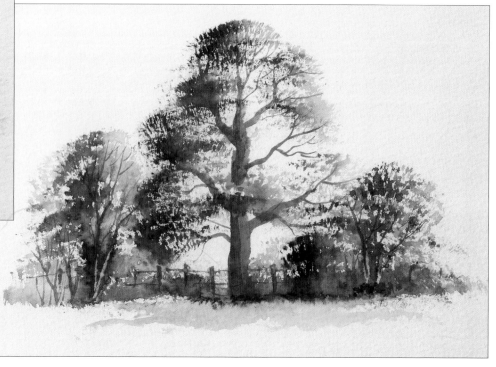

Winter tree

The stark framework of a deciduous tree can make a compelling painting and immediately evoke a feeling of winter. Here, I have painted in the trunk and branches with a mix of country olive and burnt umber and added a canopy of twigs.

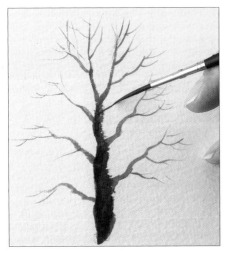

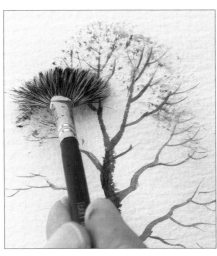

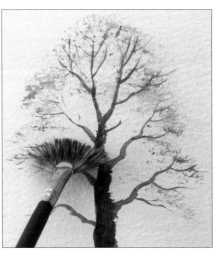

1. Paint in the trunk and larger branches with the medium detail brush, then add the finer branches with the half-rigger.

2. Using the fan stippler and a fairly dry mix of shadow colour, start at the top of the tree and lightly stipple over the branches.

3. Working downwards and still stippling lightly, complete the canopy of twigs.

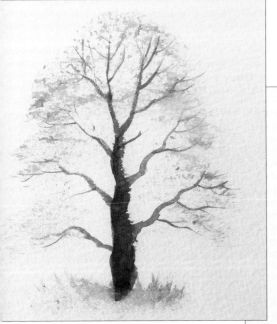

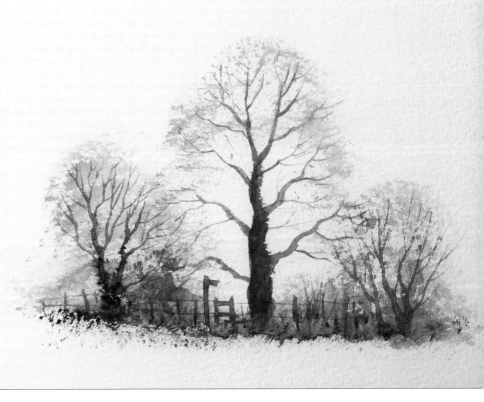

The trunks and branches are prominent in this winter scene. They are softened with stippled impressions of twigs in shadow tones which help to create the wintry atmosphere.

Winter tree with ivy

Occasionally you will see winter trees with their trunks densely covered in ivy. I love painting this subject because it adds character to a tree. The important thing is not to get involved with detail. It is easy to create an impression of ivy with this simple technique. Use the fan stippler brush and midnight green.

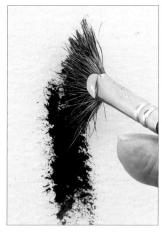

1. Hold the brush at right angles to the paper and dab in the shape of the trunk.

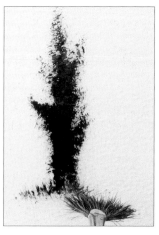

2. Turn the brush and flick up some grasses beneath the trunk.

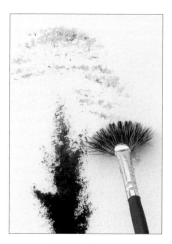

3. Load the brush with shadow colour and dab in the canopy of twigs.

4. Using the half-rigger and a light mix of cobalt blue and shadow colour, paint in the background branches.

5. Using a darker mix of shadow colour and burnt umber, paint in the trunk and the branches at the front of the tree. Remember that the tree is three dimensional. To create a feeling of depth, the lighter branches are in the background and the darker ones are at the front of the tree.

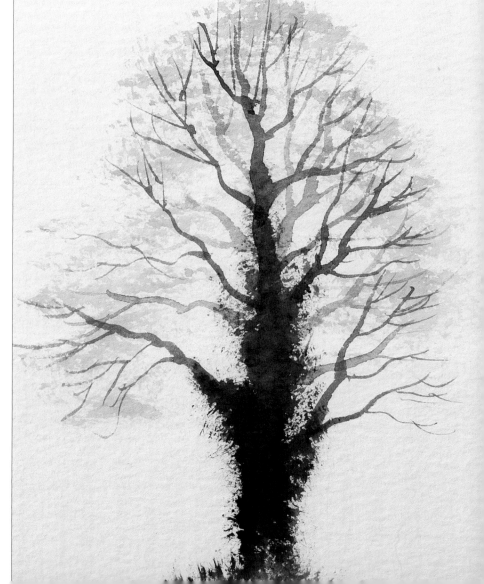

The finished tree.

Winter copse

This scene is initially worked wet-into-wet so that shapes soften and blur. Then the network of trunks and branches are painted when this background is dry. The combination of techniques captures the atmosphere of a cold winter's day. The same techniques can be used to create misty landscapes.

1. Wash in a cobalt blue sky with the golden leaf brush.

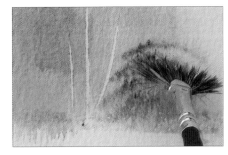

2. While the paper is still wet, add the shapes of trees with the fan stippler and shadow colour.

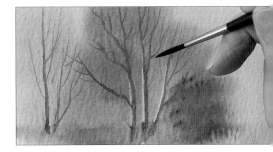

3. Using raw sienna, keep adding the tree shapes while the paper is still wet.

4. Before the paper dries, stipple midnight green ivy on to the central tree.

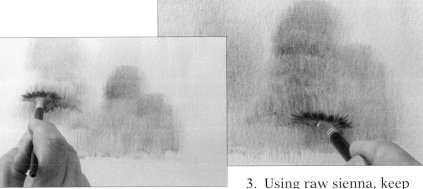

5. Scrape out the trunks of the smaller trees with a fingernail or the corner of a credit card. Add the foliage on the right using burnt sienna. Leave to dry.

6. Using the half-rigger and shadow colour, paint down one side of the scraped-out areas. This will create an impression of sunlight and shade. Paint all the trunks and branches using the same colour.

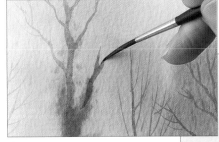

7. Add the fine branches with the half-rigger.

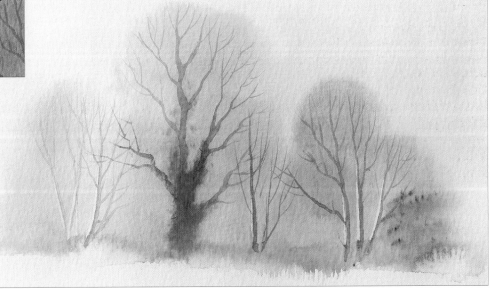

The finished painting: this small copse is made more atmospheric with the use of wet-into-wet washes and subdued colours.

Moving on

The following pages contain simple techniques that can be used to paint a variety of known trees. I begin with the very simple cypress below, and include demonstrations later on for more challenging trees.

Speedy cypress

One of the easiest trees to paint is a cypress. No trunk, no branches – just a sunlit side and a shaded side.

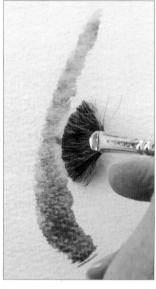

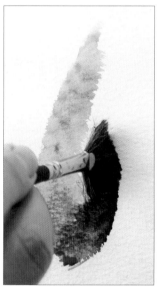

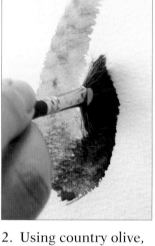

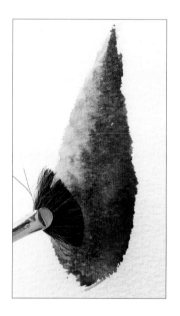

3. Hold the brush at an angle and blend the greens.

1. Load the fan gogh with sunlit green. Paint from the outside edge towards the centre of the tree, following the cypress shape.

2. Using country olive, paint the other side of the tree in the same way while the lighter green is wet. Allow the two colours to merge.

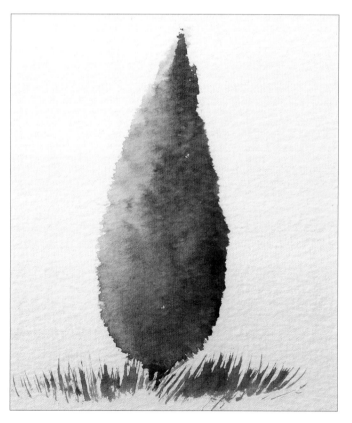

4. Using the same greens, flick grasses up at the base of the tree.

Tip
If you find some painting angles difficult, simply turn the paper around.

The finished tree: the cypress looks three dimensional with its sunlit foliage contrasting strongly with the darker shadows.

Loose spruce

The fan gogh is ideal for creating fir trees. The shape of the brush is the same as the shape of the branches. Load the brush quite fully as the foliage is thick and you need to achieve a fairly solid effect.

 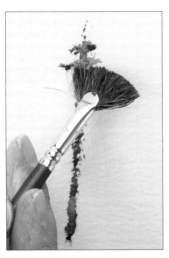 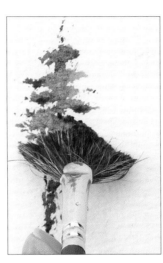 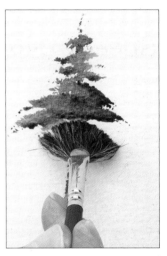

1. Hold the brush at right angles to the paper and dab a vertical line on to the surface using midnight green.

2. Turn the brush and use the corner to paint in the small branches at the top of the tree.

3. Paint in more branches, keeping the effect loose and free.

4. Use progressively more of the brush as you work downwards, pushing it firmly into the paper. Zig-zag down the trunk...

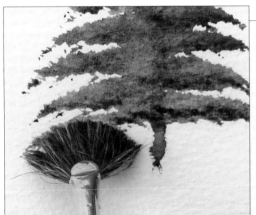

5. ...until you reach the bottom of the tree.

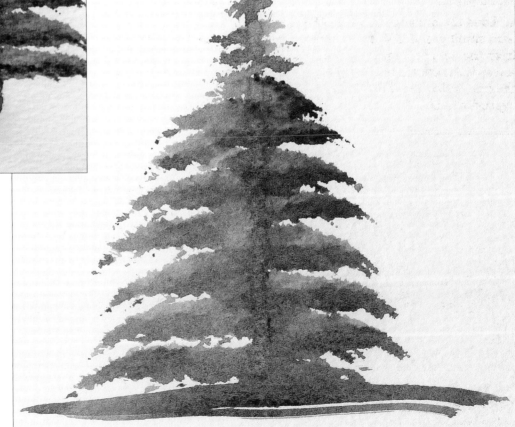

6. Using the same green, add a suggestion of grass beneath the tree with broad sweeps of the brush.

Lonesome pine

This Scots pine is simple to paint and is one of the few trees to have a brown trunk. Start with the framework and then add the foliage. If you have photographs of these trees, refer to them when following this demonstration (see page 12). This will help you to become familiar with the shape which will be useful for future paintings.

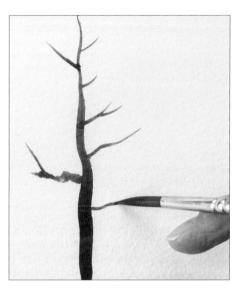

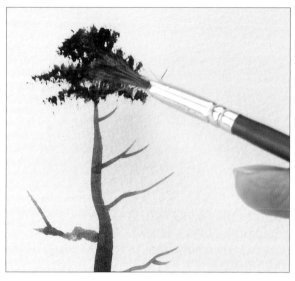

1. Paint the trunk using the medium detail brush and burnt umber.

2. Add the branches, pulling the brush away from the trunk, tapering the strokes lightly.

3. Change to the fan stippler brush and midnight green, and dab in the foliage.

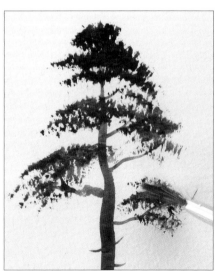

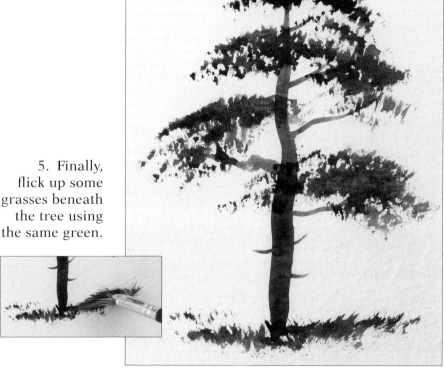

4. Work down the tree, dabbing more foliage on to the branches to create the pine shape.

5. Finally, flick up some grasses beneath the tree using the same green.

Weeping willow

Once you have mastered the technique for dragging down the foliage, the willow is simple to paint. Use a fairly dry fan gogh brush and not too much sunlit green.

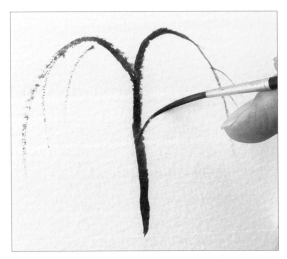

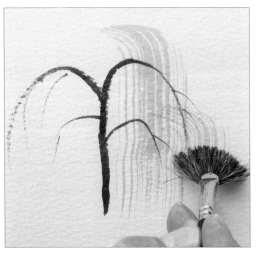

1. Using the half-rigger and a mix of country olive and burnt umber, paint in a simple framework.

2. With the fan gogh brush and sunlit green, use the tip of the brush and 'drag' foliage over the branches, curving the top of each stroke and pulling the brush downwards.

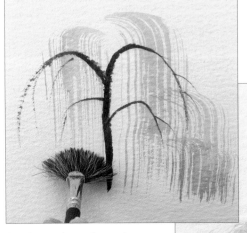

3. Complete the other side of the willow in the same way.

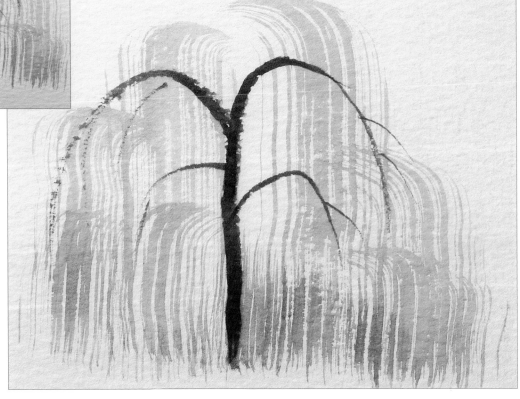

This impression of a willow is very effective when used in a landscape, yet the techniques are simple.

Popular poplar

I think the reason why I am often asked to paint these trees is that people like them! Joking apart, they are much easier than they look.

1. Using the half-rigger with a mix of country olive and burnt umber, paint in the delicate framework of the tree. The branches are painted upwards at a steep angle.

2. Change to the fan stippler and sunlit green with a little country olive. Stipple the foliage in at an angle, following the curve of the branches.

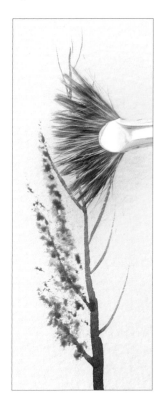

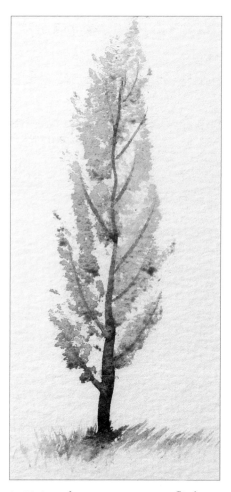

3. Using the same greens, flick the grasses up beneath the tree.

Simple palm

This must be one of the easiest trees to paint. There are two ways to paint the leaves. For the first method, simply paint them straight on to the paper as shown below.

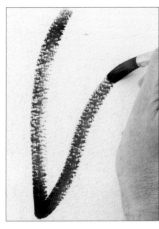

1. Using burnt umber, sweep a double trunk upwards with a fairly dry medium detail brush. The rough surface of the paper gives a textured effect.

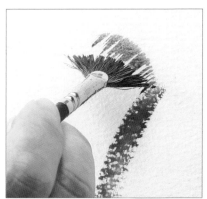

2. Using midnight green and the fan gogh, paint in the first leaf with a downward stroke of the brush. All the leaves start at the same point on the trunk.

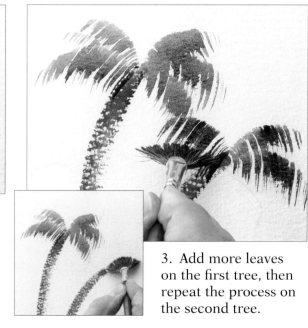

3. Add more leaves on the first tree, then repeat the process on the second tree.

Perfect palm

This is a very simple method and just as effective. Paint in the central ribs first, then add the sweeping fronds.

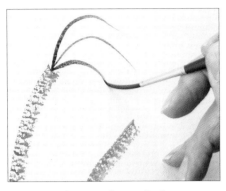

1. Paint the trunks as before. Then, using the half-rigger and midnight green, start to paint in the ribs of the leaves.

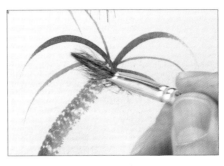

2. Finish painting the ribs. Then load the fan gogh brush with midnight green. Line up the brush on the first rib.

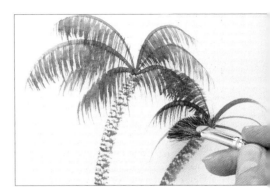

3. Drag the brush downwards to create the fronds. Repeat on the other ribs.

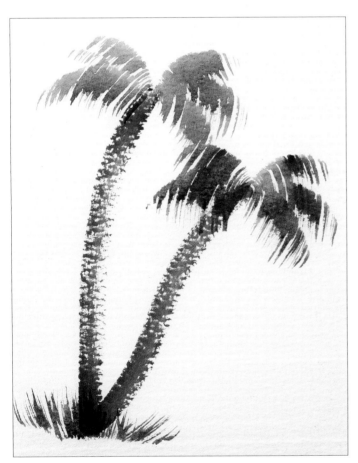

The finished paintings: either of these methods can be used to create convincing palm trees. The dry-brush trunks give an impression of texture and the fan gogh brush is ideal for creating the sweeping palm leaves.

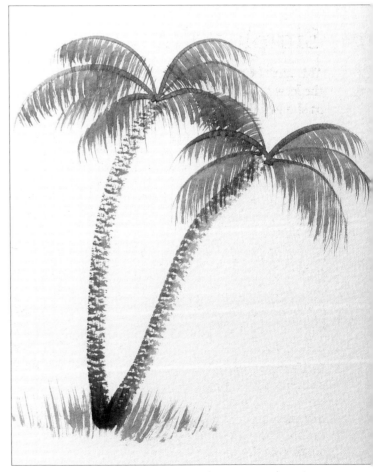

Apple tree in blossom

It can be difficult to reproduce blossom convincingly. Here, I use masking fluid to suggest drifts of blossom, which is often better than trying to paint every flower. This technique is extremely effective and it can be used on all types of blossom-bearing trees.

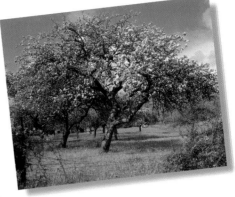

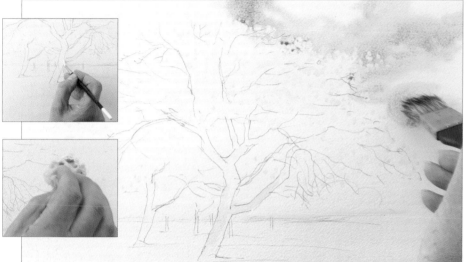

1. Using a 2B pencil, sketch in the main outlines. Referring to the photograph above and using masking fluid, first 'paint' over the sunlit areas of the trunk and branches, then sponge it in drifts across the branches to be covered by foliage. Each little 'dab' of masking fluid will represent blossom. Allow the fluid to dry. With the golden leaf brush and cobalt blue, paint in the sky.

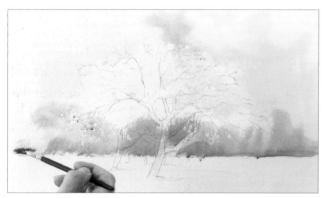

2. Working wet-into-wet and using the fan gogh brush and cobalt blue with sunlit green, paint in the background behind the tree, allowing the colours to merge. Do not make this area too dark. Leave to dry.

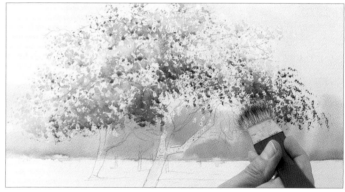

3. With the golden leaf brush and mixes of sunlit green and country olive, stipple in the foliage. Use more of the darker green as you work down the tree.

4. Using the fan gogh brush and sunlit green, country olive and raw sienna, paint in the grass and shadows beneath the tree.

5. With the medium detail brush and a dark green mix of midnight green and burnt umber, paint in the unmasked areas of the trunk and branches.

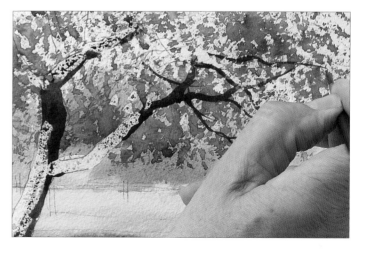

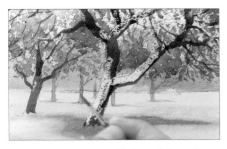

6. Using the small detail brush and a mix of country olive and cobalt blue, paint in the tree trunks and their shadows in the middle distance.

7. Rub away the masking fluid to reveal the white areas.

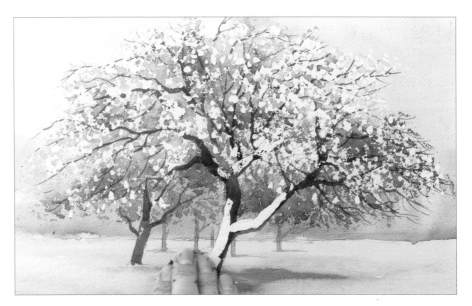

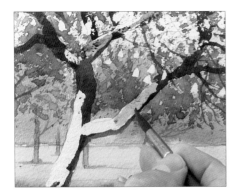

8. With the medium detail brush and a light mix of sunlit green and burnt umber, paint in the sunlit areas on the trunk and branches.

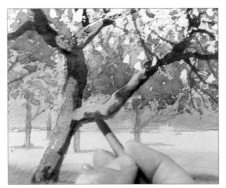

9. Add shadows using a mix of burnt umber and country olive.

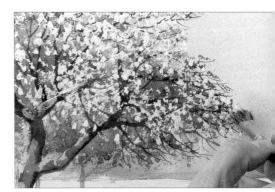

10. Using the foliage brush and a touch of alizarin crimson, stipple colour over the blossom.

The finished painting
510 x 330mm (20 x 13in)
Longer grass is added beneath the two main trees and in the foreground by flicking up midnight green with the fan gogh brush.

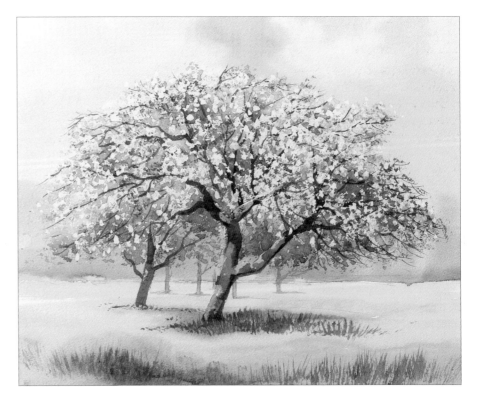

Oak tree

I drove past this scene many times thinking 'nice tree, but shame about the surroundings', then finally decided to park and take a photograph. A bit of tinkering – otherwise known as artistic licence – was needed to remove the road signs and tarmac. I also decided to paint the oak tree standing alone and this is the result.

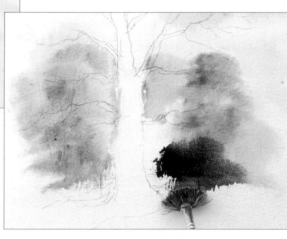

1. Using a 2B pencil, lightly draw the main outlines of the picture. I have retained the fence, and will replace the tarmac foreground with grass.

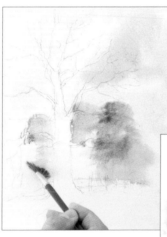

2. Wash in a simple sky using the golden leaf brush and cobalt blue. Then, working wet-into-wet, paint in the background foliage with the fan gogh brush and using shadow tones...

3. ...and country olive. While the foliage is still wet, drop in burnt umber behind the tree on both sides.

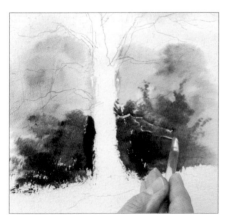

4. While the colours are still wet, use a brush handle to scrape away branches on the right hand side of the trunk.

5. Repeat this on the left hand side, then scrape away the shape of a fence.

6. Flick up some grasses beneath the tree using the fan gogh brush and sunlit green, burnt sienna and country olive.

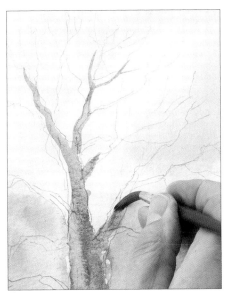

7. Using the medium detail brush and a mix of country olive and burnt umber, paint in the tree trunk and upper branches.

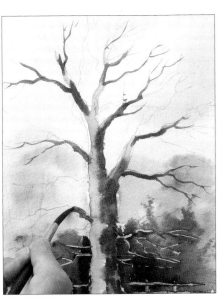

8. Paint in the darker shadow areas with a mix of country olive and burnt umber, starting at the top and working downwards.

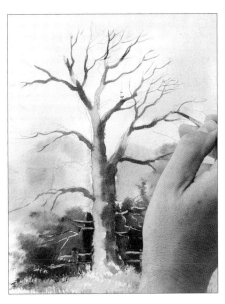

9. Change to the half-rigger and add the tiny branches.

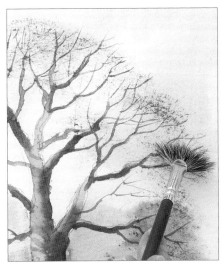

10. Using the fan stippler and shadow colour, dab in the canopy of twigs.

The finished painting
280 x 310mm (11 x 12¼in)
I use photographs for reference only and often use artistic licence to create more pleasing compositions. The solitary oak tree is sunlit against dark winter foliage in a peaceful setting, instead of being portrayed on a busy junction.

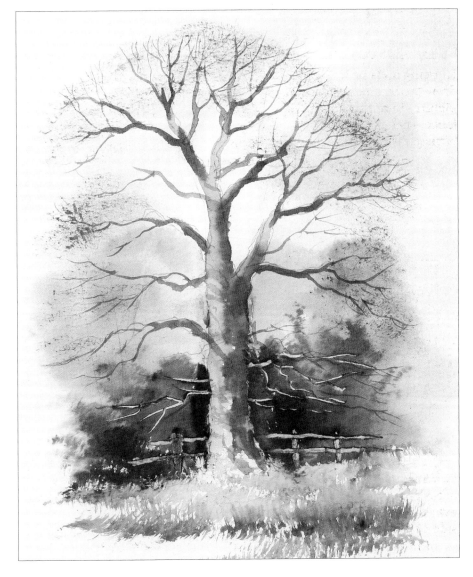

Silver birch

The delicate trunk and texture at the base of the tree make the silver birch a favourite with artists, and I am no exception. When I am working in watercolour I often use masking fluid to reproduce the characteristic trunk. I have also devised a technique that uses an old plastic credit or store card to produce an amazingly fast and convincing effect (see page 16). When you paint the trunks, remember to make them darker towards the ground.

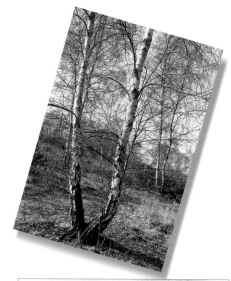

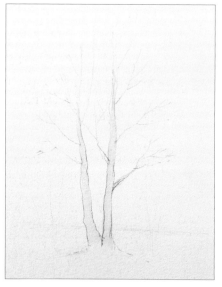

1. Using a 2B pencil, draw in the trees and paint masking fluid on to the trunks. Remember to coat your brush with soap before using the fluid.

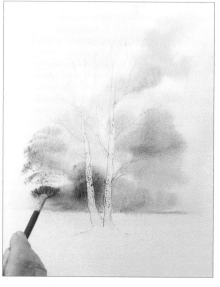

2. Wash in a cobalt blue sky, then, using the fan gogh brush and cobalt blue with sunlit green, paint in the soft background tones wet-into-wet.

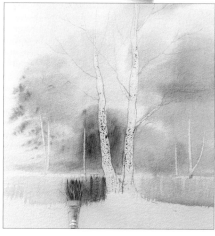

3. While the background is still wet, scrape away the distant tree trunks with a brush handle. Using the wizard and sunlit green with cobalt blue, wash in the water. Add the reflections with downward strokes of the brush, working wet-into-wet.

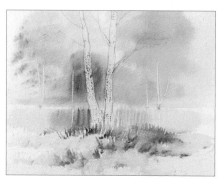

4. Using the fan gogh brush and sunlit green, country olive and raw sienna, flick up an area of grass beneath the trees.

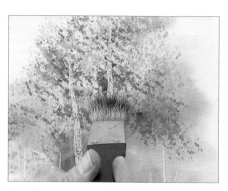

5. Change to the golden leaf brush and dab in foliage over the tops of the trunks using sunlit green and country olive.

6. Using a fingertip, gently rub off the masking fluid.

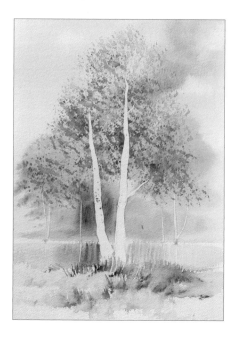

44

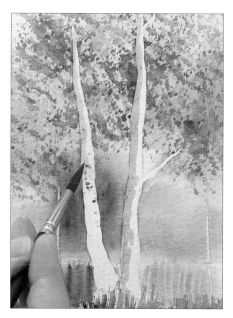

7. Using the small detail brush and diluted cobalt blue with a touch of raw sienna, paint in the shadows on the trunks.

8. Using the half-rigger and a mix of ultramarine and burnt umber, paint in the bark texture and add the darker branches.

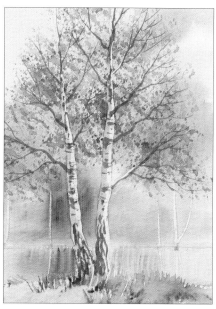

9. Paint the bark at the base of the trees, where the bark splits, leaving little islands of white.

10. Finally, using the golden leaf brush and country olive, dab in areas of foliage over the top of the trunks for a natural effect.

The finished painting
280 x 310mm (11 x 12¼in)
I used a photograph on the top of the opposite page for reference but made the composition more pleasing by painting the silver birches in full foliage on a quiet riverbank.

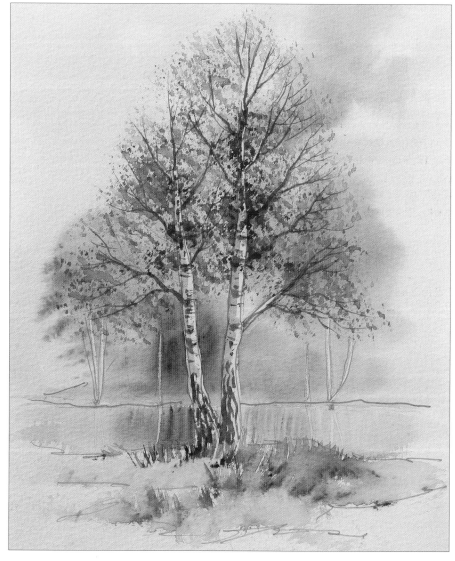

Horse chestnut

Most trees, unless they are specimen trees in arboretums, are not seen standing alone. The horse chestnut is an exception in that you will often see just one, perhaps in the middle of a park or playing field. I have used masking fluid to give an impression of the characteristic 'candles' but you can omit this element if you prefer just to paint the shape of the tree.

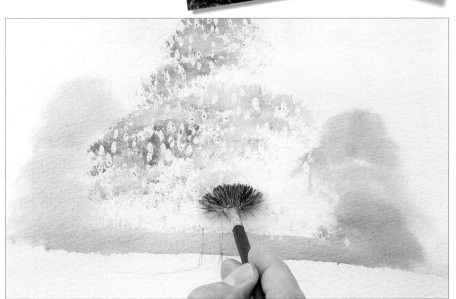

1. Sketch the outline of the tree using a 2B pencil, then use masking fluid to paint in the 'candles'. (Remember to coat the masking fluid brush with soap.)

2. Dampen the paper and, working wet-into-wet with the golden leaf brush, paint in the cobalt blue sky. Add the soft background using cobalt blue and sunlit green. Allow to dry. Using the fan stippler and sunlit green, start to stipple in the lighter shades of the tree.

3. Using country olive, add the medium shades to selected areas of the tree.

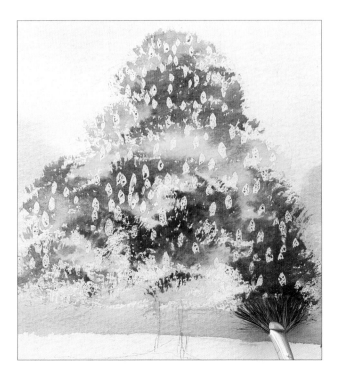

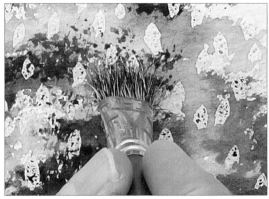

4. Using the foliage brush and midnight green, add darker shades and more texture on a dry background.

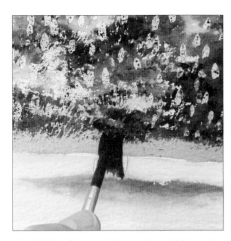

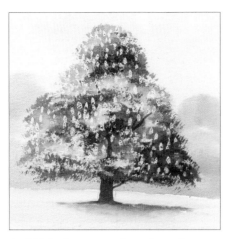

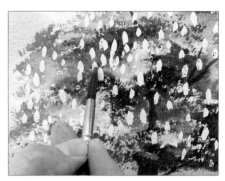

5. With the medium detail brush and sunlit green, paint the grass, adding the shadow with country olive. Using a midnight green and burnt umber mix, paint in the trunk.

6. With the same brush and paint mix, add a few branches within the foliage, tapering the ends to give a realistic effect.

7. Remove the masking fluid with a fingertip. Using a mix of sunlit green and raw sienna, take the starkness off a few of the 'candles'.

The finished painting
310 x 280mm (12¼ x 11in)
Simple techniques can be combined effectively to create this horse chestnut with its distinctive 'candles'.

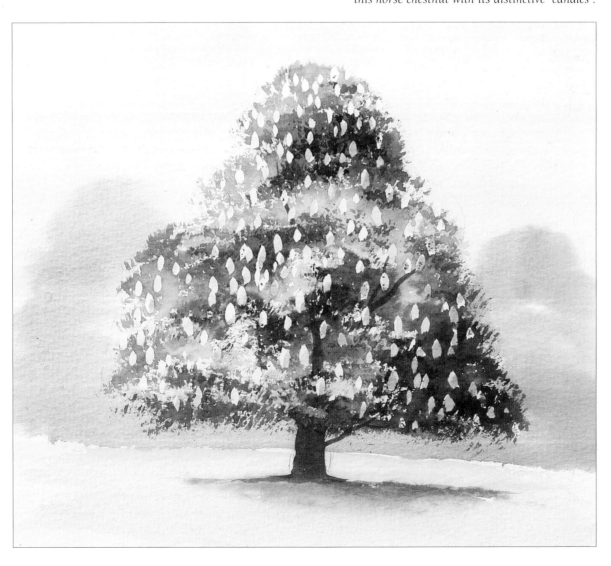

Olive tree

These splendidly gnarled trees are a feature of the Mediterranean landscape. Here the strong foreground tones of the textured bark, branches and dark foliage contrast beautifully with the paler tones of the sea, the quiet beach and the houses nestling at the foot of the hill.

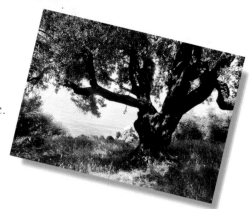

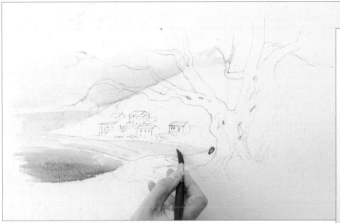

1. Draw the main outlines with a 2B pencil. Wash in the sky with cobalt blue. Wash in the sea with the medium detail brush and a mix of cobalt blue and sunlit green. Wash in the beach using raw sienna.

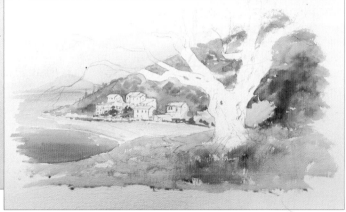

2. Paint in the far distant headland using a mix of pale cobalt blue and sunlit green. With a stronger mix of the same colour, paint in the hill leading down to the beach. The foreground is a warmer mix of country olive, sunlit green and burnt sienna.

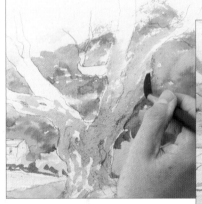

3. Paint the trunk and branches using a light mix of country olive and burnt umber.

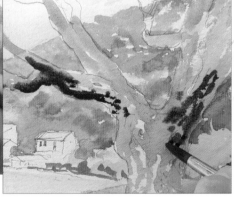

4. Add darker areas using a mix of midnight green and burnt umber.

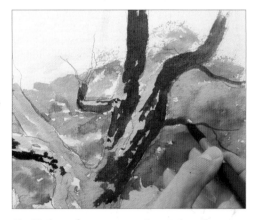

5. Using the same mix, paint in the darker branches.

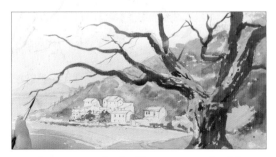

6. Change to the half-rigger and add the finer branches.

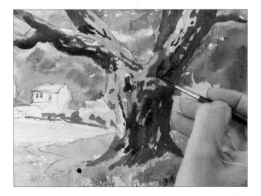

7. Add the gnarled features and detail with a mix of midnight green and burnt umber.

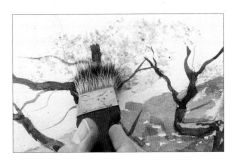

8. With the golden leaf brush and the lighter sunlit green, start to stipple in the foliage.

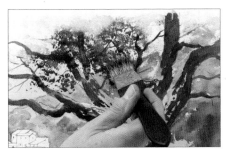

9. Change to country olive and add darker tones.

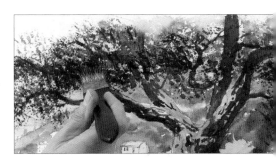

10. Keep building up the darker tones with midnight green.

11. Add finer branches using the half-rigger and a mix of burnt umber and midnight green.

12. Now, using midnight green and the fan gogh, flick grasses up at the base of the tree.

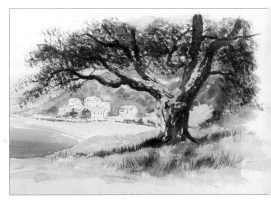

13. Add detail to the foreground grasses using the half-rigger.

The finished painting
510 x 310mm (20 x 12¼in)

Finally, lay a light wash of raw sienna over the walls of some of the buildings, with an occasional touch of alizarin crimson. Paint in the rooftops with mixes of cadmium red, cadmium yellow and touches of cobalt blue. Add touches of cadmium red, cadmium yellow and ultramarine along the edge of the beach.

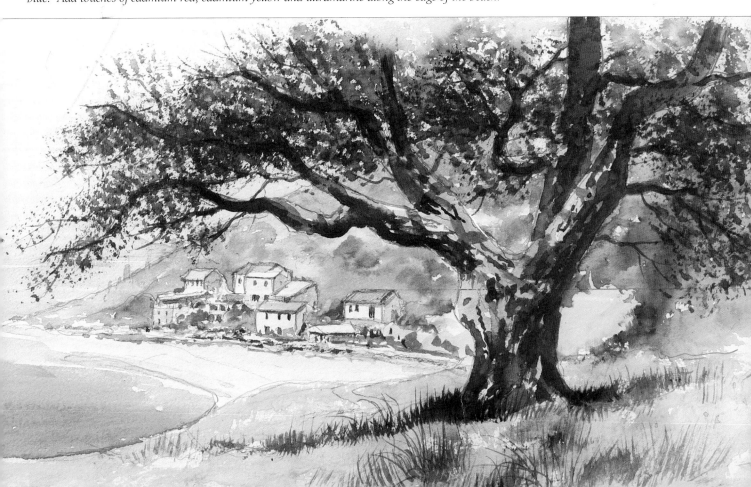

Watercolour Flowers

I love painting flowers and hopefully I can share some of the hints and tips for painting them with you. That said, I'm an artist, not a botanist; and this section is in no way a botanical reference work. Rather, it is intended to show how you can use some fairly standard and also some more unusual techniques to add flowers to your watercolours. After all, you don't need to be a gardener to paint a good picture!

When doing painting demonstrations or workshops, I often jokingly tell my students that if a painting is going horribly wrong, they can rescue it by simply adding bluebells or poppies! While bluebells and poppies are obviously not always appropriate, the idea is that by using a prop such as flowers in a painting, you can not only improve the overall look of it but also make the finished painting look more eye-catching.

For example, a lot of my paintings use a footpath as a way of leading people into a painting. Used on its own, a footpath can be a little uninspiring; but by dressing up the scene with poppies, the whole character of the painting is changed.

When I first started painting, I found winter scenes more appealing to paint because of the somewhat limited palette, and I would rely on different weather conditions and wintry moods to give the composition its main theme. I found summer landscapes, with their dominant colours leaning towards greens, much more restrictive until I found that simply by adding some flowers to the foreground, I could change the whole thrust of the painting, bringing colour and life to an otherwise ordinary scene.

Looking back at many of my paintings, I am surprised to see how much floral detail I have used in a variety of different types of scene, such as landscapes, townscapes and river scenes; and some typical Terry Harrison-style examples of these are covered on the following pages. I hope this section is of some help in adding a little splash of colour into your artwork.

Terry Harrison

Heart of the Village
480 x 600mm (18¾ x 23½in)
This idyllic country village, and its key elements of thatched cottages, a pub and church are linked together with splashes of floral colour.

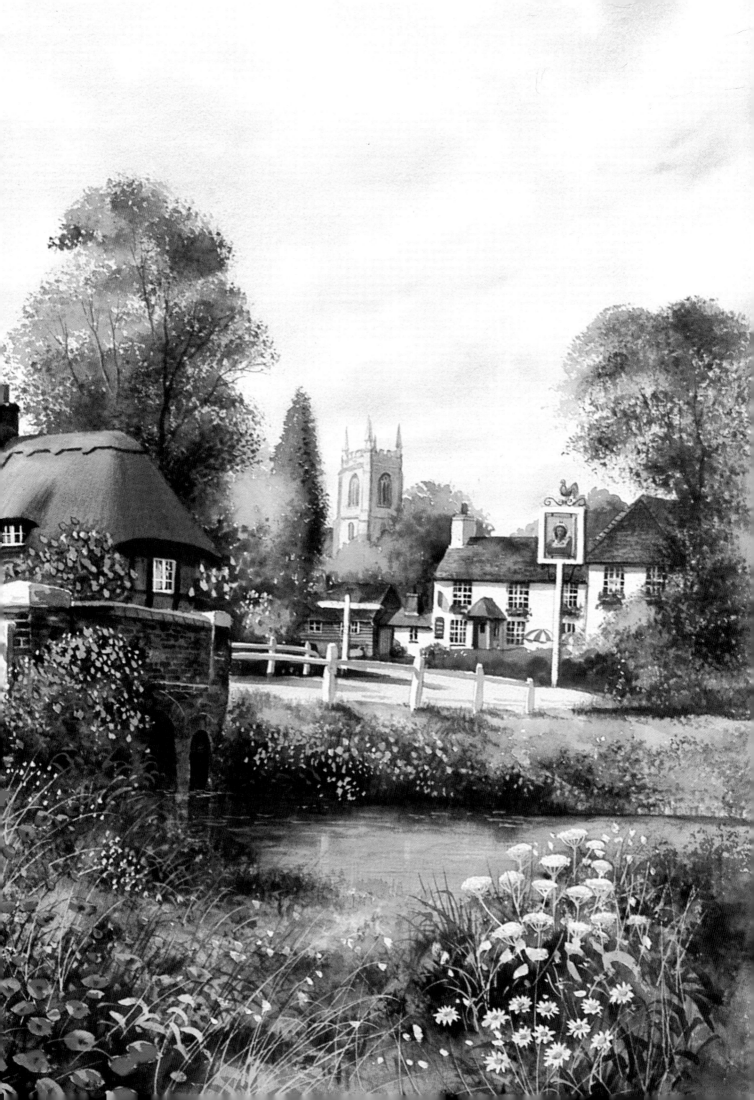

My palette

There are so many colours available to the artist these days, it can be very confusing choosing a selection to use. As you paint, you will get used to using a certain range of colours, so if you restrict yourself to the colours that you find you use the most, you will eventually learn to get consistency in your painting style.

With this in mind, don't be afraid to extend your palette; some things require a specific colour. For example, permanent rose is a great colour for painting fuchsias, but is very difficult to mix from a limited palette.

Colours I use

burnt umber

raw sienna

burnt sienna

ultramarine

cobalt blue

permanent mauve

In a starting palette, you need a good range of earth colours; I use burnt umber, raw sienna and burnt sienna, but you could also add yellow ochre.

You also need a warm and a cool blue. Ultramarine and cobalt blue respectively are ideal. Permanent mauve is a blue-violet which is used for petunias, and is an excellent addition to your colour range.

cadmium red

alizarin crimson

permanent rose

permanent magenta

shadow

The first red I have on my palette is cadmium red, which is neither too blue nor too yellow, and so will not become muddy when mixed with other colours. The other red I use is alizarin crimson which is ideal for mixing with blues to create a whole range of purple hues. Permanent rose and permanent magenta are good alternative reds.

This mix of cobalt blue, alizarin crimson and a touch of burnt sienna gives a subtle purple shade which is ideal for painting shadows. The manufactured colour 'shadow' is a transparent shade, so that when it is applied over another colour the base colour shines through.

cadmium yellow

midnight green

sunlit green

country olive

The reason that I only use one yellow is because I have three ready-mixed greens, which eliminates the need for a whole variety of yellows. Midnight green is a dark bluey-green, perfect for painting on the shaded parts of trees but also can be diluted to a pale bluey-green for distant trees; sunlit green is a yellow-green, good for highlighting foliage and also for fresh, sunlit passages of a landscape. The final green is country olive, a middle range green, which can form the overall 'summer' colour, but is also useful for mixing with other colours to give the whole range of greens without the fear of the paints turning muddy.

Useful mixes

This is a simple guide to mixing some colours that are used for painting a selection of popular flowers.

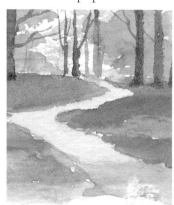

cobalt blue

permanent rose

bluebell mix

Bluebells

Bluebells are surprisingly difficult to paint, mostly because the colours of bluebell woods appear to vary quite a bit due to changing light conditions. A simple mix that you can use for bluebells is cobalt blue and permanent rose. You can substitute alizarin crimson for the permanent rose for a variation.

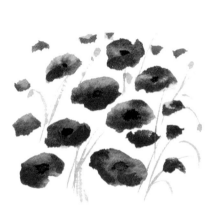

cadmium red (weak mix)

cadmium red (strong mix)

two-tone effect

Poppies

In contrast to bluebells, poppies are simple to paint! The main colour I use is cadmium red, which can be used neat for a strong, bright red, or watered down to give the appearance of sunlight shining through the petals for a two-tone effect. The centre of the poppies is simply added with a dot of shadow.

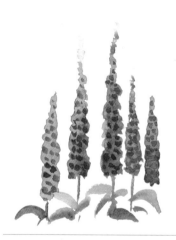

permanent rose (lighter tint)

permanent magenta (darker shade)

shade added wet-into-wet

Foxgloves

These flowers look their best with a dark background, so it is best to mask the area where you want them beforehand. The contrast emphasises their unusual shape and brings out the brightness of the colours. The base colour for foxgloves is permanent rose, and I use permanent magenta for the darker shades. You can vary this darker shade by using alizarin crimson.

A note on my palette

The watercolour palette I use has a clip-on lid. When the palette is not in use, it keeps the tube colours from drying out. The benefit of this is that when you want to start painting again, you can simply open the lid and the paints are still workable. The other advantage is that when you finish painting, you can clip the lid back on to protect the colours while you rinse the rest of the palette clean.

Cool colours

Colours are split into two groups, warm colours and cool colours. Cool colours such as cobalt blue and midnight green are associated with winter or spring scenes, so spring paintings often use a cooler palette than summer ones.

A good example of cool colours; this painting of a spring scene uses a selection of cool blues for a misty background and still waters. This has a calming effect, and using the bluebells as the focal point enhances the springtime feel.

I have used some warm colours in the foreground flowers. This contrasts with the bluebell colour and emphasises the coolness of the background. Notice how the yellow flowers have a large impact on the painting. This is because warm colours tend to come to the fore of a painting and be immmediately noticeable, while cool colours recede. This is also why things in the background tend to be bluer than things close up.

Compare this painting with the similar scene on the facing page, and notice that although I have used many of the same colours, the ones that I have changed give a completely different feel to each of the paintings.

Bluebell Glade
330 x 500mm (13 x 19½in)

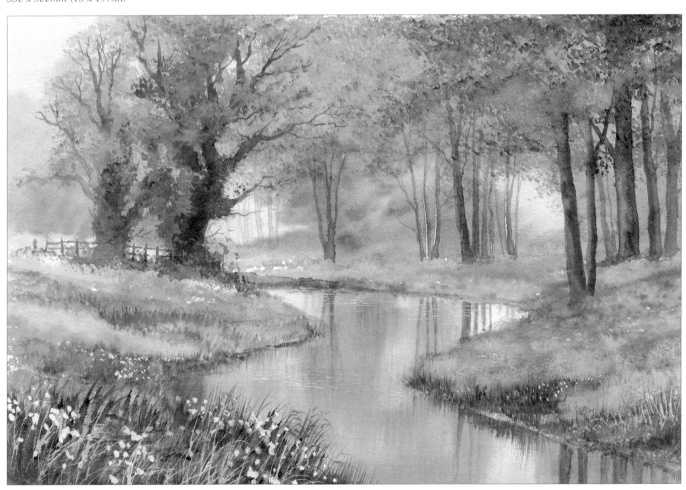

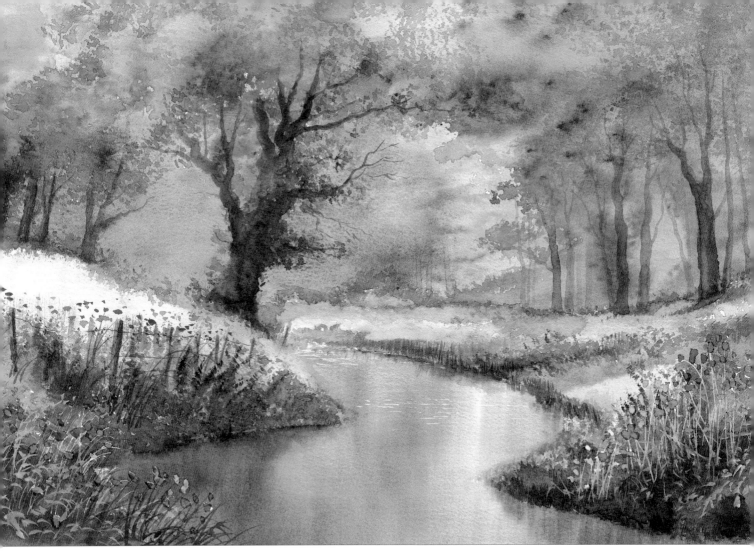

Summertime
330 x 500mm (13 x 19½in)

Warm colours

Warm colours such as cadmium red, cadmium yellow and sunlit green are more associated with summer scenes or sunnier climes, so using a warm palette will enhance the effect of such a painting. Earth colours such as burnt sienna and burnt umber are warm colours: the word 'burnt' is the giveaway!

This painting has a very similar composition to *Bluebell Glade*. The background colours were painted wet-into-wet using mainly the warm colours sunlit green, country olive and cadmium yellow, but also a little cool cobalt blue to enhance the feeling of recession at the back of the painting. These colours are also reflected in the water.

As the painting comes forward, I have used raw sienna and a mixture of burnt umber and burnt sienna to build up the warm summer shades on the water's edge. This is highlighted by splashes of red that prevent the warm browns from dominating the painting and making it dull. This is a good example of how flowers can immediately enhance and lift a painting.

Similarly to its companion piece opposite, *Summertime* has flowers at the front of the painting; but this time I have used cool colours on this warm scene. The cool colours at the top and bottom of the painting act as a frame for the warm focal point at the centre.

Using photographs

This section explains how you can use a selection of photographs to produce one masterpiece. The finished painting is a typical watermill with a chalk stream, and is fairly faithful to the actual scene. However, I have combined several views of the same scene to create the final picture.

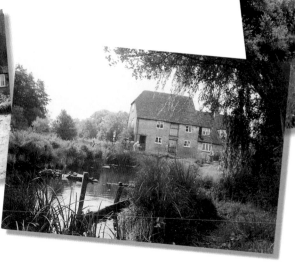

The third photograph shows the detail in the foreground, including the gate.

This first photograph shows the detail of the mill, including where the mill stream runs through the arched outlet from the mill wheel.

The second photograph has the mill in the middle distance, giving the painting depth, and ensuring that although the mill is the focal point of the painting, it is not the dominant feature.

One of the big problems with using photographs is if you copy them too faithfully, you can end up with a dull finished picture. For example, the third photograph shows the gate perfectly, but the mill itself is obscured by a mass of trees, and is also in the shade. The first photograph shows the mill more clearly but the foreground is uninspiring.

Although each photograph could be used as a painting in its own right, by selecting the best elements of each, and with a little artistic licence, you can create a more successful painting. For example, the photograph showing the gate is fine, but by having the gate slightly opened rather than as a barrier, the viewer is drawn into the painting.

Every time I hear a professional artist using the expression 'I only use photographs as an *aide-mémoire*', I know as well as you know that they copy and combine them to create a convincing painting. In short, don't feel that you are cheating by using photographs, but if you are asked, be sure to tell people that you only use them as an '*aide-mémoire*'!

Tip

I have a little motto that I use when painting: 'If it looks wrong, it is wrong'. This means that if you notice the painting not looking quite right, then now is the time to change it. For example, if something is too dark, use lighter tints when painting it. If the foreground is too dull, add more colour to it.

It is a simple expression, but it can help to compose a painting whether using photographs or not.

Opposite
The Watermill
350 x 500mm (13¾ x 19½in)
This painting was made by combining various photographs of the same scene with a little artistic licence. The important part of this painting is adding the variety of different flowers in the foreground, bringing colour and interest to the overall picture.

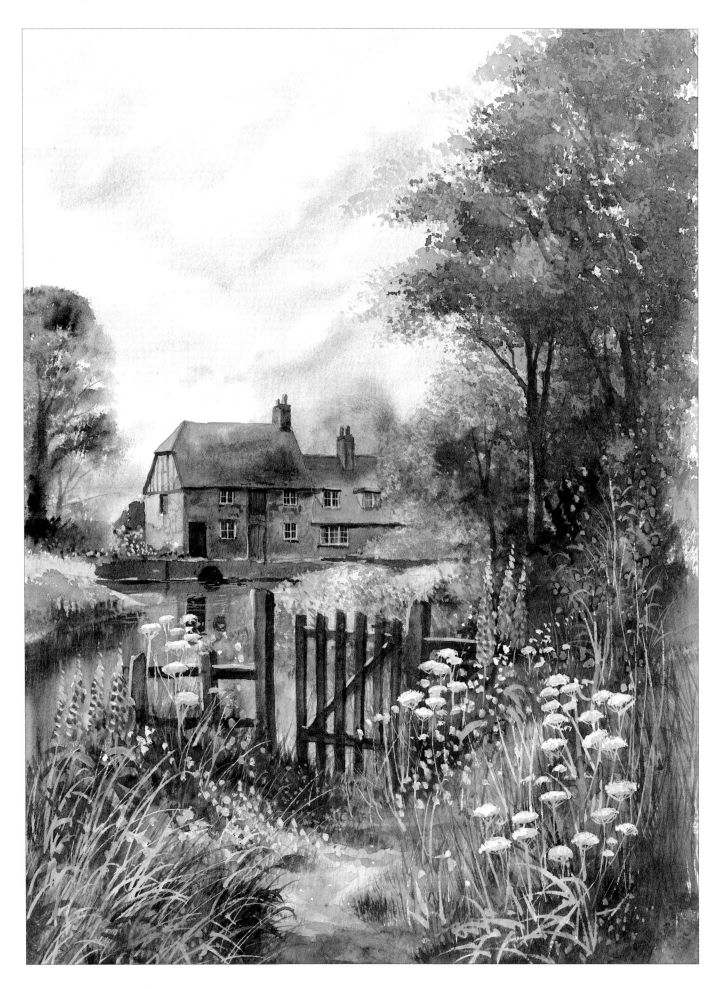

Techniques

Using the brushes

Different brushes create different effects. Here is a variety of different brushes that will give you a whole selection of brush strokes.

Large detail

The large detail brush can hold a large amount of paint, but still tapers to a fine point. This makes it perfect for larger leaves and petals.

Medium detail

When you need more control, for instance when painting broad but long leaves or plant stems, the medium detail brush is ideal.

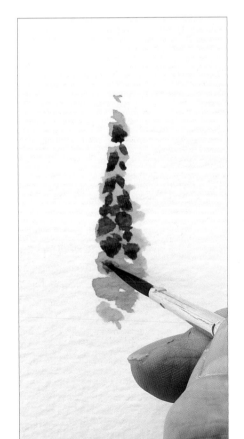

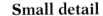

Small detail

The small detail brush, as its name suggests, is used for the very finest details – including adding shading to flowerheads, as shown.

Half-rigger

Very long, fine grasses and stems are easy to paint with this brush. The hair is long and goes to a very fine point, but it still holds a lot of paint.

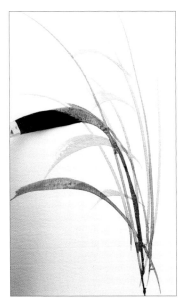

Sword

The sword holds a lot of paint, and the angled head tapers to a blade. This makes painting stems and grasses very simple, and produces results similar to traditional Chinese brush painting.

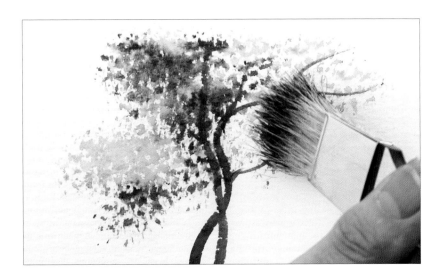

Golden leaf

The golden leaf is great for laying in washes. The hard bristles of the brush are mixed with softer hair that curls when wet, so when used with dryer mixes, you can get fantastic texture with this brush – perfect for underlying foliage or leaves.

Foliage

Essentially, the foliage brush is a smaller version of the golden leaf brush. It is ideal for foliage, as its name suggests; but it is also fantastic for painting carpets of bluebells.

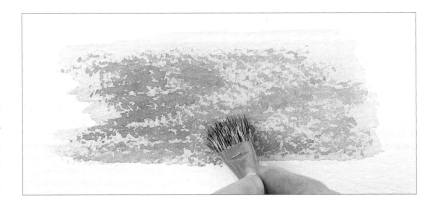

Wizard

As well as being useful for laying in small washes, the two different lengths of hair on this brush give a slightly ragged effect that is ideal for grasses.

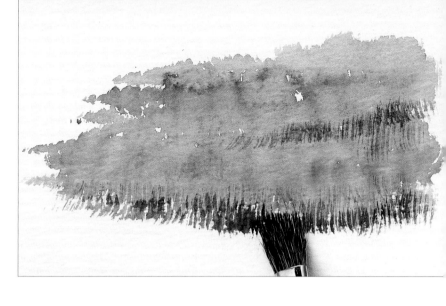

Fan stippler

The fan stippler makes painting trees easy, since the fanned end is the curved shape of treetop foliage.

Fan gogh

By flicking a lightly-loaded fan gogh upwards, you can easily paint grasses, and by turning the brush on its side so that it points vertically, you can paint ferns by touching the brush to the paper and pulling sideways.

Fan gogh px

This brush has the same head as the fan gogh, but the perspex handle is angled and perfect for scraping out grasses and the veins of leaves.

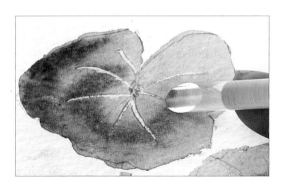

Other techniques

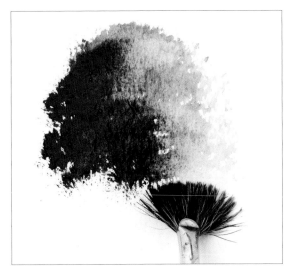

Double-loading
You can paint in ready-shaded foliage with the fan gogh brush. Simply load one side of the brush with light green, and the other with dark green (angle the brush into the paint to avoid mixing them). Then simply dab the brush on to the paper for ready-shaded trees.

Quick poppies
Block in the petals with the large detail brush and a thin wash of cadmium red, then add a slightly stronger shade of the same mix for shading. Working wet-into-wet, use the colour shadow to drop in the centre of the poppy. Finally, press the centre of the poppy firmly with your finger (see inset) and remove to reveal a quick, perfect poppy.

Scraping out rocks
The texture of rough watercolour paper makes it simple to paint realistic rocks quickly, using a plastic card to scrape them out.

1. Block in the shape of the rocks using the wizard and a variety of greens and yellows. These colours should be applied fairly dry.

2. Cover the rocks with a wash of ultramarine; again, not too wet.

3. Place the plastic card on the paper and, with a sharp tug downwards, scrape the paint off the paper. Repeat for the rest of the rocks.

Masking fluid unmasked

Masking fluid is a water-resistant latex that is used to mask detail on watercolour paper and preserve the white of the paper from the watercolour paint. When the paint is dry, the masking fluid can be removed by rubbing it with your finger, revealing clean paper underneath. Paint can then be added to these areas, ensuring the colour is clean and fresh.

Masking fluid can be applied with a variety of techniques. This demonstration will unravel the mysteries of masking fluid.

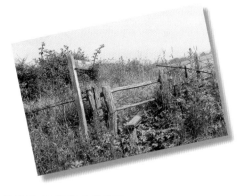

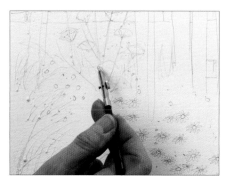

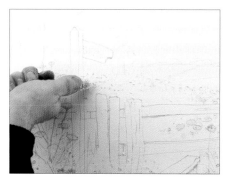

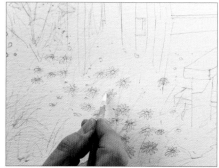

1. Draw the scene with an HB pencil, then mask the stems of the flowers and some of the grasses in the foreground using the ruling pen.

2. Dip a toothbrush into the masking fluid and draw your thumb over the bristles to spatter masking fluid over the cornfield area. Spattering is uncontrollable, so do not overload the toothbrush.

3. Using the masking fluid brush, mask the flowerheads. It is important to draw the daisies in detail first before attempting to paint the petals.

Tip
When using a brush to apply masking fluid, wipe the head over a bar of soap first. The soap acts as a barrier between the bristles and the masking fluid, so you won't damage your brush. It also ensures that the masking fluid is easily rinsed off with clean water afterwards.

4. Still using the masking fluid brush, mask the foxgloves, leaves, fence and signpost in the foreground, and the poppies in the middle distance.

5. Allow all the masking fluid to dry, then use the golden leaf brush to wet the sky with clean water, then add an ultramarine wash wet-into-wet. Leave spaces for the clouds, and paint these with a thin wash of raw sienna.

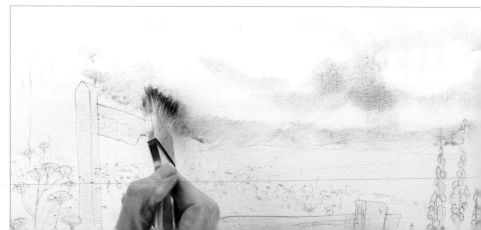

6. Add shading to the bottom of the clouds with a thin mix of ultramarine and burnt umber.

7. Touch in the distant hills on the horizon with the small detail brush, using a mix of ultramarine and midnight green.

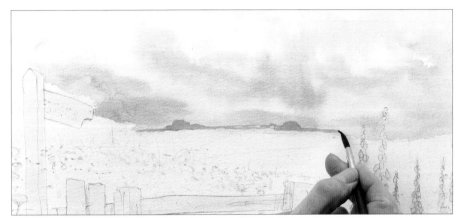

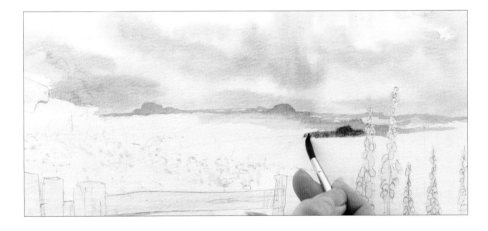

8. Paint in the hedgerows in the distance using a stronger mix of the same colours.

9. Using various mixes of raw sienna, sunlit green and burnt sienna, paint in the distant fields.

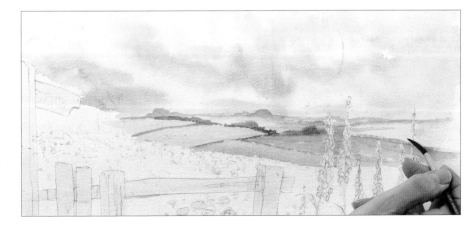

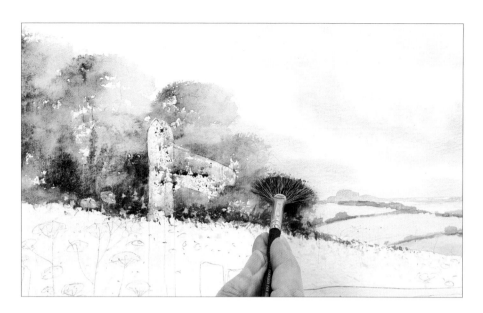

10. Double-load (see page 61) the fan gogh with sunlit green and a mix of midnight green and country olive. Paint in the trees on the top left. Keep the mix fairly strong as this area will provide a dark background for the signpost later.

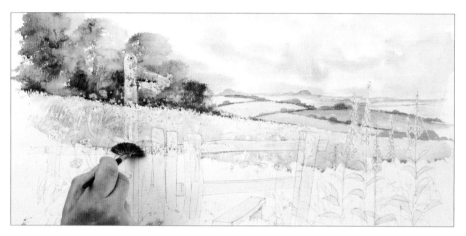

11. Paint the cornfield using the fan gogh brush and raw sienna. Introduce burnt sienna to the colour on the left to vary the tone.

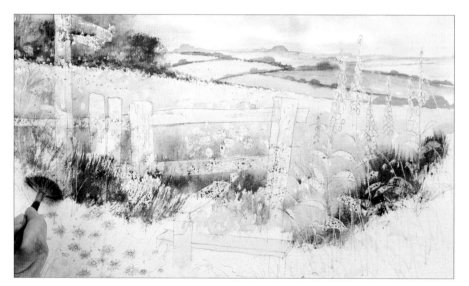

12. Returning to the fan stippler, block in the grass with a mix of raw sienna and country olive. Vary the tones by adding a little midnight green.

13. Use burnt sienna for the dead grasses, then add a thin wash of sunlit green underneath. Frame this with a strip of midnight green.

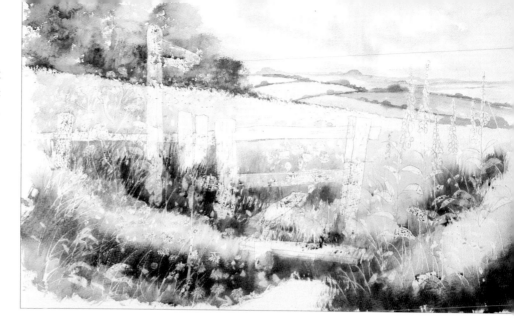

14. Repeat this dark green, light green, dark green pattern on the right-hand side of the painting.

15. Paint in the footpath with a fairly strong mix of raw sienna.

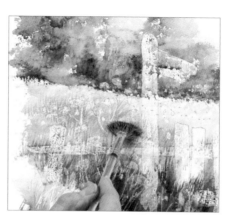

16. Allow the painting to dry, then darken the cornfield behind the cow parsley with the fan gogh and a mix of raw sienna and burnt sienna.

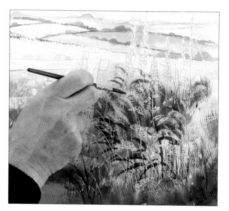

17. Use midnight green to add texture to the grass, then switch to the half-rigger and paint in dark stems and grasses on the right.

Tip

When painting grasses or trees, paint in the direction the plant grows. This is generally from bottom to top, but branches may grow sideways, or even downwards. The important thing is that you start at the base.

18. Make sure the masking fluid is dry and remove it by rubbing it with your fingers. Switch to the large detail brush. Paint in the fence and stile with a raw sienna/sunlit green mix. Add burnt umber for the parts in the shade. Allow to dry, and add detail with a mix of burnt umber and country olive.

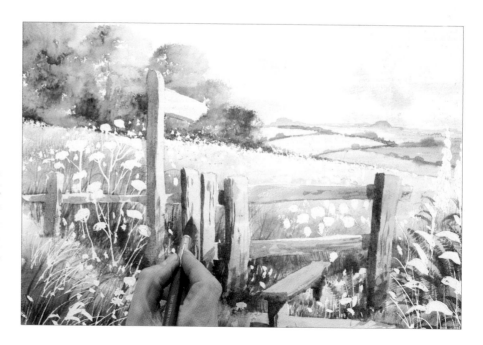

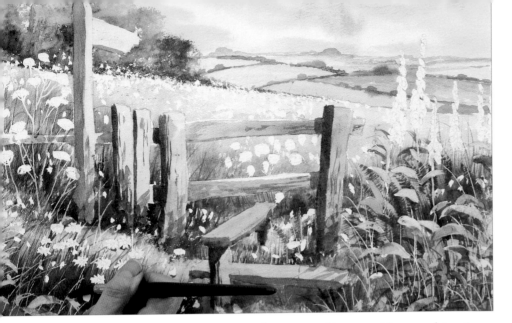

19. Gently wash over the foreground stems and leaves with a combination of the three greens and a sunlit green/raw sienna mix. Be careful not to wash over the flowerheads.

20. Use the half-rigger to tidy up the petals of the daisies, then dab a spot of cadmium yellow into each centre. Tidy up the daisies with pure white gouache.

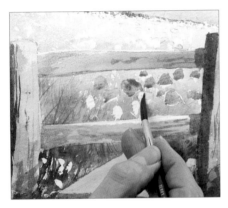

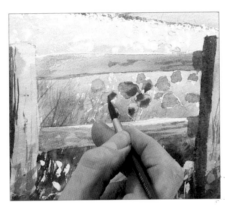

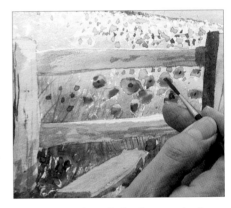

21. Using the medium detail brush and a thin mix of cadmium red, paint the poppies.

22. Dab a stronger mix in wet-into-wet to give a two-tone effect.

23. Add a dot of shadow with the half-rigger to finish off the poppies.

24. Returning to the medium detail brush, use a mix of permanent rose and permanent mauve to paint in the foxgloves. Work wet-into-wet with a stronger mix to show the shaded insides of the foxgloves. Add a touch of sunlit green at the top of each flowerhead.

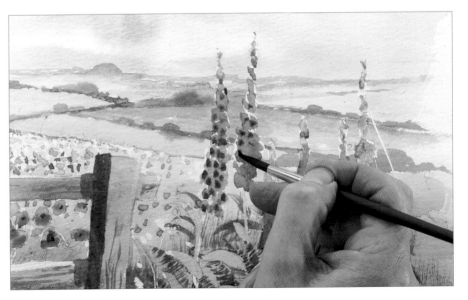

25. Shade the cow parsley with a thin mix of cobalt blue and a touch of raw sienna.

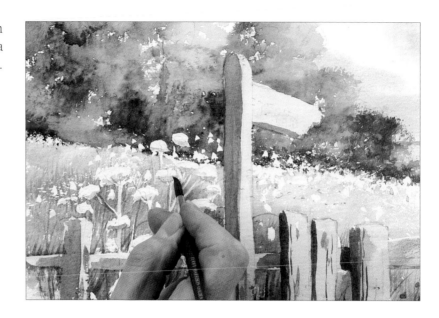

The finished painting

380 x 560mm (14¾ x 21¾in)

I have added a few details such as some additional shading on the fence and some small yellow flowers with cadmium yellow in amongst the foreground grasses.

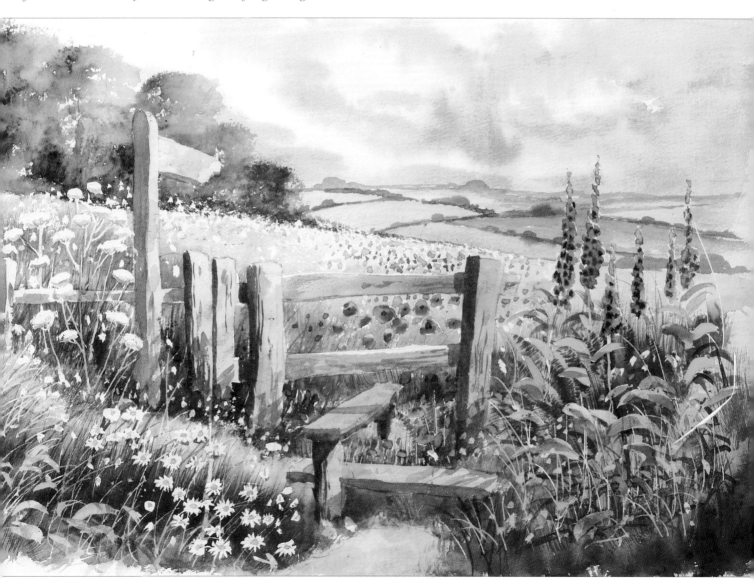

Rose Doorway

This could be a typical mediterranean courtyard, with roses around the doorway and potted plants in the foreground, all bathed in dappled sunlight.

The photographs that I have used were gathered over a period of time. The main photograph with the blue shutters would make an interesting painting, but it lacks colour. By adding the pink roses at the top of the picture and the additional pots in the foreground, the scene is made to look more idyllic.

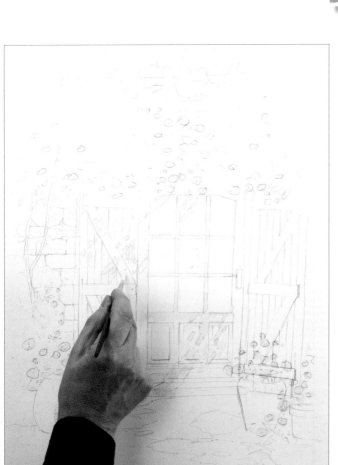

1. Mask out the flowers on the vine and in the pots, the window frames and the dappled sunlight on the door and shutter.

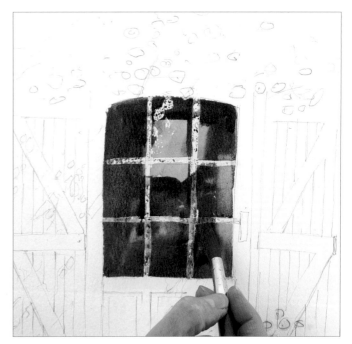

2. Use the large detail brush to lay in a dark wash of ultramarine, burnt umber and a touch of midnight green on the window of the door.

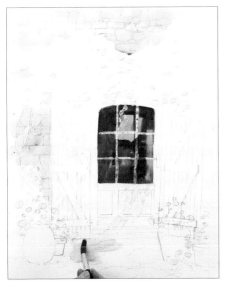

3. Continue using the large detail brush to wash in the wall using raw sienna tinged with a spot of permanent rose to warm it slightly. Use a lighter wash for the ground.

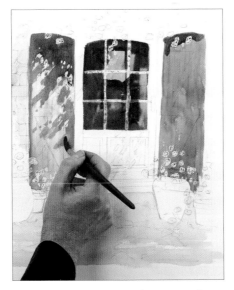

4. Paint the doors with a mix of cobalt blue and permanent rose with a touch of shadow. The key to this colour is keeping it fresh. Use a stronger wash for the door on the right, and detail the left-hand door with this darker colour.

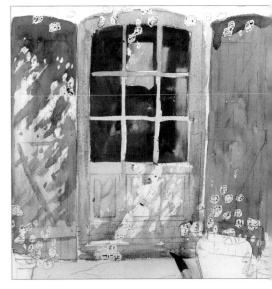

5. Remove the masking fluid from the window frame. Wash a raw sienna and cobalt blue mix on to the door and window frame. Deepen the shadows around the door by adding more cobalt blue.

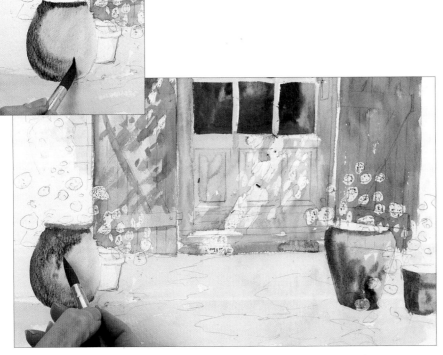

6. Paint the pots with a thin wash of burnt sienna, then add shadow wet-into-wet to shade. Finally, use a stronger mix of burnt sienna for texture.

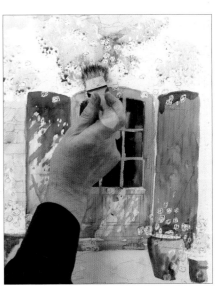

7. Use the golden leaf brush to stipple the background foliage in sunlit green.

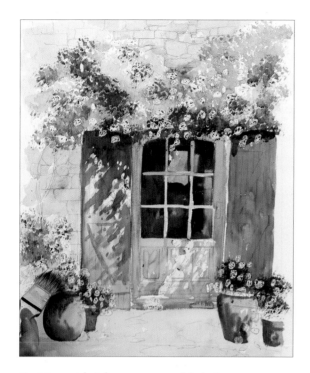

8. Use midnight green to add darker tones to the foliage.

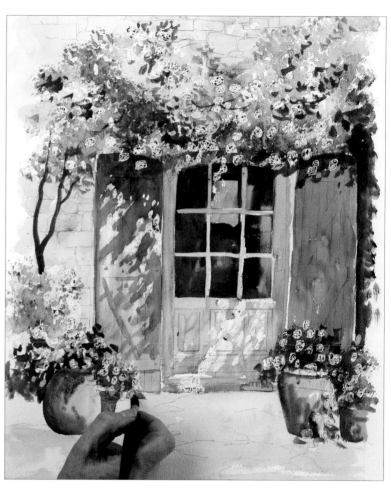

9. Define the foliage with the large detail brush using midnight green and country olive. Add the vine on the left using a mix of burnt umber and midnight green.

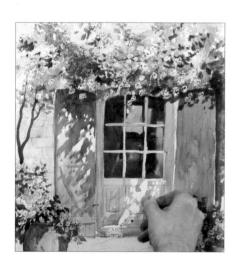

10. Remove masking fluid from the door and shutter.

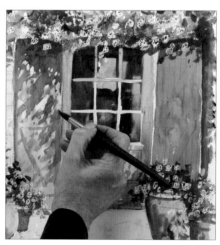

11. Lay in a very thin cobalt blue wash on the shutters with the medium detail brush.

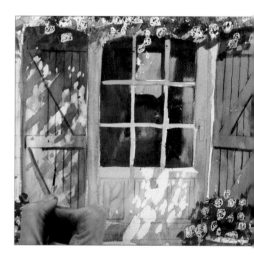

12. Use the half-rigger with a shadow and ultramarine mix to add fine details to the shutters.

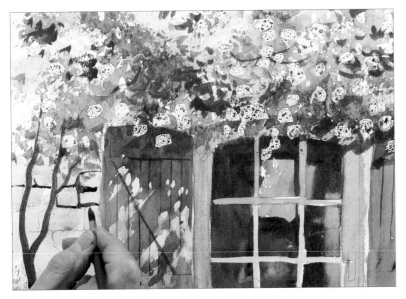

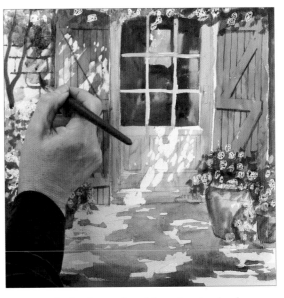

13. Apply a mix of burnt umber and ultramarine using the medium detail brush to suggest detailing on the brickwork.

14. With the large detail brush, shade the dappled ground with a mix of shadow and cobalt blue. The dark colour at the bottom of the page anchors the painting and stops the eye drifting out of the picture. Use the same mix to shade behind the shutter.

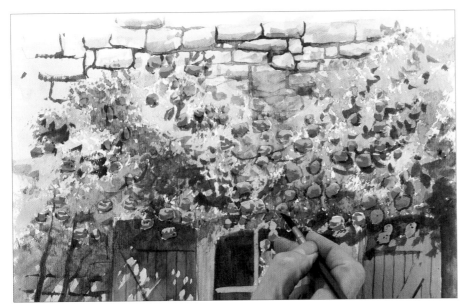

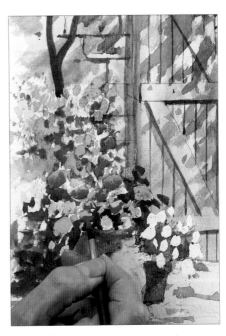

15. Remove the remaining masking fluid from the painting. Use the medium detail brush to apply a thin wash of permanent rose to the blooms above the doorway, then add a stronger mix wet-into-wet to add detail.

16. Dilute cadmium red and paint the roses in the pot, at bottom left. Drop in a darker tint wet-into-wet.

17. Using permanent mauve, paint the begonias in the next pot with a dilute wash. Dot a darker mix in the centre of each flower.

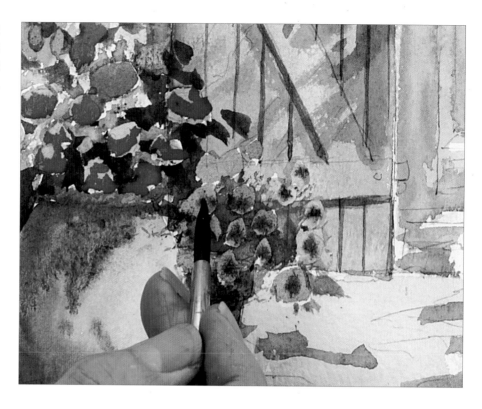

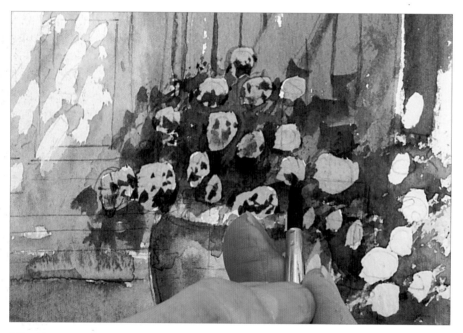

18. Use permanent rose to paint the flowers on the bottom right. Allow this area to dry and then stipple a mix of permanent rose and permanent mauve on to it to add texture.

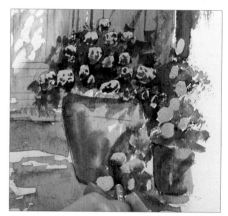

19. Use a cadmium red and cadmium yellow mix for the flowers in the final pot. Add more red to vary the tone and add texture.

Opposite
The finished painting
560 x 380mm (21¼ x 14¾in)
Standing back, I decided the final painting needed some additional detailing, such as the door handle, which was added using shadow.

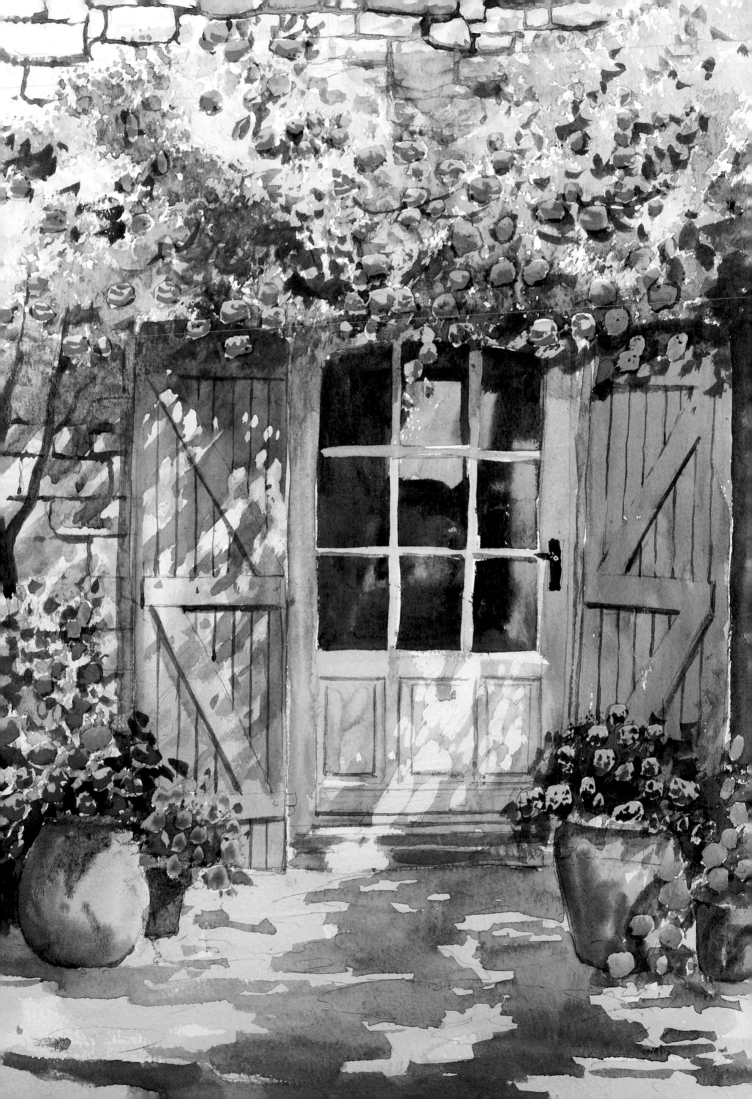

Floral Stream

I used two photographs as inspiration for this painting. The photograph of the stream provided the basis for the painting, with the large tree on the left of the scene. I decided that the original photograph was too enclosed, so I pruned the tree back to reveal the rolling hills in the distance. This is a good example of how to enhance your pictures with a little artistic licence.

1. Draw the scene, and use masking fluid to mask the daisies in the foreground, and the other flowers bordering the riverbank on both sides.

2. Block in the sky with clean water using the golden leaf brush, and then paint the spaces between the clouds with ultramarine. Paint the clouds with a dilute mix of raw sienna, and shade them with a mix of burnt umber and ultramarine.

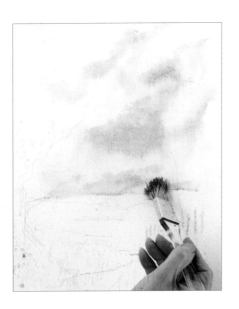

3. Use the medium detail brush to paint the hedgerows in the distance with a mix of ultramarine and midnight green. Increase the amount of midnight green in the mix for the closer hedgerows.

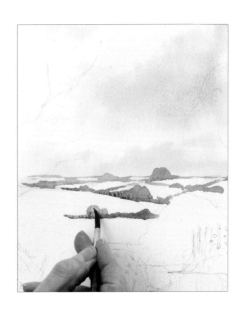

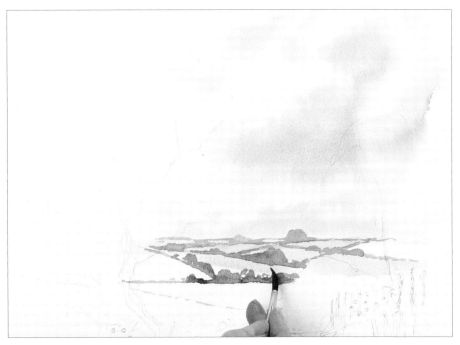

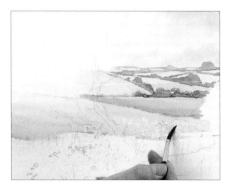

4. Lay in the closest hedgerows with a mix of sunlit green and midnight green. When dry, use ultramarine and midnight green to paint the most distant field. Add country olive to the mix as you paint the nearer fields, and add raw sienna for the very nearest.

5. Use raw sienna to paint the fields in the middle distance. Do not use too strong a mix: it will act as a barrier to the eye. Continue building up the fields into the foreground.

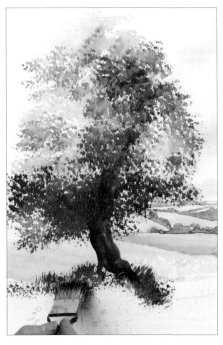

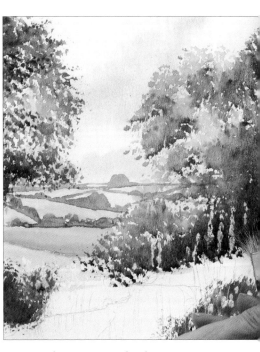

6. Paint in the trunk of the tree on the left using the large detail brush and a mix of burnt umber and country olive.

7. Stipple sunlit green and then country olive with the golden leaf brush to form the mass of leaves. Use burnt umber and midnight green for the shaded grass at the base of the tree.

8. Use the same method to paint the tree and foliage on the right.

 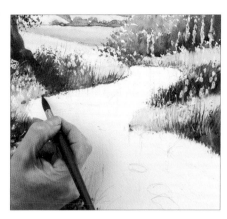 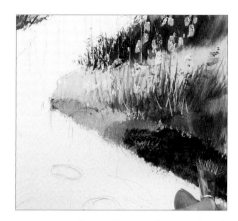

9. Add alternating bands of yellow ochre/sunlit green and midnight green/burnt umber down the painting using the fan gogh. Ensure the dark bands frame the majority of the flowers.

10. Use the large detail brush to paint a mix of burnt sienna with country olive on to the edges of the riverbanks. Use the same colour to add rushes and dead grasses.

11. Paint the rocks on the riverbank using fairly dry mixes of raw sienna for the most distant, then sunlit green for the middle rocks, then burnt umber for the nearest.

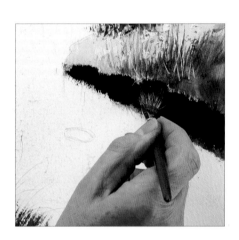

12. Using the wizard brush, paint ultramarine over all the rocks on the riverbank. Again, use fairly dry mixes.

13. Scrape out the rocks following the instructions on page 61. Repeat from step 11 for the rocks in the stream.

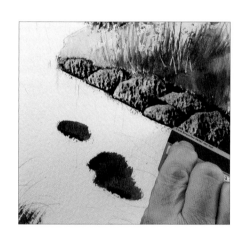

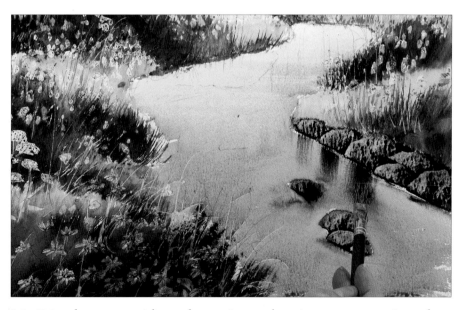 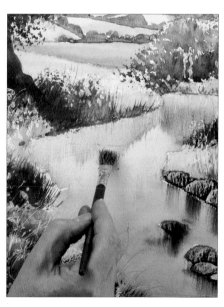

14. Paint the stream with an ultramarine wash, using a stronger mix as the stream gets closer. Use the wizard to pull paint from the bottom of the rocks into the river to form the reflections.

15. Using the wizard brush, paint reflections wet-into-wet, ensuring the same colours are used in the reflections as in the object.

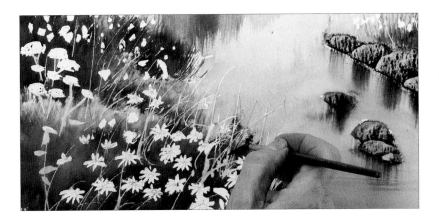

16. Remove all of the masking fluid from the painting. Paint in all the stems using a sunlit green and raw sienna mix with the medium detail brush.

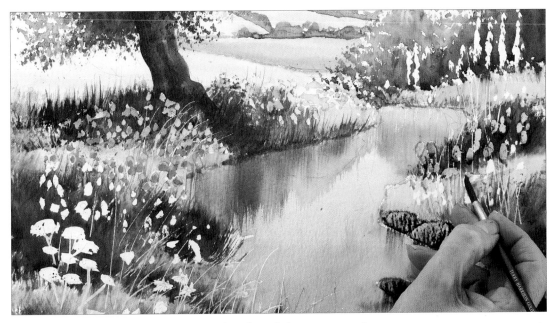

17. Paint in the pink flowers on both sides of the stream with permanent rose. Use a stronger mix on those closer to you.

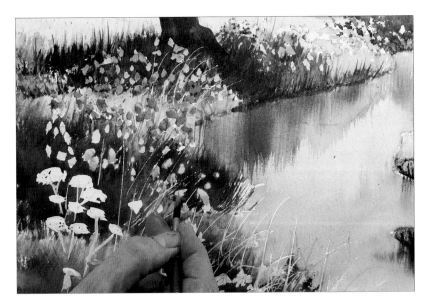

18. Use a strong mix of cadmium yellow to paint the yellow flowers, and add a touch of cadmium red to the mix to shade.

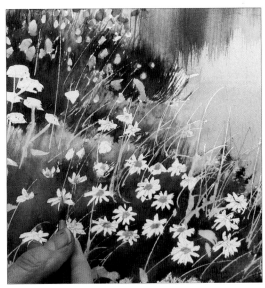

19. Use this same orange mix to paint the centres of the daisies.

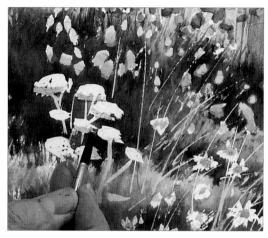

20. Shade the cow parsley with a weak mix of cobalt blue and raw sienna.

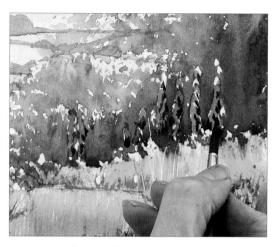

21. Paint the foxgloves using a permanent rose and permanent mauve mix. Detail when dry with a stronger mix of the same colour.

22. Using the half-rigger and midnight green, paint in some tall grasses amongst the daisies.

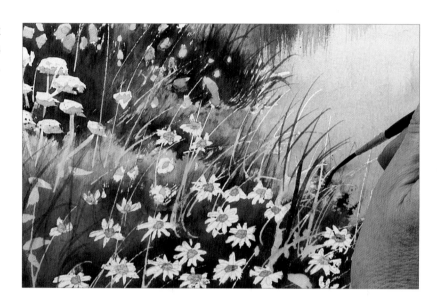

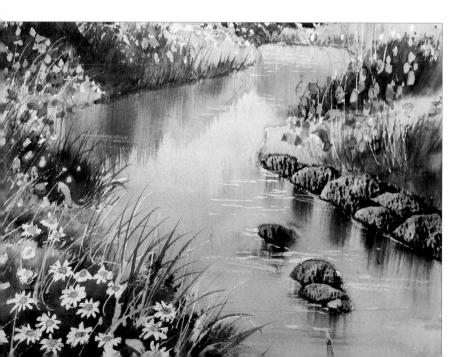

23. Using the small detail brush and permanent white gouache with a touch of cobalt blue, add fine ripples to texture the stream.

Opposite
The finished painting
380 x 560mm (14¾ x 21¾in)
With the splashes of colour provided by the summer flowers, this scene becomes much more interesting and appealing.

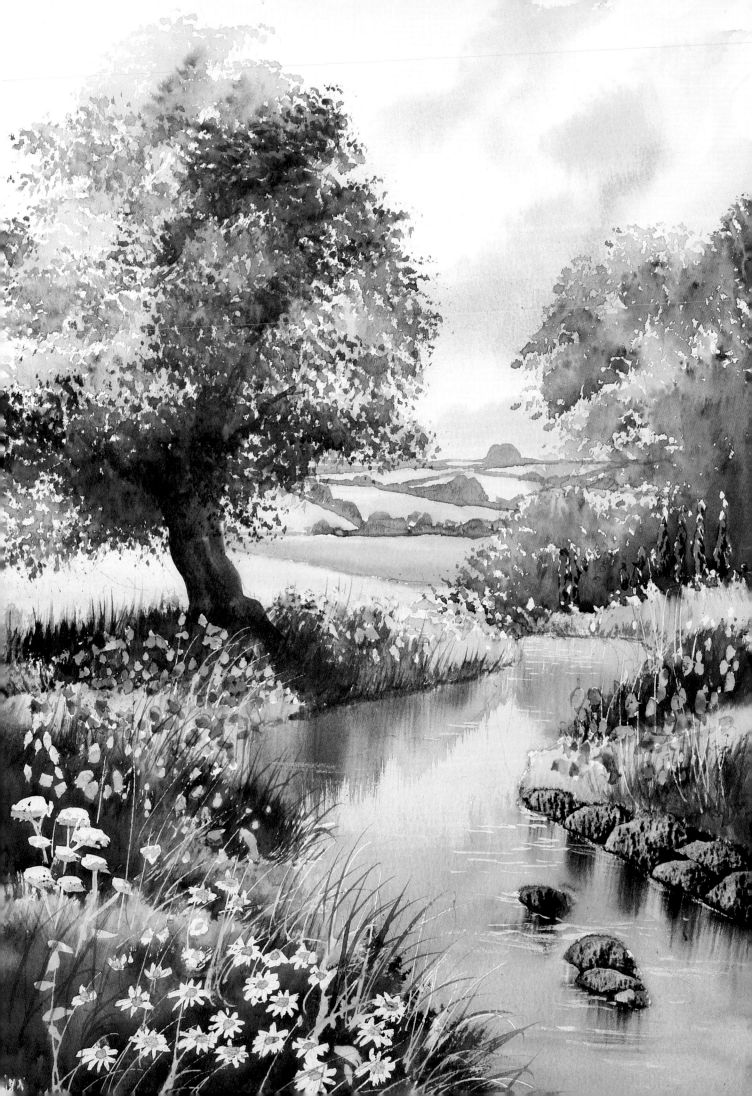

Farm Poppies

The addition of poppies quickly transformed this landscape into a more interesting and appealing painting. The farmhouse forms the backdrop to the painting, with the fence running horizontally across the centre of the picture. This could form a barrier across the composition, but the poppies lead the viewer's eye into the scene.

I mainly used warm colours to evoke the feeling of summer, and the bright, appealing poppies only enhance this feeling.

1. Mask the flowers and fence with the masking fluid brush. Use the ruling pen for the longer grasses.

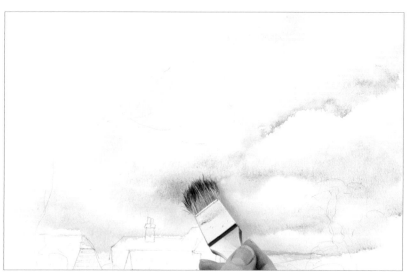

2. Wet the sky area with clean water. This is best done with the board at a slight angle. Using the golden leaf brush, dab ultramarine into the damp area, leaving spaces for clouds.

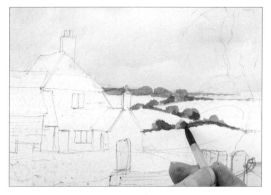

3. With the medium detail brush and a mix of ultramarine and midnight green, paint the distant trees and hedgerows. Add more midnight green to darken the mix for the closer hedgerows.

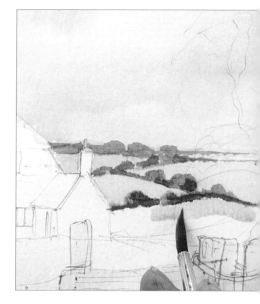

4. Lay country olive into the most distant fields, sunlit green into the field in the middle and raw sienna into the nearest.

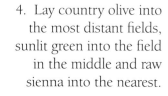

80

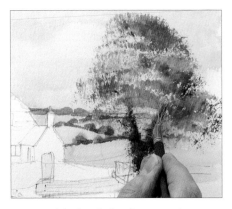

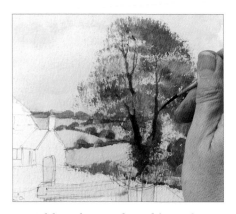

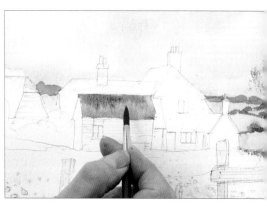

5. Double-load the fan stippler with midnight green and country olive, and work down the tree from top to bottom. Stipple vertically with midnight green to represent ivy on the trunk.

6. Add in the trunk and branches with the half-rigger brush and midnight green. Add the hedgerow using a mix of country olive and sunlit green.

7. With the medium detail brush, paint the trees between the buildings with the ultramarine/midnight green mix. Paint in the central roof with a burnt sienna, raw sienna and shadow mix; add a stronger mix of the same colours wet-into-wet to vary the tone.

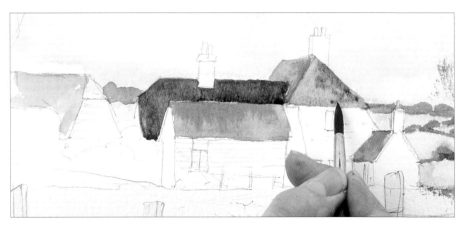

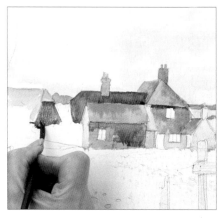

8. With the medium detail brush, paint the other roofs and house using a mix of burnt sienna and raw sienna. Add more burnt sienna for the darker roof. Add texture by adding a little midnight green and shadow to the mixes. Use raw sienna with burnt sienna dropped in for the gable as shown.

9. Use a mix of raw sienna and country olive for the barns. Vary the tones of each section wet-into-wet before moving on to the next.

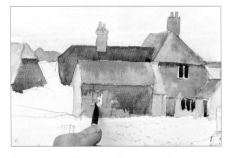

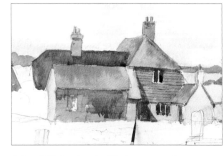

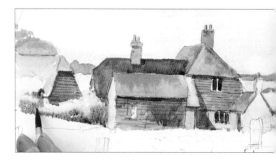

10. Paint the windows and door in with a burnt umber and ultramarine mix.

11. With the half-rigger and shadow, add detail to suggest brickwork and hung tiles. Paint the shadows cast by the buildings.

12. Using the medium detail brush and sunlit green, add in the foliage around the farm buildings. Add shading with midnight green wet-into-wet. Let the darker shades bleed into the lighter parts.

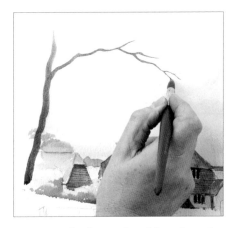

13. Use the large detail brush with a mix of burnt umber and country olive to paint the tree on the left.

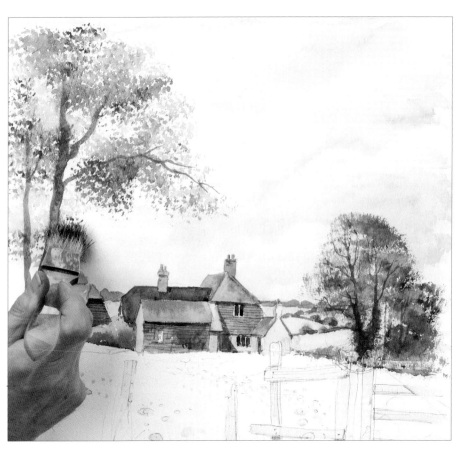

14. Use the golden leaf brush to stipple in foliage using sunlit green. Add shading with midnight green.

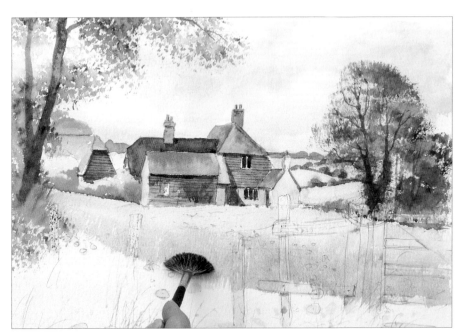

15. With the fan gogh, block in the cornfield with a wash of raw sienna. With a stronger mix of the same colour, add the closest rows of corn.

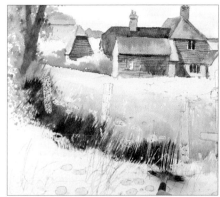

16. Still with the fan gogh, work wet-into-wet and flick country olive up to form grass that softens the edge of the field. Add a layer of midnight green over the top of this to add texture and shade.

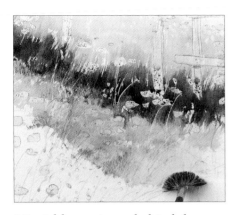 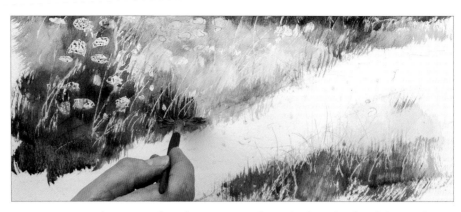

17. Add raw sienna behind the poppyheads to form a 'hot spot' of warm colours. Add sunlit green underneath this area near the path.

18. Continue the strip of sunlit green on the right-hand side of the path, then add midnight green areas under the poppies and the light green strip. This will frame the poppies.

 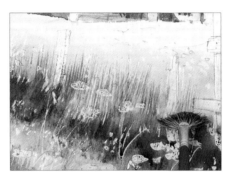 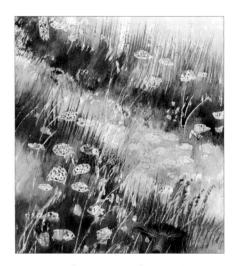

19. Use the wizard to paint in the path with raw sienna, and texture and shade it by adding burnt umber.

20. Add standing corn by flicking a mix of raw sienna and burnt sienna upwards with the fan gogh.

21. Use the same technique with midnight green to add foreground grasses.

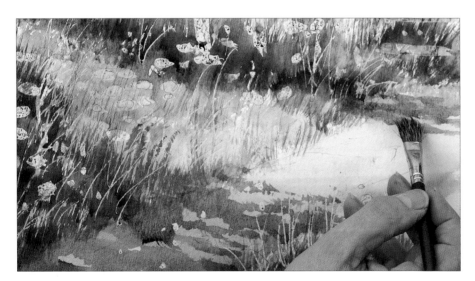

22. Add shadow to the main path with the wizard, then allow it to dry and rub off all the masking fluid.

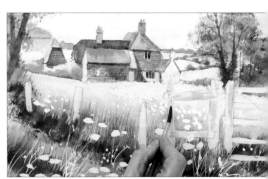

23. Paint the fence with raw sienna and sunlit green, using the medium detail brush.

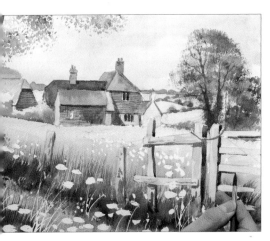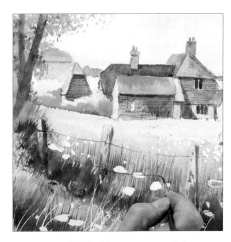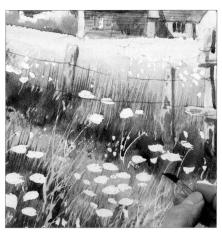

24. Shade the fence with a mix of burnt umber and country olive.

25. Use the half-rigger to add in the wire, with burnt umber toned down with a little country olive.

26. With the medium detail brush, block in the poppy stems with a mix of country olive and sunlit green.

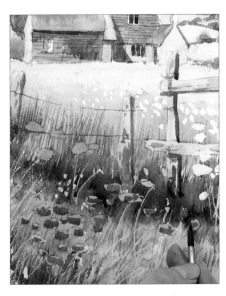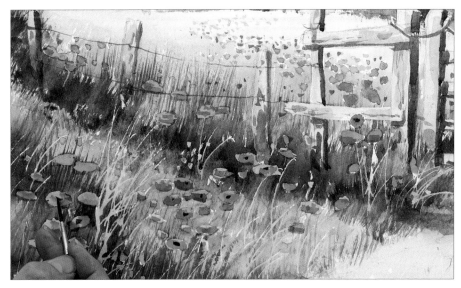

27. Paint the poppies in with a weak mix of cadmium red, and add detail with a stronger mix.

28. Use shadow wet-into-wet to put dots in the centres of some of the poppies. Not all the flowerheads will be facing you, so do not paint the centres of all the poppies as this will look strange.

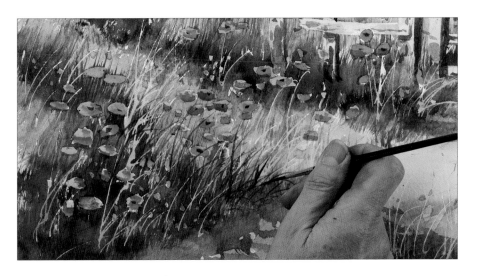

29. Paint the yellow flowers with cadmium yellow, then use the half-rigger and midnight green to flick in extra grasses for interest.

Opposite
The finished painting
380 x 560mm (14¾ x 21¾in)
This is a good example of how to use flowers in a landscape to create a beautiful country scene.

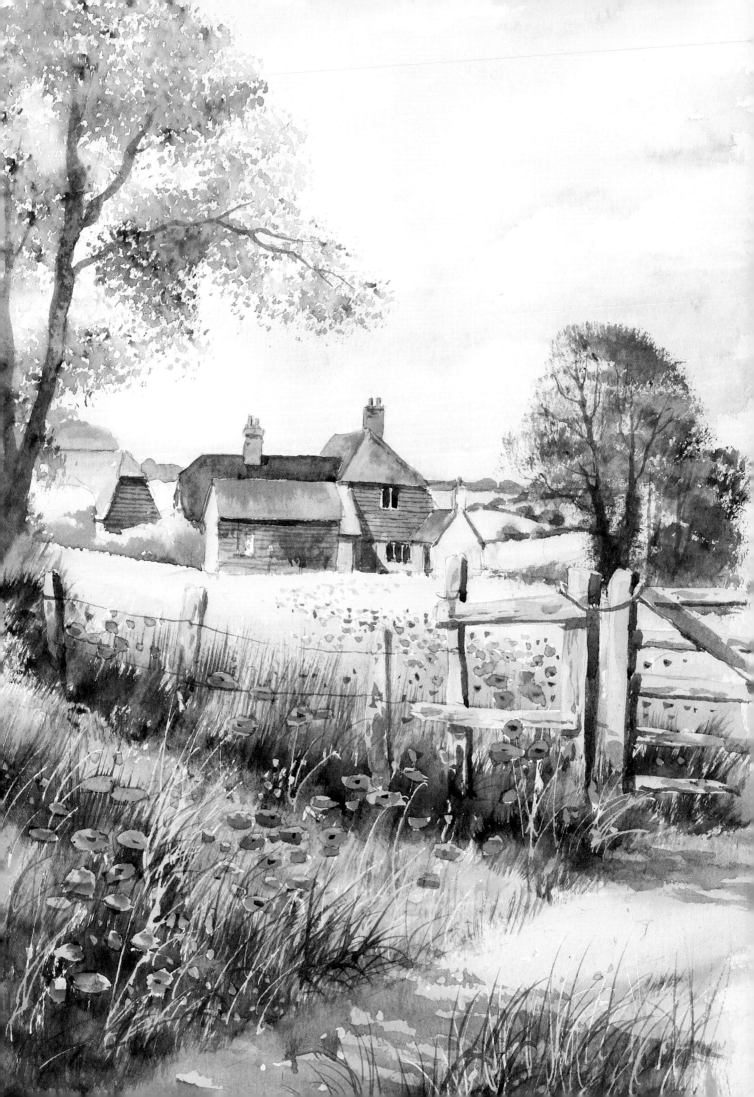

Bluebell Wood

Who can resist a bluebell wood? Certainly not me! This demonstration is created in a fairly loose style; I have not put in too much detail. Using a combination of photographs, I have created a fairly simple scene with a footpath leading to the centre of the painting through the drifts of bluebells, and framed by simple trees.

1. Mask out the silver birch trees on the left and the grasses at the bottom. Dot in the flowerheads.

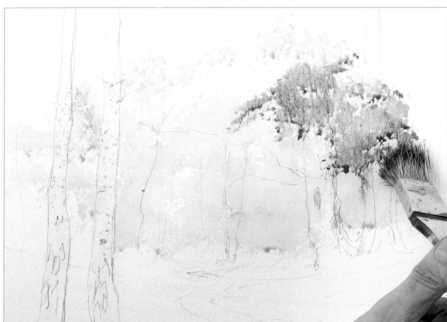

2. Using the golden leaf brush, and working wet-into-wet, stipple cobalt blue into the centre of the painting, then surround this with cadmium yellow, and finally surround this with sunlit green.

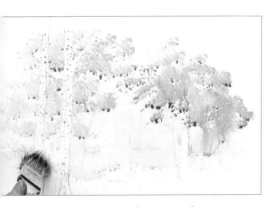

3. As you work outwards, start using stronger mixes of the same colours.

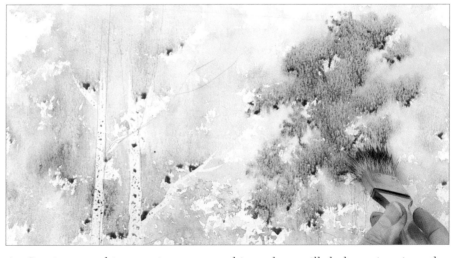

4. Continue working wet-into-wet, and introduce still-darker mixes into the work. Allow to dry.

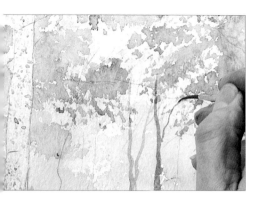

5. Using the half-rigger and cobalt blue with a touch of sunlit green, paint faint tree trunks into the misty central area.

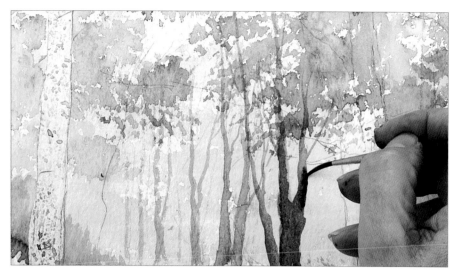

6. Add the trees in the middle distance using a mix of cobalt blue with country olive.

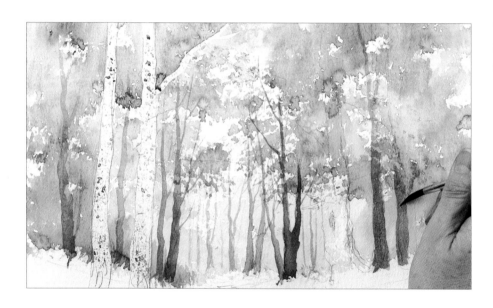

7. Paint the near-distance trees with the medium detail brush and a mix of country olive and burnt umber.

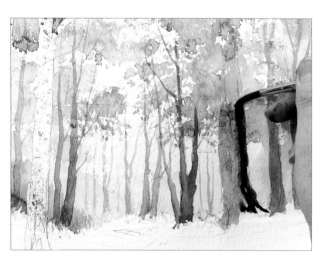

8. Paint the tree on the right with a mix of burnt umber and country olive. Add details with a stronger mix.

9. Use the wizard to paint the path with raw sienna. Start with a weak mix in the distance, becoming stronger as you reach the foreground.

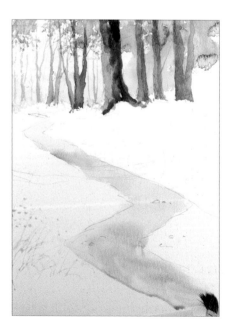

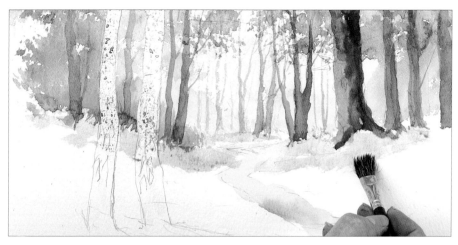

Tip
A clean palette is a must to get the necessary translucency for the bluebells. Rinse off the palette before mixing the bluebell colour.

10. Use a mix of cobalt blue and permanent rose to add a soft wash of bluebells with the wizard.

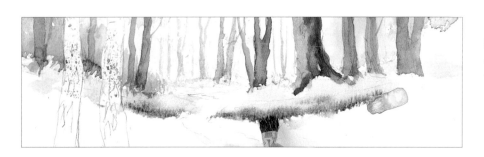

11. With a stronger mix of the same colours, add a darker swathe of bluebells; then a further line of the lighter shade.

12. Add strips of grass below the bluebells using a pale mix of midnight green.

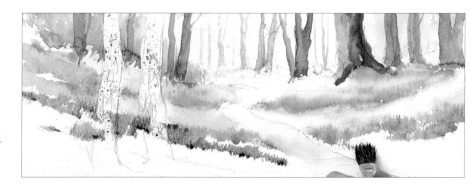

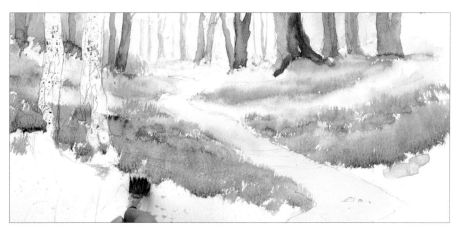

13. Pat the brush downwards on the paper with the darker bluebell mix for further bluebells underneath the grassy strip.

14. Working wet-into-wet, blend sunlit green into this bluebell strip.

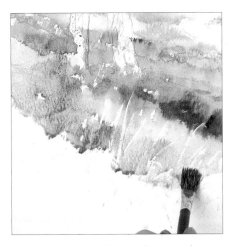

15. Extend the forest floor with raw sienna.

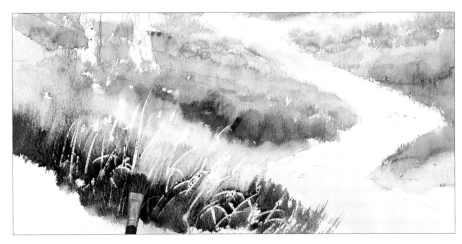

16. At the bottom of the painting, flick midnight green wet-into-wet into the forest floor and extend it to the edge of the paper.

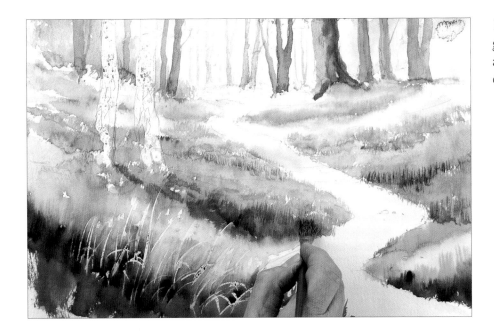

17. When dry, use midnight green to texture the grassy areas. Use the wizard with short downward strokes.

18. Load the fan gogh with midnight green and add detail to the foreground grassy area with an upwards flicking motion.

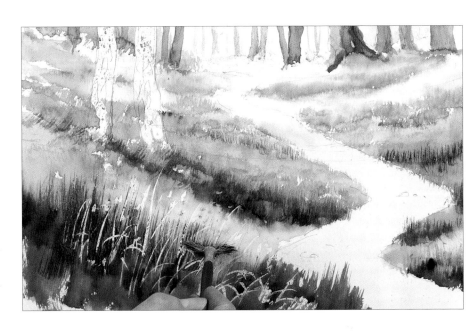

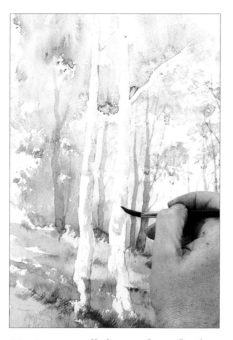

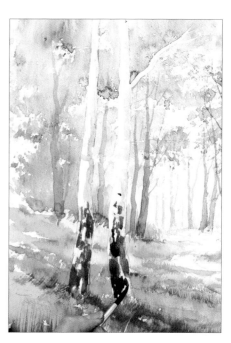

19. With the wizard, add a fairly weak mix of shadow across the path and under the trees.

20. Remove all the masking fluid, and shade the silver birches with a mix of cobalt blue and raw sienna. Use the medium detail brush.

21. Paint the split bark at the bases of the trees with an ultramarine and burnt umber mix.

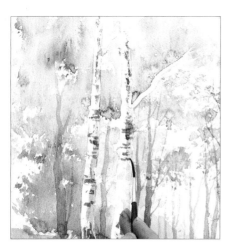

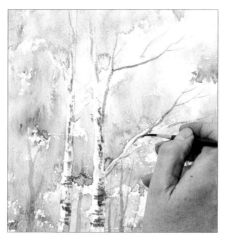

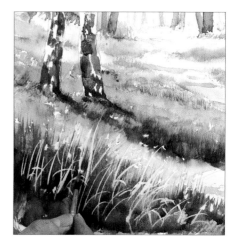

22. With the same mix, use the half-rigger to paint horizontal strokes across the tops of the trees.

23. Still using the same mix and half-rigger, hint at branches at the tops of the silver birches.

24. Wash over the grasses with a pale mix of sunlit green and the medium detail brush. Paint the flowers with cadmium yellow.

25. Using midnight green and the golden leaf brush, stipple foliage on to the silver birches wet on dry.

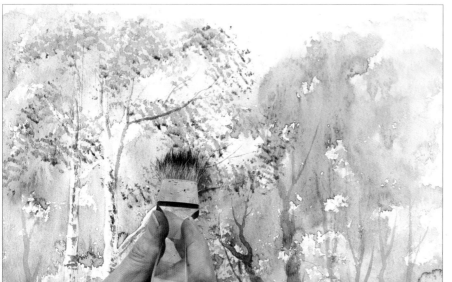

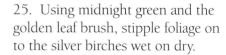

Opposite
The finished painting
380 x 560mm (14¼ x 21¾in)
I hope that after seeing how easy it is to create a bluebell wood, you will not be able to resist painting one either!

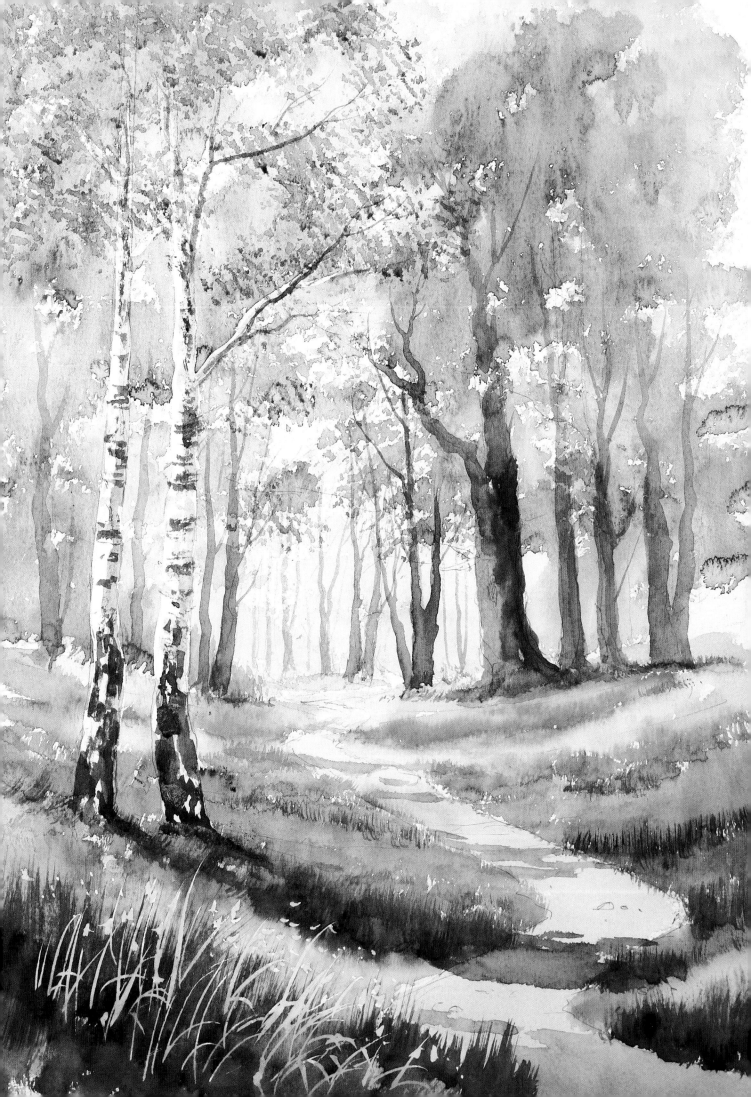

Watercolour Mountains, Valley & Streams

Like many people, I have a love of mountain scenes, even though the last thing I want to do is climb up one. As a youngster I went on a school trip to the Lake District, which entailed hiking over mountains from youth hostel to youth hostel. I now look back on this fondly, but at the time I'm sure the experience was clouded by painful blisters and the burden of an overloaded rucksack.

In this section I demonstrate how a non-geologist can create realistic looking mountain scenes.

Inevitably with mountains you get valleys, and at the bottom of a valley there is usually a river or stream, so the three elements are closely linked. If you are looking for inspiration and reference for painting valleys and streams, the easy bit is going down to find your subject; unfortunately the down side is that you then have to climb back up. Once you have your reference material such as photographs or sketches of mountains, waterfalls, bridges and different rock formations, you have the basis for producing your own composition.

Over the years I have developed lots of techniques (short cuts) for painting many different subjects in watercolour. In this section, I have collected together the techniques best suited to painting mountains, valleys and streams. They include using masking fluid, paper masks, wet in wet and scraping out. Once you have mastered these simple techniques, you can then move on to paint virtually any subject you choose.

Many of the paintings in this section are painted on textured paper, and the texture is used to great effect when painting mountains and rocks with the credit card technique I have developed. This technique came about by accident, when a student of mine said that she saw someone paint a tree trunk using a credit card. I tried this, but with disastrous effects: because all the tree trunks looked like rocks. With a bit more practice, the credit card rock technique was developed, and it is explained in detail in this section. I eventually mastered the tree trunk technique, so this is also included.

This book should be a great comfort to armchair mountaineers – knowing that they can produce wonderful mountain scenes without actually leaving the studio.

Terry Harrison

Lakeland Reflections
420 x 560mm (16½ x 22in)
I wanted to capture the reflections in the lake in this scene. The stones in the foreground add impact by leading the eye into the picture.

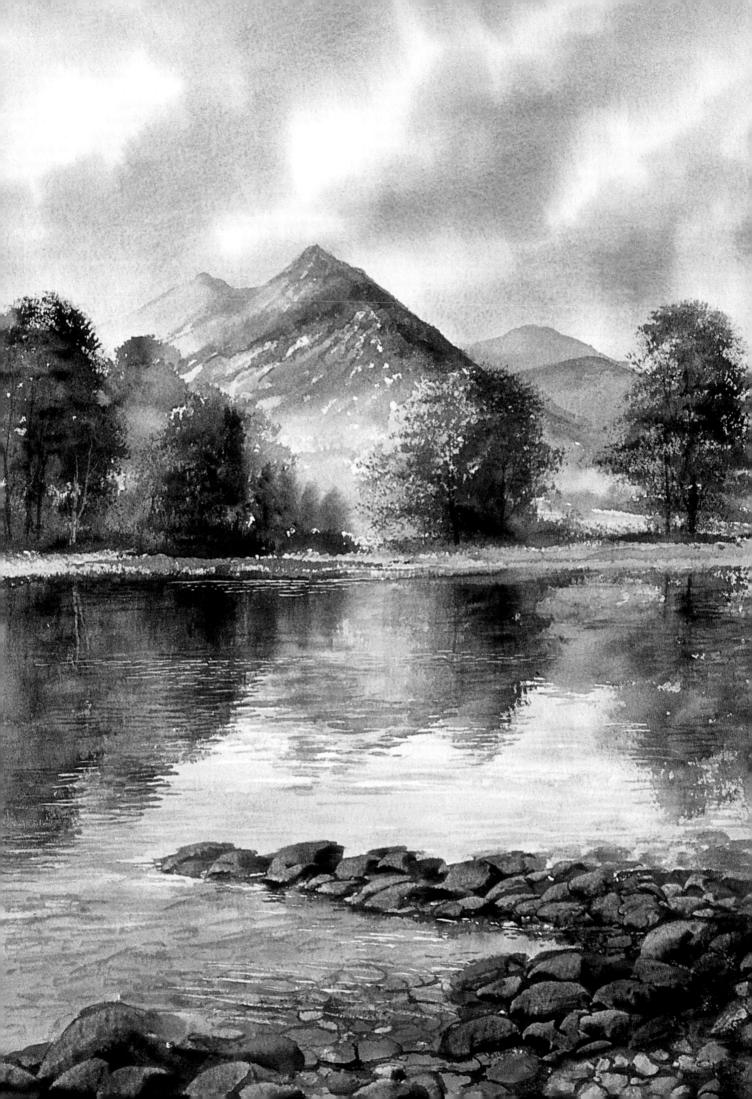

My palette

I am not a great fan of a limited palette, but having said that, I do limit myself to a relatively small selection of colours. In my palette I have a selection of colours that can be used for virtually any painting I choose to paint. The colours I use are shown on the right. Using combinations such as alizarin crimson and cobalt blue, you can create fabulous distant hills. Ultramarine and burnt umber is a great alternative to using black or grey. By using more blue you get a cooler colour, and by using more burnt umber you get a warmer colour. Adding raw sienna to a grey mix creates the effect of sunlight on the side of a mountain. The colour shadow is a fresh, transparent colour that can be mixed with others or used in its own right. It is used to great effect in many of the paintings in this book.

The colours I use
With this range you can mix most colours.

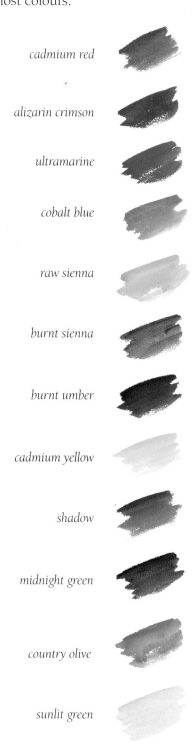

cadmium red

alizarin crimson

ultramarine

cobalt blue

raw sienna

burnt sienna

burnt umber

cadmium yellow

shadow

midnight green

country olive

sunlit green

Useful mixes

In this section, I have put together a selection of colour mixes that are suitable for painting a variety of mountain scenes as well as foliage and vegetation. These are fairly basic mixes that you will find useful for painting many other subjects.

Ultramarine and burnt umber make a useful grey which is excellent for painting rocky mountains. More blue can be added for the shadowed areas, and more burnt umber for sunlit parts. A paler, bluer mix of the same colours is ideal for more distant mountains.

Alizarin crimson and cobalt blue also make a good purple mix for distant mountains. Once again, those furthest away can be made bluer, since the cooler shade suggests distance.

Alizarin crimson, cobalt blue and burnt sienna is a useful mix for painting rocks. Make a paler, browner mix for the sunlit parts of the rocks and use a darker, bluer mix for the shadowed areas.

Cobalt blue and midnight green is a good mix for distant valleys and grassy mountains. Hedgerows in the valley can be applied using a greener version of the mix. Once again, more distant mountains should be bluer.

Warm colours

Using different colours can create a variety of atmospheres. In the painting shown, I have used a selection of colours such as alizarin crimson mixed with raw sienna to add pink to the sky. Raw sienna and burnt sienna are used for the sunlit mountainsides. This is enhanced by the use of cooler shades on the shadowed sides of the mountains and in the valley. Although the predominant colours in the valley are blues and greens, there are still splashes of warmth created by similar colours to those used on the mountainsides.

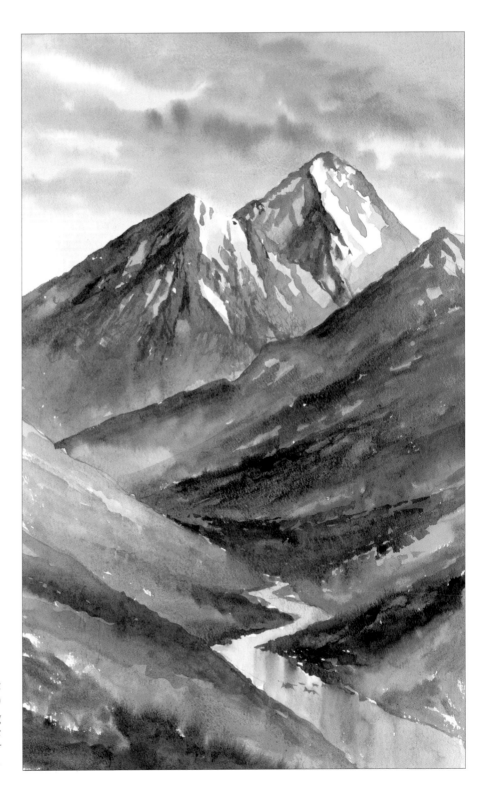

Approaching Sunset
350 x 520mm (13¾ x 20½in)
The dominant colours in this painting are the warmer shades, but these are highlighted by the use of some cooler colours for contrast.

Cool colours

The dominant colour in this painting is blue, which is the ultimate cool colour. The mountains were painted using the scraping out technique and cobalt blue and ultramarine blue. The darker shades of blue contain a hint of burnt umber. Coming forwards, the fir trees were painted mainly with blue, but with midnight green added. The rock formations on either side of the river were painted using the scraping out technique. The colours used were ultramarine blue with burnt umber. The warmer colours in the foreground and the cooler shades in the background help to create the illusion of distance.

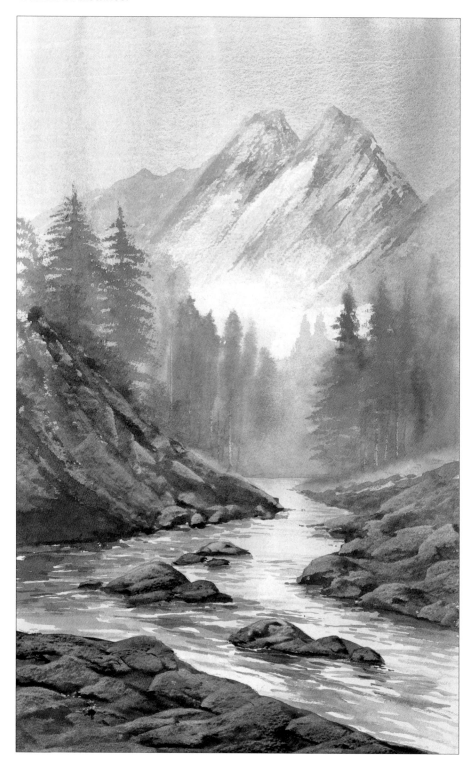

Cool Waters
320 x 510mm (12¾ x 20in)
The chill of the mountain air is suggested by the use of cool blue shades, contrasted by the slightly warmer tones in the foreground.

Using photographs

When you are producing a painting, good reference material is essential. Not everyone has the good fortune to travel the country sketching, but a good alternative is the use of photographs, either your own or ones from books or magazines. You can pick out an interesting section of a photograph and combine it with elements from others to create an ideal scene. In this way you can remove parts of the scene that you simply don't want to use.

In my experience, most artists use photographic reference, so there is no need to feel that you must climb a mountain in order to paint one!

Care must be taken when using reference from books and magazines that might be covered by copyright laws. If you are using a 'how to paint' book such as this one, this is not a problem. Feel free to copy any of the images in this book. However, if you do copy another artist's work and then offer your painting for sale, you should credit the artist by saying, for example, 'after Terry Harrison' or 'in the style of Terry Harrison'.

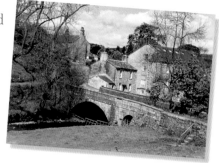

I have used the buildings and the bridge from this scene, but have removed the trees.

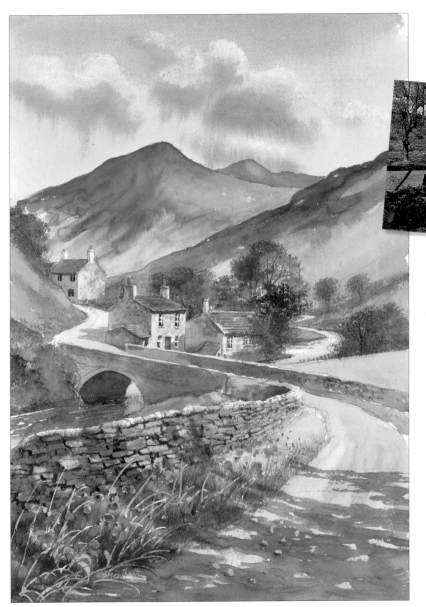

The foreground shadows and the road were taken from this photograph.

In this painting, which appears as a project on pages 130–139, I used elements from both reference photographs and added the mountains in the distance and the continuation of the stream, leading the eye into the scene.

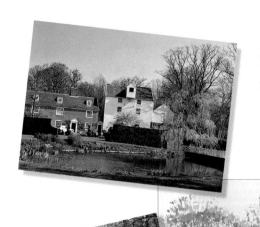

I photographed this delightful mill on a visit to Suffolk. What caught my eye was the contrast between the white of the mill and the mellow colours of the mill house.

The mill stream and little waterfall taken from this photograph are used as a device to lead the eye into the painting. This stream does lead from the mill shown but the photograph was taken from a different angle. The two views were combined to create an idyllic scene. This is called 'artistic licence'!

The focal point of this painting, which appears as a project on pages 140–149, is the mill buildings. The flowers create interest and colour in the foreground.

Techniques

Using the brushes

You can create wonderfully realistic effects using just the range of brushes shown here.

Large detail

Flat brush

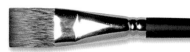

This brush is useful for washes as it holds a lot of paint. For large areas of colour, use a sweeping, horizontal motion from side to side and from top to the bottom.

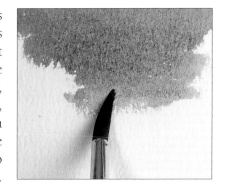

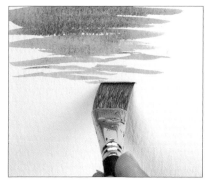

The 19mm (¾in) flat brush is useful for washes and for water. To create a rippled effect, brush it from side to side to produce horizontal lines.

Medium detail

Small detail

This is ideal for smaller details. Paint the outline of the mountain and then fill in the shape, adding more water to the mix when necessary.

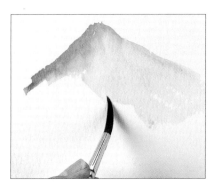

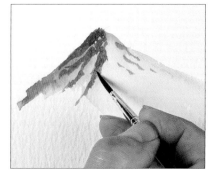

This brush is useful for really delicate work. Add the shapes of the rock formations wet on dry using a strong mix of ultramarine and burnt umber.

Half-rigger

Golden leaf

The half-rigger has a really fine point but holds a lot of paint. The hair is long, though not as long as a rigger. It is excellent for adding very fine details wet on dry. Use an upwards flicking motion to create reeds, as shown here.

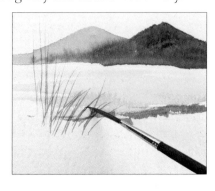

A large wash brush, ideal for skies. Sweep a wet mix of blue across the paper, then add ultramarine and burnt umber wet in wet to paint clouds.

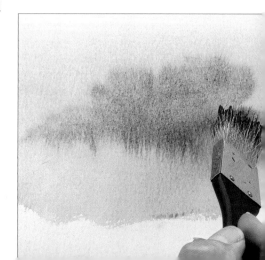

Foliage brush

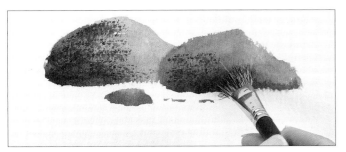

This smaller version of the golden leaf brush is good for stippling. Paint rocks with a flat wash and let it dry. Then, using a fairly dry brush, stipple with the ends of the bristles to create texture.

Fan stippler

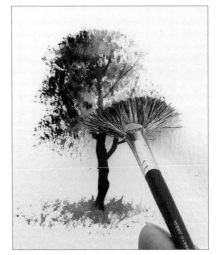

This is a fan-shaped version of the foliage brush, and is ideal for trees. Stipple in green, then stipple a deeper green on top for foliage.

Wizard

Twenty per cent of the hair in this brush is longer than the rest, which produces some interesting effects. To create reflections, apply a light wash, then take the dark colour and drag it down wet in wet. Only a little paint comes out of the brush, producing a useful streaked effect.

Fan gogh

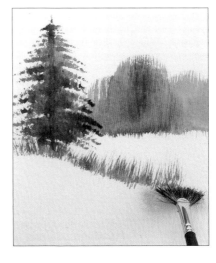

This thick fan brush holds lots of paint and is excellent for trees. Paint the background trees and leave to dry. Use the curve of the brush to add the fir tree, then flick up to create grasses.

Fan gogh px

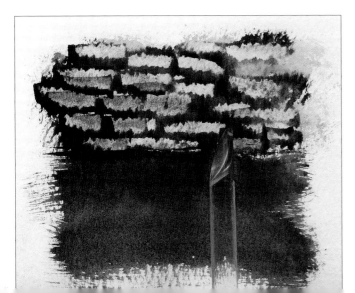

This version of the fan gogh has a clear handle that is great for scraping out stonework. First apply raw sienna, then light green, not too wet. Paint a dark colour such as ultramarine and burnt umber on top of the first colour. While it is wet, scrape out shapes for stones with the shaped end of the brush handle.

Washes

Washes need to be done quickly and with confidence, but this does not mean rushing, so don't panic. Watercolour does not dry as quickly as you would imagine. To avoid streaks in a wash, a good tip is to wet the background with some clean water and paint the wash wet into wet. You must use a large brush that will hold plenty of liquid so that you do not need to reload it too often.

Skies

Use the golden leaf brush to apply a wash of ultramarine, adding more water as you go down the paper. Then make a thin mix of ultramarine and paint a cloud wet in wet. Use a slightly stronger mix to create a shadow under the cloud, still painting wet in wet.

Mountains

Mix a blue wash from ultramarine with a little burnt umber and use the large detail brush to paint the distant mountain. Then make a darker version of the mix to paint the outline of the mountain in front of the distant one. Fill in the shape.

Water

Make a thin wash of ultramarine to reflect the sky colour and use the 19mm (¾in) flat brush to paint the water. Use the horizontal line of the brush to create a rippled effect, moving the brush from side to side as shown.

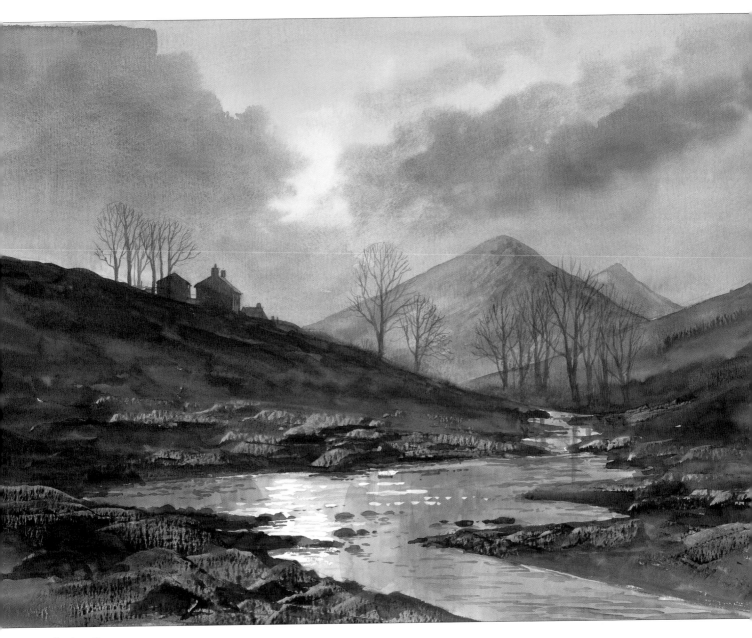

Gathering Storm

500 x 350mm (19¾ x 13¾in)

This painting uses the wet into wet technique, but each section was allowed to dry before the next was started. The sky was painted first using a warm wash of raw sienna, then the darker cloud colours were dropped in wet into wet. The sky was then allowed to dry. The mountains were painted next. If they had been painted on to a wet background, they would have dissolved into the wet paint. The stronger mix for the middle distance, creating the dark silhouette of the buildings, was also used for the winter trees. The foreground was painted next using the scraping out technique to create the rock formations. Finally, when that was dry, the water was painted, reflecting the colours used in the sky.

Scraping out using a plastic card

This technique can be used to create effective textures. The effects created in this book, suggesting mountains, rocks and tree trunks, require a rough surfaced paper. By scraping the paint off the raised part of the rough paper, you can create the lighter shades of the rocks or mountains. The darker tones are suggested by the paint left in the indentations.

The key to this technique is the uneven pressure applied to the plastic card, allowing more paint to be scraped off the surface where you want the tone to be lightest. If the light is on the left-hand side of the rock or mountain, hold the card towards the left-hand edge, and this is where the most pressure will be applied. There will be less pressure on the trailing edge, so less paint will be removed. The paint needs to be applied fairly thickly, as if it is too wet, it will flow back over the paper. Practise this technique before attempting a painting.

Mountains

The trick with this technique is to scrape the paint off with a quick, sharp movement.

1. Apply a wash using the golden leaf brush. Then scrape diagonally across it with the plastic card to create a mountain.

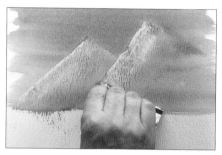

2. Scrape out a second mountain in front of the first. Allow the painting to dry.

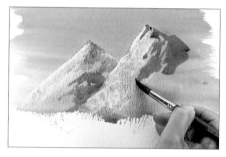

3. Use the large detail brush and shadow colour to add detail, giving shape to the rock formations.

Rocks

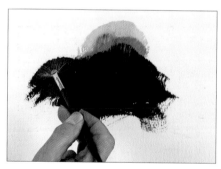

1. Use the fan stippler to paint on layers of thick, dryish paint for the rock formation, going from light to dark. First paint on raw sienna, then burnt sienna, then burnt umber mixed with ultramarine. Lastly paint on midnight green to add interest.

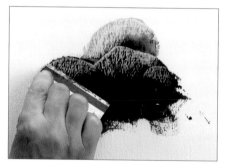

2. Starting at the back of the rock formation, scrape out rock shapes with the plastic card. Using extra rough paper helps to create a rocky texture.

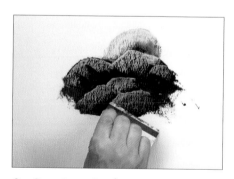

3. Continue in the same way to the bottom of the rock formation, scraping paint off the surface to leave darker colour in between the rock shapes, suggesting shadowed crevices.

Tree trunks

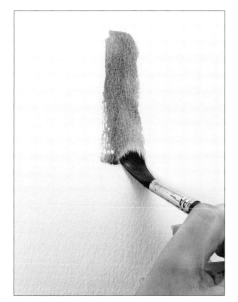

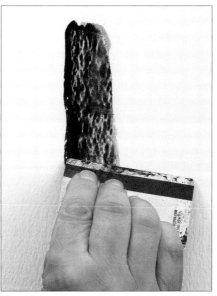

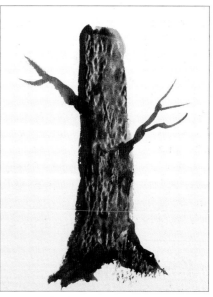

1. Paint the trunk with a light green wash of raw sienna and sunlit green.

2. Paint country olive over the top, and then burnt umber and ultramarine. While the paint is wet, scrape the card straight down the trunk.

3. Use the large detail brush to add branches and roots to complete the tree trunk.

Scraping out using a brush handle

Whatever base colour a wall is, for instance a warm sandstone shade or a harsh granite colour, you need to paint this on first. In the example shown, I have used raw sienna and then green to give the impression of a mossy, mellow wall. This colour stains the paper, then you put the dark colour on top. Before it dries, scrape the dark colour off the top to expose the colour underneath. Scraping pushes the top colour aside, creating a dark outline to each stone.

Stone walls

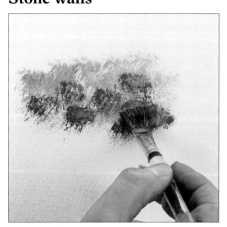

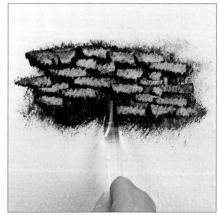

1. Use the foliage brush and thick raw sienna paint to dab on texture. Then scumble sunlit green on top.

2. Scumble a darker mix of ultramarine and burnt umber on top. Make sure it is not too wet.

3. Before the paint dries, scrape off stone shapes in the wall using the scraper end of the fan gogh px brush.

Using masking fluid

Many artists do not like using masking fluid because it ruins brushes – see the tip! Once you have mastered the art of using masking fluid, it gives you the opportunity to create all sorts of different effects. The obvious effect when painting mountains is the snowcapped peaks. When using masking fluid, you need only mask out the lightest areas. Another application for masking fluid is the sparkly effect of sunlight on water, and the white foam of a waterfall.

Tip
Before using masking fluid, wet the brush and wipe it over a bar of soap. You will then be able to wash the masking fluid out of the brush when you have finished.

Snowcapped mountains

1. Draw the mountains first, then paint the snowy areas with masking fluid on a fine brush.

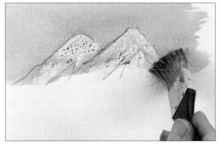

2. When the fluid is completely dry, paint the sky using the golden leaf brush. Paint over the mountain tops.

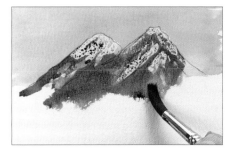

3. Mix a dark grey from ultramarine and burnt umber and use the large detail brush to paint in the mountains.

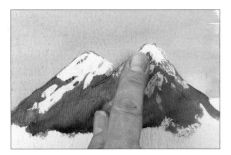

4. When the paint is dry, rub off the masking fluid with your fingers to reveal the white paper underneath.

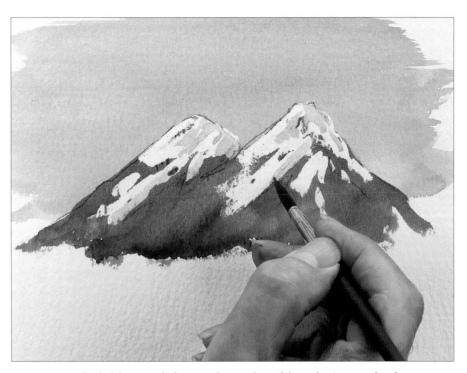

5. Using cobalt blue and the medium detail brush, paint shadows in the snow.

Ripples on water

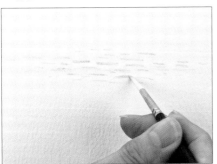

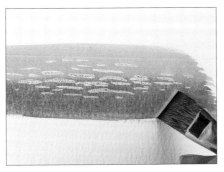

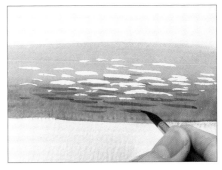

1. Paint the ripples using masking fluid and a fine brush.

2. Use the 19mm (¾in) flat brush with horizontal strokes to paint the water.

3. Rub off the masking fluid when the paint is dry. Add darker ripples in the foreground using the medium detail brush and a strong mix of ultramarine.

Waterfall

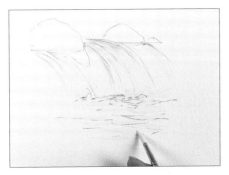

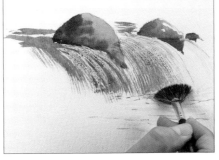

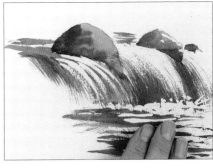

1. Draw in the rocks and the water. Paint the masking fluid on, dragging the brush down the fall of water. In the rock pool, add dots, splashes and ripples.

2. Paint in the rocks using raw sienna, burnt umber and ultramarine. Paint a darker mix of ultramarine and burnt umber in to the shadowed part of the rock. Allow it to dry, then take the fan gogh and drag a blue mix of ultramarine and burnt umber down the waterfall.

3. Paint the foreground water with the same colour. When it is dry, remove the masking fluid with your fingers.

4. Add ripples in a lighter blue with the medium detail brush.

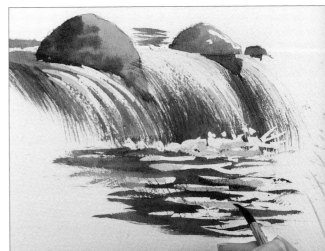

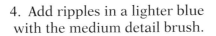

Using a paper mask

This is a very simple way of achieving great results. You take a piece of coated paper from something like a brochure or leaflet (photocopier paper is too absorbent), and use the edge to mask an area where you want a straight line, for example the side of a building, a wall or the water's edge. You can cut the paper to any shape required.

Water's edge with trees

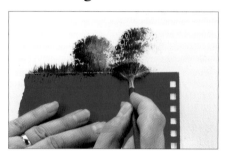

1. Place a paper mask where you want the water's edge to be and use the fan stippler and various greens to suggest grasses and trees.

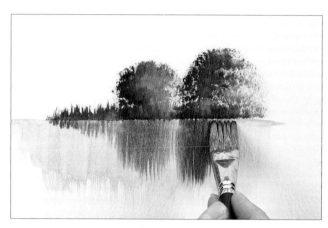

2. Remove the mask and use the 19mm (¾in) flat brush to paint water with downward strokes. Pick up some green and drag it down in to the wet blue.

Stone walls

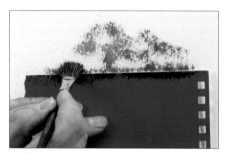

1. Mask the bottom of the wall area and use the foliage brush and ultramarine and burnt umber to stipple texture above it.

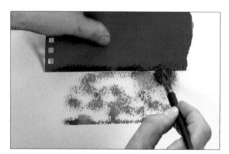

2. Mask the top of the wall and continue stippling.

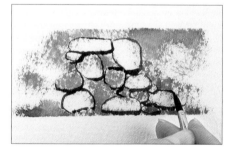

3. Take a darker mix of the same colours and the medium detail brush. Pick out dark and light areas in the stippling and paint round them to create stones.

Hillside barn

1. Draw the barn first.

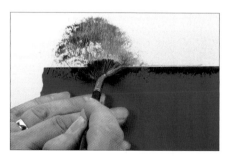

2. Mask the top of the roof and use the fan stippler to create foliage behind the barn.

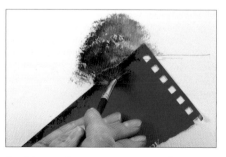

3. Move the paper to mask the angle of the roof and continue stippling.

4. Mask the wall of the barn and stipple behind it.

The finished shape of the barn.

Village Stream
390 x 420mm (15⅜ x 16½ in)
The patchwork fields with their hedgerows and trees in this green and pleasant valley were created using the paper mask technique. The foliage brush was used to create the texture of the stonework on the cottages, and the detail was added using the half-rigger.

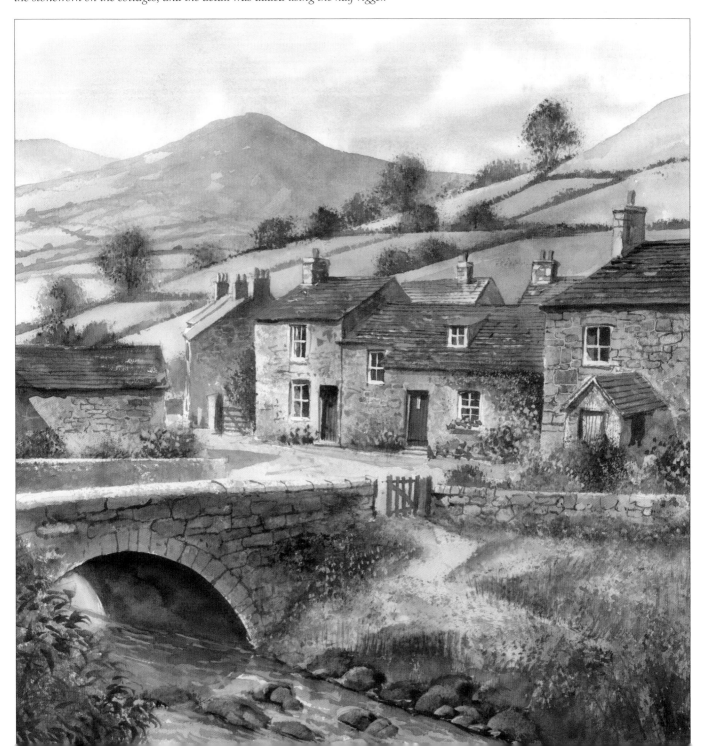

Painting skies

When painting landscapes, you are bound to have to paint skies. If you learn to paint a basic sky, you can apply the techniques to most landscapes.

Summer sky with lifting out

1. Wash the sky area first with clean water. Use the golden leaf brush and ultramarine to apply a blue wash. As the brush travels down the paper, the water on the surface dilutes the colour in the brush, making it progressively lighter towards the horizon.

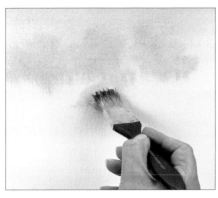

2. Paint in clouds wet into wet using a dark mix of ultramarine and burnt umber.

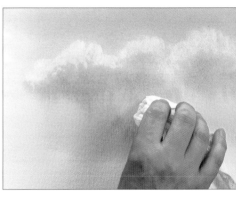

3. Dab the tops of the clouds with kitchen paper or tissue to lift out colour.

Winter sky

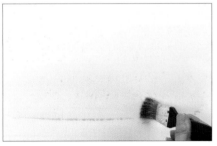

1. Wet the sky area with clean water, then using the golden leaf brush, apply a weak wash of raw sienna to the bottom half.

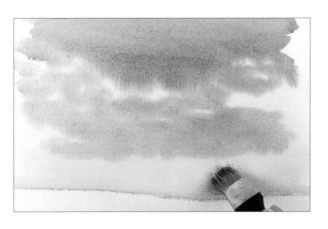

2. Apply a second wash of ultramarine and burnt umber from the top, wet in wet. Leave some white for clouds.

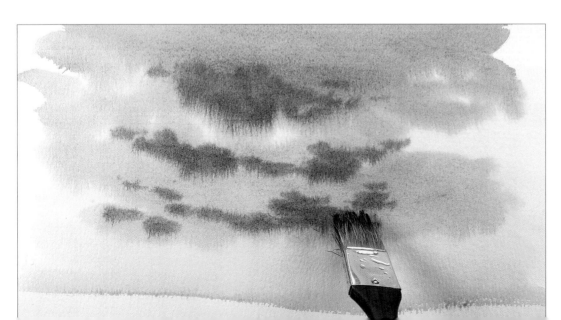

3. Using a stronger mix of the same colours, dab with the bristle ends of the golden leaf brush to suggest dark clouds.

Stormy sky

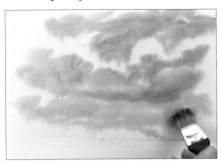

1. Wet the sky. Use the golden leaf brush and ultramarine with a touch of burnt umber to paint a cloud formation.

2. Rough in darker clouds wet in wet using a stronger mix of the same colours.

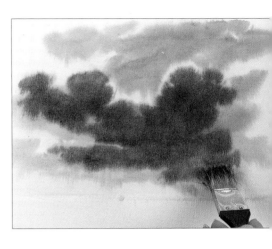

Sunset

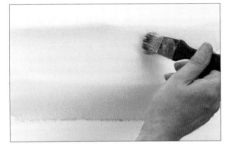

1. Wet the paper then, using the golden leaf brush, paint a wash of cadmium yellow in the centre and crimson at the top and bottom. Fade the crimson bands into the yellow wet in wet.

2. Paint a wash of cobalt blue from the top, fading down into the wet crimson. Using crimson will stop the blue and yellow turning to green.

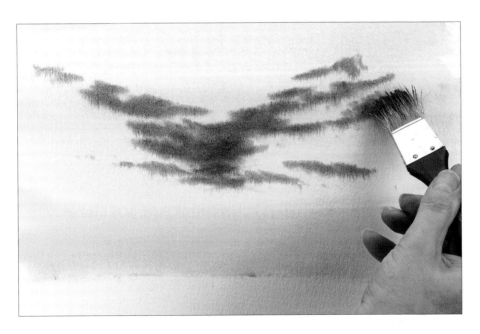

3. Use shadow and the golden leaf brush to paint a cloud formation wet in wet, drifting into the centre of the sky.

Painting mountains

Mountains can be painted in many different moods: distant, misty mountains; harsh granite edifices and imposing, majestic peaks. Using a variety of simple techniques, you can easily create the painting of your choice.

Snow-covered mountains

1. Draw the mountain and paint masking fluid on to the snowy areas.

2. Wet the sky area and use the golden leaf brush and ultramarine to suggest cloud shapes. Add darker shapes wet in wet with a stronger mix.

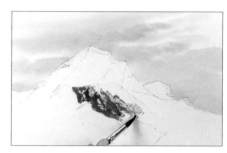

3. Mix a cool bluey-brown from ultramarine and burnt umber and using the large detail brush, drag it over the shaded area using the dry brush technique.

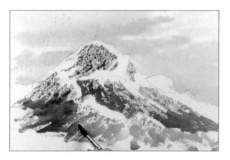

4. Make a warmer mix of burnt umber with a touch of ultramarine and drag paint over the sunlit side of the mountain.

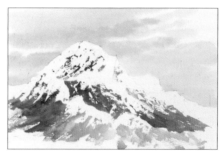

5. When the paint is dry, remove the masking fluid.

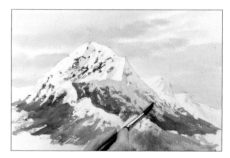

6. Use a cool blue such as cobalt blue and the large detail brush to paint the shaded areas of snow. Allow to dry.

7. Use the medium detail brush and a bluey-grey mix to paint in the finer details of the rock formation.

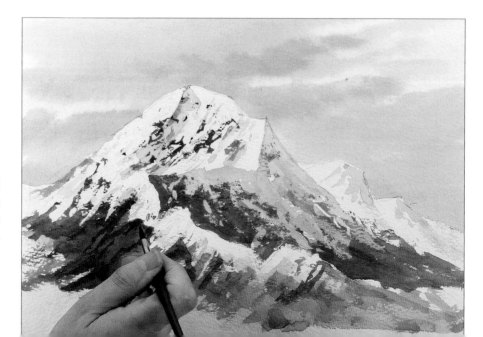

112

Distant mountains

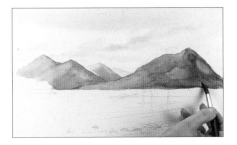

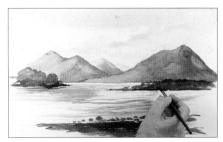

1. Wet the sky area with clean water. Using the golden leaf brush, paint the sky behind the hills with raw sienna. Then paint ultramarine from the top down into the wet raw sienna. Allow the painting to dry.

2. Using the large detail brush with pale ultramarine, paint the distant mountain. Let each mountain dry before beginning the next. Paint the mountain in front of that using shadow. Then paint the mountains on the left with shadow and raw sienna. Use a stronger mix to paint the mountain on the right.

3. Take the 19mm (¾in) flat brush and ultramarine with a touch of shadow and paint the water. In the foreground use shadow with burnt umber and the medium detail brush with the dry brush technique to paint pebbles on the shoreline. On the far shore paint dark rocks, and on the right a dark headland.

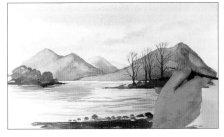

4. Use the half-rigger and the same dark mix to paint in trees on the headland.

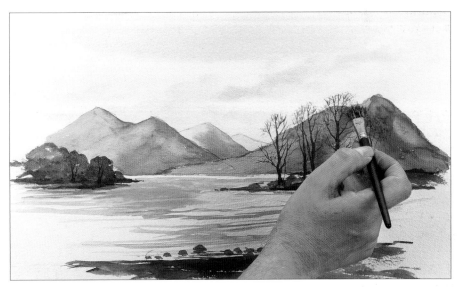

5. Pick up the same mix again with the foliage brush and stipple into the trees.

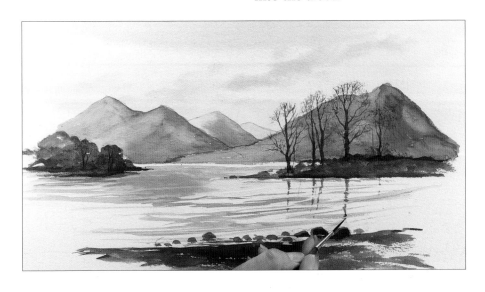

6. Use the half-rigger to paint reflections beneath the trees, using broken lines to suggest ripples in the water.

Misty mountains

1. Wet the sky area and the mountains. Take the golden leaf brush and paint an ultramarine wash. Suggest clouds with ultramarine and burnt umber and lift out the tops with kitchen paper.

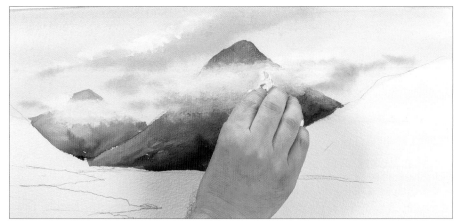

2. Paint in the distant mountain with shadow and a touch of ultramarine, using the large detail brush. Add raw sienna wet in wet. Paint the larger mountain with raw sienna. While this is still wet, lift out the clouds again using kitchen paper or tissue.

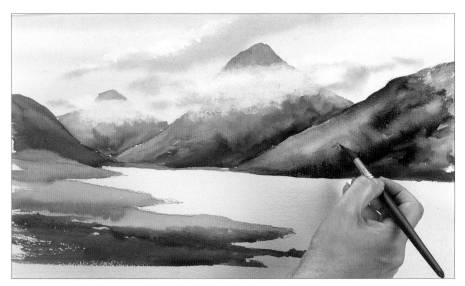

3. Paint the right-hand mountain with shadow. Add raw sienna wet in wet. Paint raw sienna and sunlit green towards the foreground, then burnt umber and country olive. Paint the right-hand bank with shadow and country olive, and add raw sienna wet in wet.

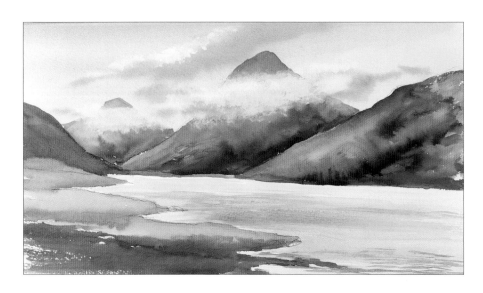

4. Mix ultramarine with a touch of burnt umber and sweep in the water with the 19mm (¾in) flat brush.

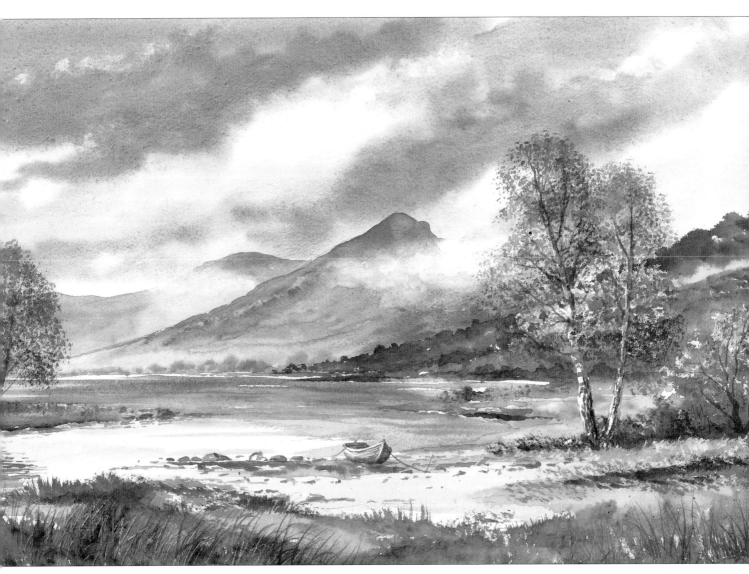

Misty Glen
520 x 350mm (20½ x 13¾in)
The clouds in this picture drift across the painting and obscure parts of the
mountains, creating a distant effect and a peaceful and atmospheric scene.

Painting valleys

Valleys can evoke as many different moods as mountains, from peaceful and tranquil to wild and rugged.

Rolling hills

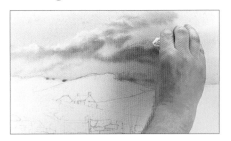

1. Wet the sky area. Apply an ultramarine wash, add ultramarine and burnt umber clouds and lift out colour with kitchen paper.

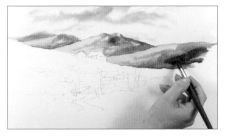

2. Paint the hill on the far left with shadow and the middle two with raw sienna and shadow. Use raw sienna with a touch of warm burnt umber for the right-hand hill. Add a touch of midnight green and country olive on the far right.

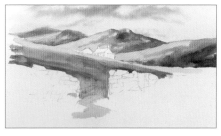

3. Using the large detail brush and raw sienna with a touch of sunlit green, paint the middle distance. Add shadow for the road and raw sienna for the footpath.

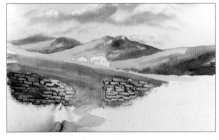

4. Use the foliage brush to stipple raw sienna on the stone wall, then sunlit green, then burnt umber and ultramarine on top. Use the scraper end of a px brush to scrape out stone shapes.

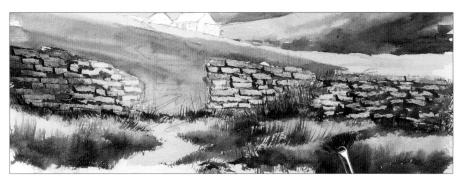

5. Paint foreground grasses using the fan gogh and country olive with burnt umber. Stipple raw sienna, then ultramarine and burnt umber on to the right-hand wall and scrape out stones. Paint darks in the foreground with burnt umber and country olive.

6. Paint the stile with the large detail brush and burnt umber with country olive. Allow it to dry, then use the small detail brush with cobalt blue and burnt umber and paint the sunlit roof. Use a warmer mix for the other roofs and architectural details, and to shadow the stile.

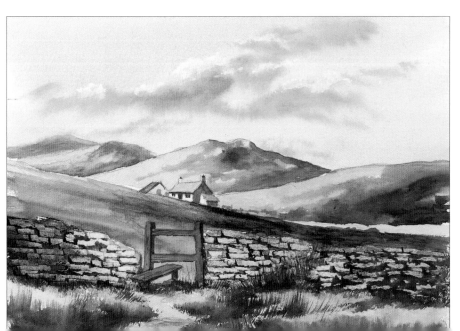

Craggy valley

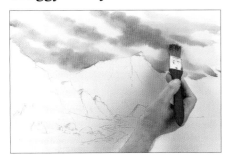

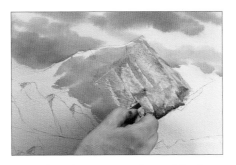

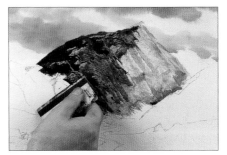

1. Wet the sky area with clean water, then apply a wash of raw sienna with the golden leaf brush. Drop in ultramarine and burnt umber cloud shapes wet in wet. Allow to dry.

2. Paint the mountains with the same brush and a mix of cobalt blue and burnt umber. Drop in raw sienna wet in wet. Firmly scrape out the shapes in the rock using a plastic card.

3. Use a darker mix of the same colours on the shadowed left-hand side and scrape out again with the plastic card.

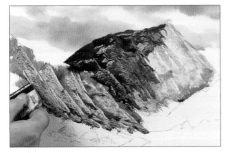

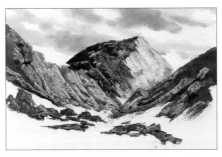

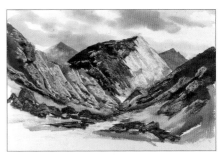

4. Paint the rocks on the left with a warmer mix including raw sienna. Scrape out the rock shapes using sharp diagonal strokes.

5. Paint the rocks on the far left, far right and in the foreground using the 19mm (¾in) flat brush and a mix of ultramarine and burnt umber. Scrape out all these areas while they are wet.

6. Use the large detail brush with raw sienna and sunlit green to fill in the spaces between rocks in the foreground. Paint the distant hills a bluey grey mixed from ultramarine and burnt umber.

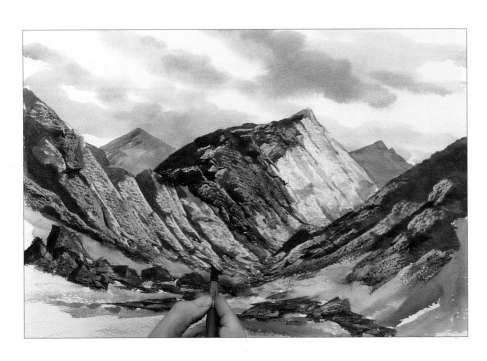

7. Allow the painting to dry before adding detail. Make an almost black mix from ultramarine and burnt umber and use the large detail brush to paint diagonals on the middle mountain, fault lines in the rocks and foreground details.

Green valley

1. Wet the sky area with clean water then drop in ultramarine with the golden leaf brush for cloud shapes. Add ultramarine and burnt umber wet in wet for darker clouds.

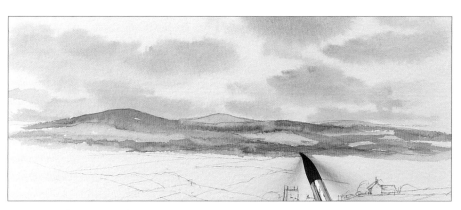

2. Paint the most distant hills with the large detail brush and cobalt blue with a touch of midnight green. Use a lighter mix with raw sienna added as you move further forwards. Paint in the shapes of the rows of hills.

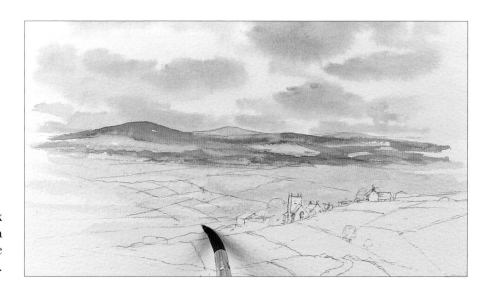

3. Make a lighter mix with more raw sienna and paint the middle distance up to the village.

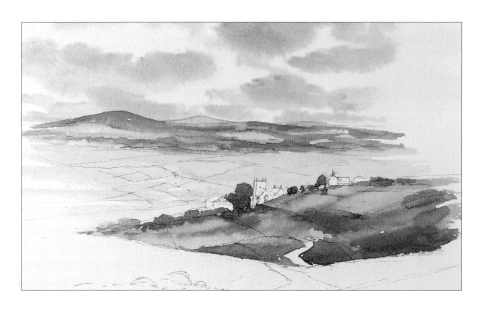

4. Mix a warm green from country olive and a little raw sienna to paint the area coming towards the foreground. Leave a space for the path. Paint the trees around the village.

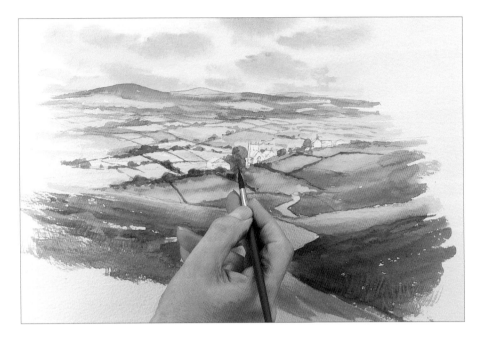

5. Mix a slightly stronger green from raw sienna with a little country olive for the foreground. Add country olive with a touch of burnt umber for the left-hand side of the foreground. Use the medium detail brush and raw sienna with a little burnt umber for the track. Paint the middle distance hedgerows with ultramarine with a touch of country olive. Dot a few trees along the hedge line. Strengthen the green in some of the middle distance fields. Vary the shades of the fields, painting some in burnt sienna. Allow the painting to dry.

6. Add detail to the village, painting wet on dry. Use the small detail brush and raw sienna to give the impression of warm stonework. Mix burnt umber and ultramarine, not too dark, for architectural details. Add lines across some of the fields in the middle distance.

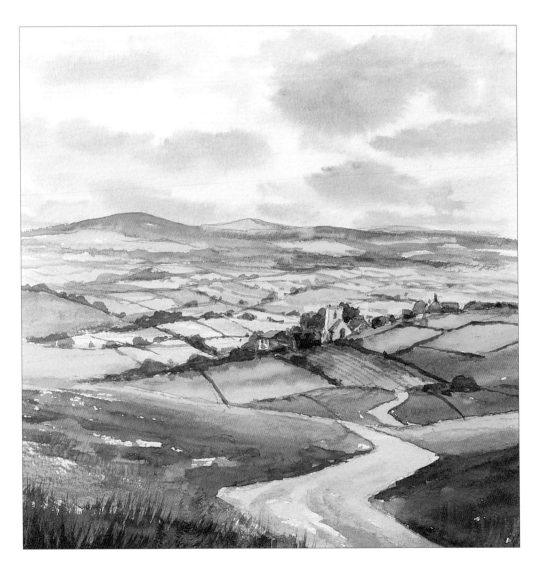

Painting water

There always seems to be water at the bottom of a mountain, whether it is in a lake, a river or a stream, so when painting mountains, the chances are you will need to paint some water. Here are a few simple techniques to help you master this seemingly impossible subject.

Still water

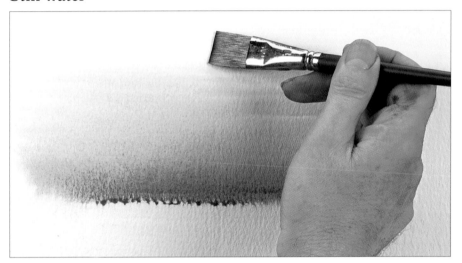

Wet the paper with clean water and a 19mm (¾in) flat brush. Make a strong mix of ultramarine. Still water is darker in the foreground so apply the wash from the bottom upwards. Zigzag up the page, and the wash will become progressively more diluted by the water on the paper.

Rippled water

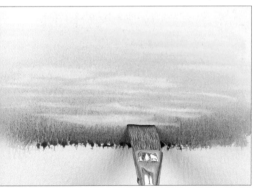

1. To add ripples, squeeze water out of the brush and use it to lift out colour in irregular horizontal lines. Also lift out any beading of paint at the bottom.

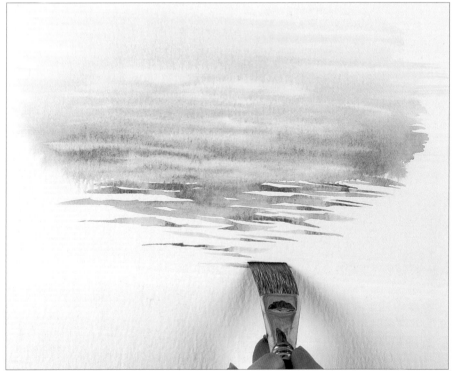

2. Painting on to the dry paper in the foreground, extend the ripples forwards with horizontal brush strokes, leaving white spaces between them.

Reflections in still water

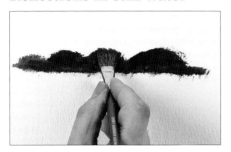

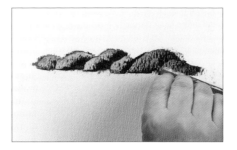

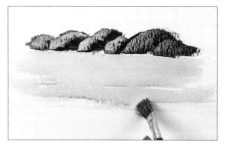

1. Using the foliage brush, paint layers of dry paint: first raw sienna, then burnt umber and then a mix of ultramarine and burnt umber.

2. Scrape out rock shapes using a plastic card. Start with the rocks furthest away. When scraping out, the edge of the card should end up horizontal at the base of the rock.

3. Using the wizard brush, paint a blue wash almost up to the rocks.

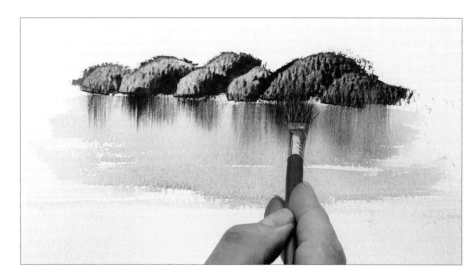

4. Working wet in wet, pick up rock colours with the wizard brush and drag them down from the rocks into the water wash to create reflections.

Moving water

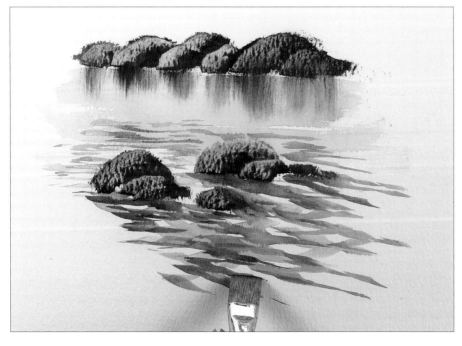

Add rocks in the foreground and scrape them out as before. Use the 19mm (¾in) flat brush and the rock mix to add ripples and to suggest water moving round the rocks. Add a bluer colour and paint more ripples, creating a crisscross pattern. Add greens.

Mountain Lake

This painting shows Ashness Bridge, overlooking Derwent Water in the Lake District. Although this is a painting of a mountain lake, the lake itself is a very small part of the scene. The bridge appears to be the dominant feature, but the eye is inevitably drawn to the lake at the foot of the mountains. The stone bridge is painted in the traditional way, painting texture on to the paper rather than using the scraping out technique. The rocks are done using the credit card technique.

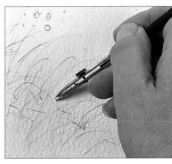

1. Draw the scene. Dip the ruling pen in masking fluid and flick up grasses in the foreground.

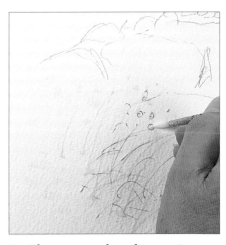

2. Change to a brush to paint on blobs of masking fluid for the flower heads. Remember to wet the brush and coat it in soap first to protect it.

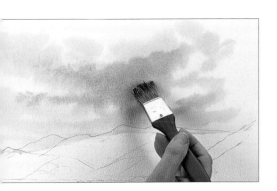

3. Use the golden leaf brush to paint clear water on the sky area, then drop in a touch of raw sienna around the horizon and the top of the hills. Brush in clouds using ultramarine, then paint ultramarine and burnt umber wet in wet to shadow them.

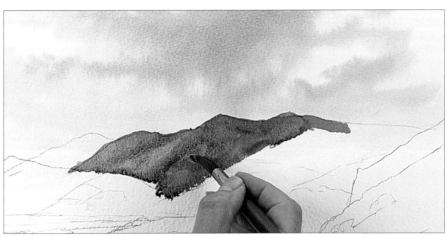

4. Paint the distant hills using the large detail brush with ultramarine, burnt umber and a touch of shadow. While the paint is wet, drop in raw sienna on the sunlit side, wet in wet. The colour will blend in to the darker paint.

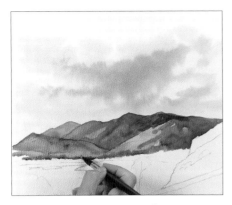

5. Continue painting the mountains, adding raw sienna wet in wet. Add sunlit green towards the middle ground. On the right add a dark bluey-grey mixed from ultramarine and burnt umber. Stop short of the trees.

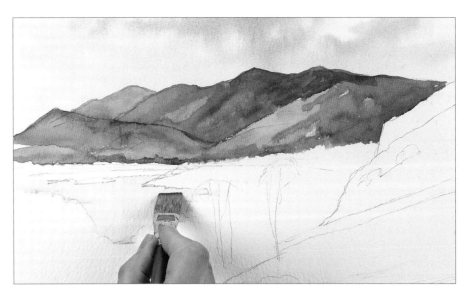

6. Use the 19mm (¾in) flat brush to paint in the lake. Pick up a little ultramarine and drag it down, then leave it to dry.

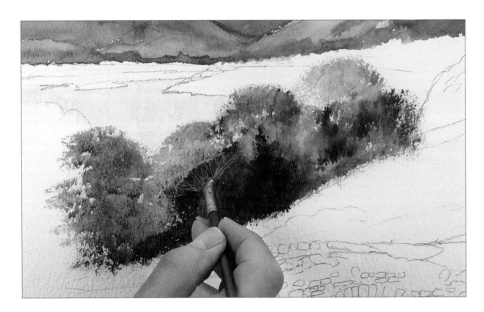

7. Use the fan stippler to paint sunlit green and country olive for the trees and hedge, then midnight green and burnt umber for the darker parts. Stipple on raw sienna wet in wet.

8. Scrape out the trunks of the silver birch trees using the scraper end of a px brush.

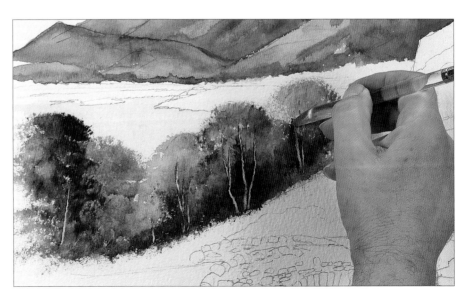

123

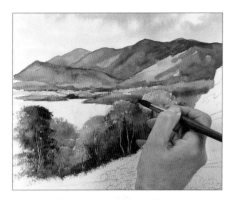 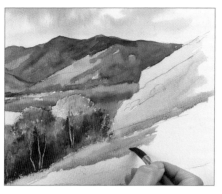

9. Finish the headland behind the trees using the large detail brush and a thin mix of sunlit green and raw sienna. Paint country olive with a touch of ultramarine in the distance to create contrast with the trees.

10. Paint the slope on the right with raw sienna, then add a touch of burnt sienna to give the impression of bracken.

11. Add a touch of country olive towards the foreground, and add burnt umber to the green, wet in wet, down towards the bridge. As the paint dries, add details using burnt umber and country olive.

12. Wash over the stonework of the bridge using the foliage brush and raw sienna. Allow it to dry.

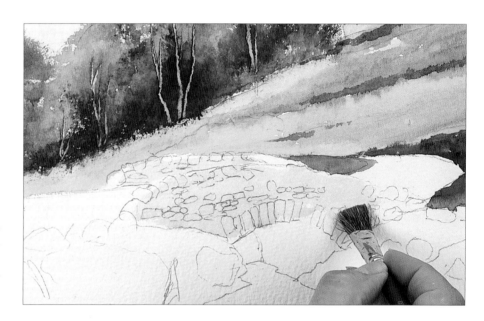

13. Stipple on ultramarine and burnt umber wet on dry. Allow the paint to dry.

14. Still using the foliage brush, stipple on a hint of country olive to add some moss. Allow to dry.

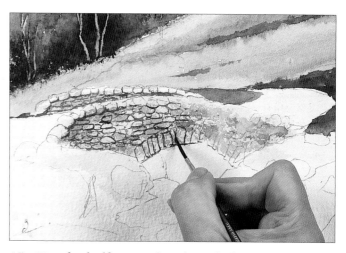

15. Use the half-rigger brush and ultramarine with burnt umber to paint the details of the stonework. Outline areas of dark and light that appear in the stippled area.

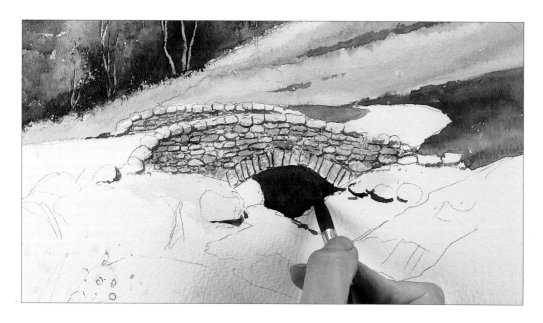

16. Paint in the dark area under the bridge using the large detail brush and ultramarine and burnt umber.

17. Paint over the rocky area in front of the bridge using the fan stippler and a very thick mix of raw sienna and ultramarine. Go over this with a darker mix of the same colours while the paint is still wet.

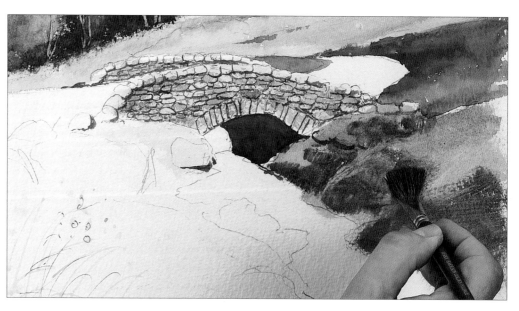

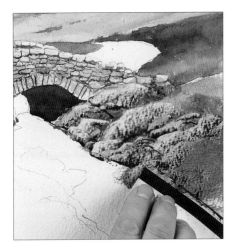

18. While the paint is wet, use a plastic card to scrape out rock shapes.

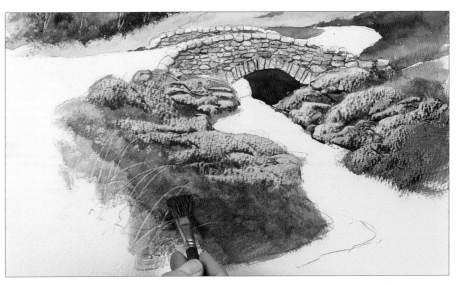

19. Paint over the rocky area on the left in the same way and scrape out rocks. Paint over the masked out grasses.

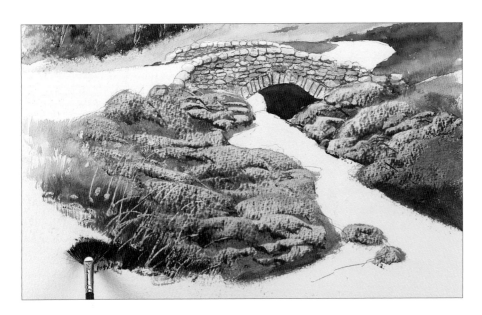

20. Use the fan gogh brush to paint the grassy area with light colours first, then darker. Start with sunlit green, then country olive, then midnight green, flicking up the brush to produce a grassy texture.

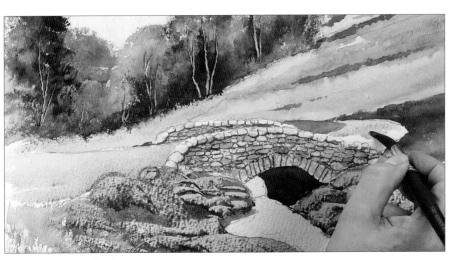

21. Wash colour into the road using the large detail brush and raw sienna with ultramarine.

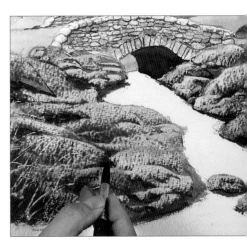

22. Add dark details among the rocks using ultramarine and burnt umber.

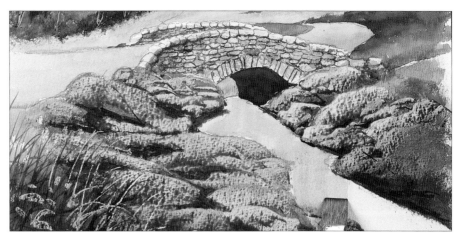

23. Use the half-rigger to add detail and grasses on top of the dried background.

24. Make a weak wash of ultramarine and use the 19mm (¾in) flat brush to drag it down to paint the stream.

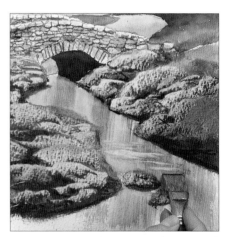

25. While the paint is wet, pick up ultramarine and burnt umber and drag it down to create reflections.

26. Clean and dry the brush and use it to lift out ripples in the stream.

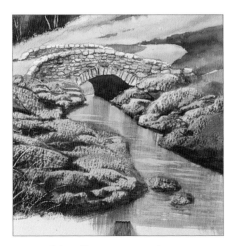

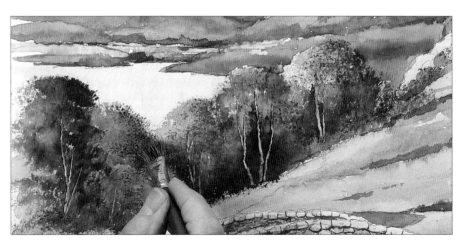

27. Add reflections to the stones and left bank using ultramarine and burnt umber.

28. Use the foliage brush and fairly dry country olive to stipple detail over the trees.

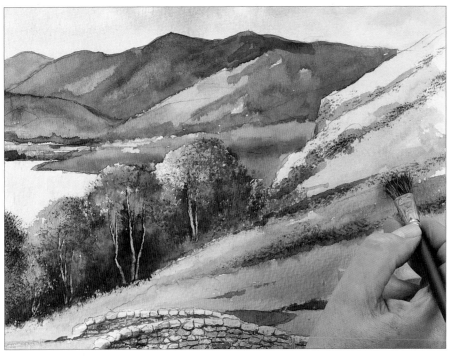

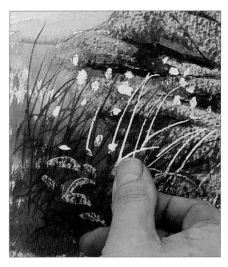

29. Stipple the bracken on the right-hand slope using the foliage brush and burnt sienna.

30. Remove the masking fluid from the grasses and flower heads by rubbing with your fingers.

31. Use the medium detail brush to paint a sunlit green wash over the white grasses. Then paint alizarin crimson on to the flower heads.

32. Touch the flower heads with a darker mix of alizarin crimson, wet in wet.

Opposite
The finished painting
360 x 510mm (14¼ x 20in)
After standing back from the painting, I added darker reflections and ripples in the water, wet on dry, and I also painted darker green branches in some of the trees.

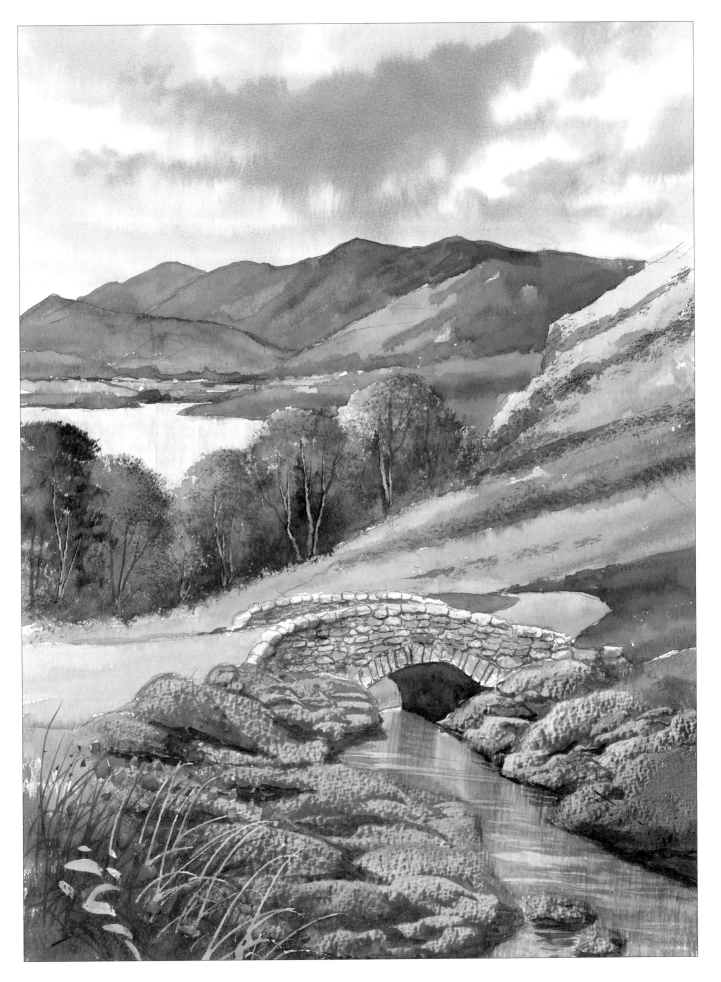

129

Valley View

This painting uses masking fluid, paper masking, scraping out and wet into wet techniques. The dominant feature is the wall that leads you into the valley, through the hamlet and on into the valleys and mountains beyond.

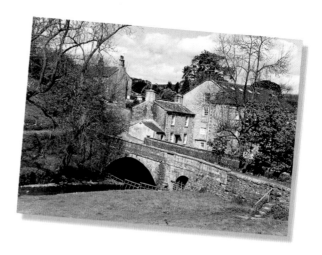

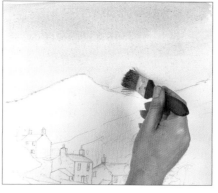

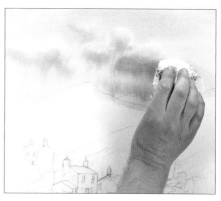

1. Use a brush to apply masking fluid to the flower heads. Then dip a ruling pen in masking fluid and mask off the chimney stacks and the foreground grasses.

2. Use a golden leaf brush to wash clean water over the sky area, then apply an ultramarine wash from the top downwards.

3. Paint ultramarine and burnt umber clouds using the golden leaf brush, then lift out the sunlit tops of the clouds using kitchen paper. Allow to dry.

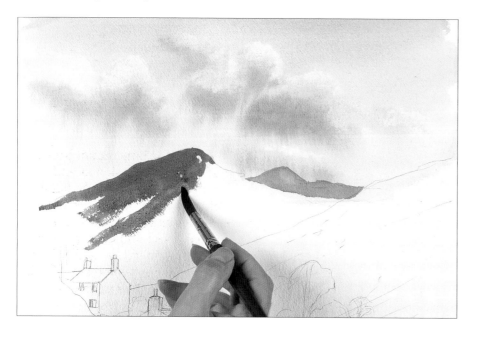

4. Paint the most distant mountain using the large detail brush and ultramarine with burnt umber. Add a touch of raw sienna to the sunlit side. Paint the dark side of the second mountain with ultramarine, burnt umber and shadow.

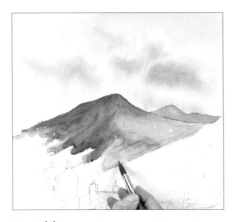

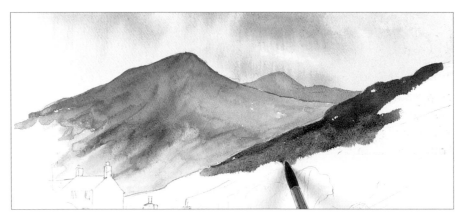

5. Add raw sienna wet in wet on the sunlit side of the mountain. It will blend into the darker paint.

6. Paint the right-hand hill using ultramarine and burnt umber with a touch of shadow. Then add raw sienna and burnt sienna.

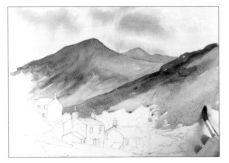

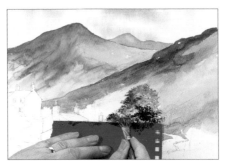

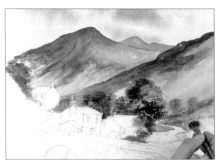

7. Continue to paint with raw sienna further down the paper, then add a touch of sunlit green as you go down into the valley. Allow to dry.

8. Mask off the roofline of a building with a paper mask and use a foliage brush and sunlit green to stipple in the trees.

9. Continue stippling the tree area in this way, varying the tone of the greens.

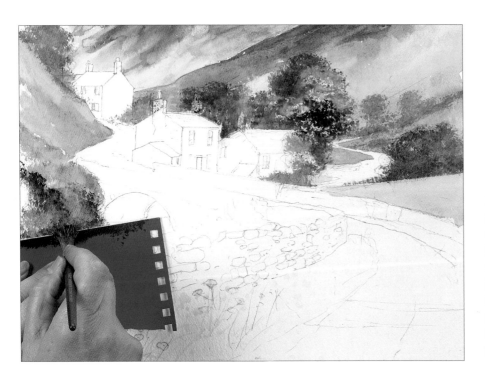

10. Take the large detail brush and wash in raw sienna and sunlit green for the right-hand field and the slope on the left of the painting. Then use the foliage brush and country olive to stipple the foliage going down towards the left-hand river bank. Mask off the river with a paper mask and continue stippling.

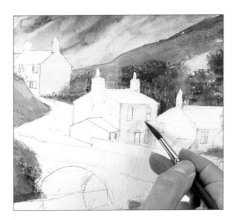 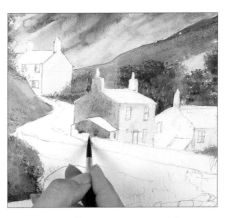 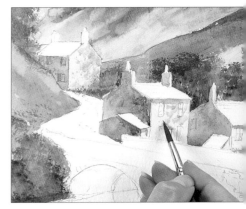

11. Remove the masking fluid from the chimney pots. Use the medium detail brush and a very pale wash of raw sienna and ultramarine to paint the sunlit fronts of the buildings.

12. Paint ultramarine and burnt sienna on the darker sides of the buildings.

13. Continue painting the darker details such as the shadows under the eaves. Use the same darker shade and dry brush work to add texture to the dried paint on the sunlit sides.

14. Use the medium detail brush to paint the slate roofs with ultramarine and burnt umber.

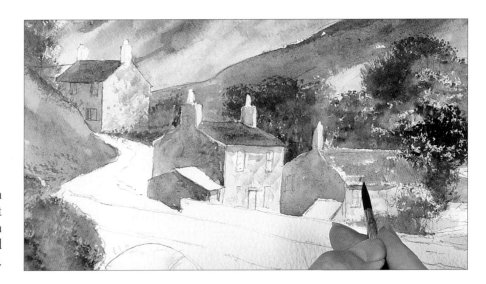

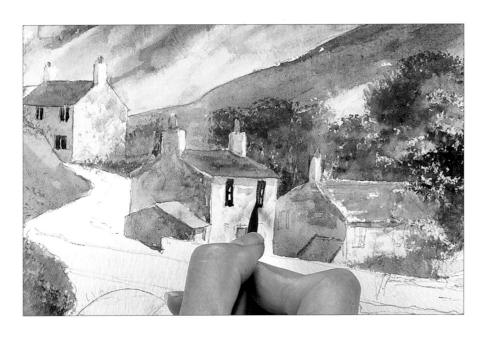

15. Paint the chimney pots and the doors with burnt sienna, then use ultramarine and burnt umber for the window darks.

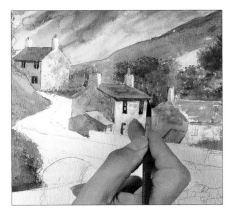

16. Use the same dark colour for the shadows under the eaves.

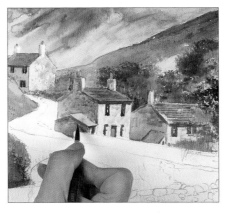

17. Continue painting the architectural details such as the slates on the roofs.

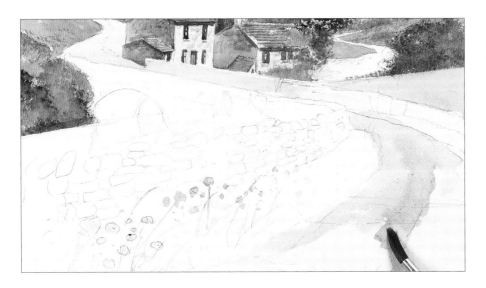

18. Use the large detail brush and a wash of raw sienna and cobalt blue to paint the road.

19. Continue painting the road, adding more cobalt blue wet in wet towards the foreground.

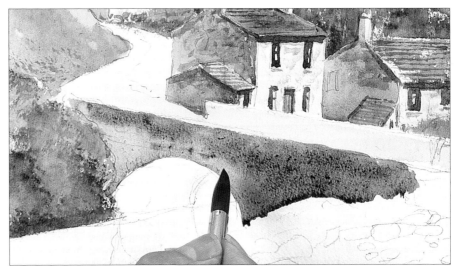

20. Paint the bridge with ultramarine and burnt sienna and the large detail brush. While the paint is wet, drop in burnt sienna.

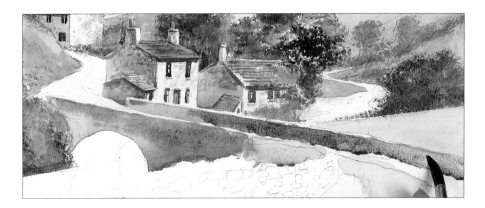

21. Paint the further parapet of the bridge using a greyer mix of ultramarine and burnt sienna.

22. Still using the large detail brush, paint greenery along the bank and wall with sunlit green and a little country olive.

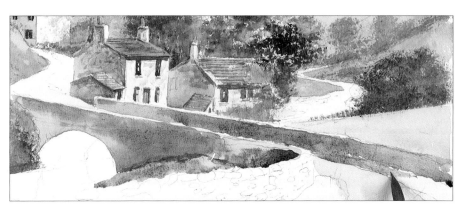

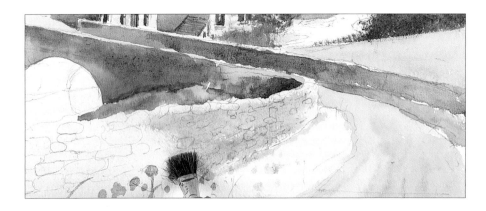

23. Use the foliage brush to stipple the stone wall with a light colour first: raw sienna with a touch of cobalt blue.

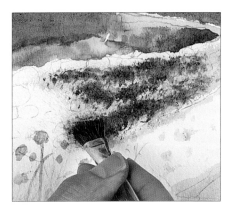

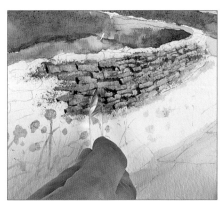

24. Stipple a darker mix of burnt umber and ultramarine over the top.

25. Scrape out stone shapes with the scraper end of a px brush.

26. On the left-hand side of the wall, stipple on a bright mix of raw sienna and sunlit green, using the foliage brush.

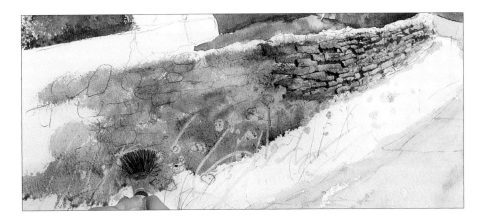

27. Stipple burnt umber and ultramarine over the bright mix and scrape out stone shapes with the end of a px brush.

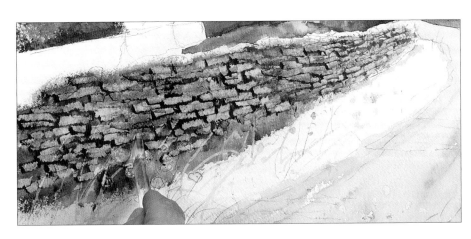

28. Use the fan gogh brush and sunlit green with raw sienna to stipple over the masking fluid in the area of the grass verge. Stipple midnight green over the top.

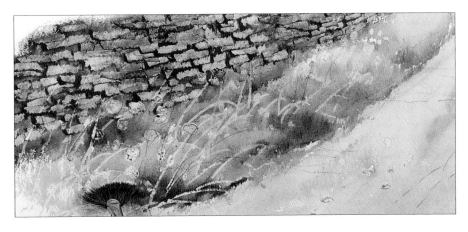

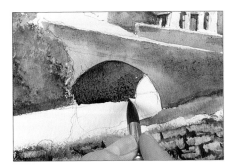

29. Paint the dark arch of the bridge with ultramarine and burnt umber.

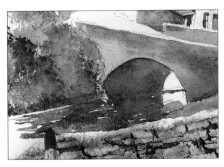

30. Paint the water with a touch of ultramarine, then add reflections of the foliage greens. Leave white spaces for ripples.

31. Paint the more distant water with the large detail brush and a weak wash of cobalt blue.

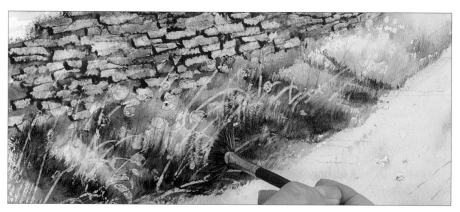

32. Use the fan gogh brush and midnight green to flick up grasses on the verge.

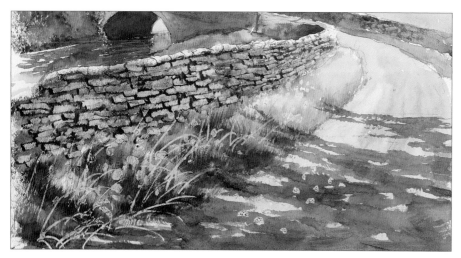

33. Use the wizard brush and shadow with a touch of cobalt blue to paint the foreground shadows, going across the road, over the masking fluid and up into the bank. This will accentuate the light area in the centre of the painting, making it the focal point.

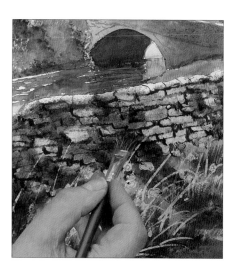

34. Continue the shadow up the wall, glazing a thin mix over the dried paint.

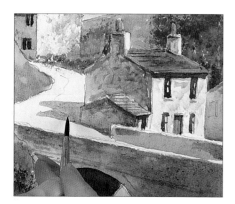

35. Use the small detail brush to add the shadow on the road from the central building.

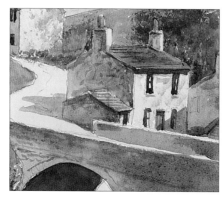

36. Shade the right-hand side of the central building where shadow from the building on the right falls on it.

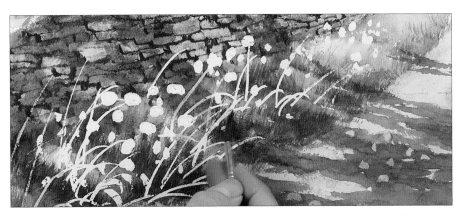

37. Add detail to the central area around the water. Use the half-rigger brush and midnight green to add branches to the trees.

38. Remove the masking fluid from the grass verge area. Use the small detail brush to paint the grasses in sunlit green and in country olive for the shaded areas.

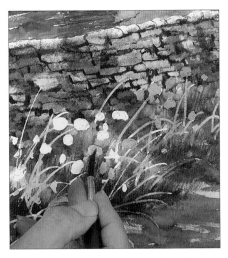

39. Drop a pale wash of cadmium red on to the flower heads.

40. Drop a deeper red mix into the wet paint.

41. To finish the poppies, drop shadow into the centres of some but not all of the flower heads.

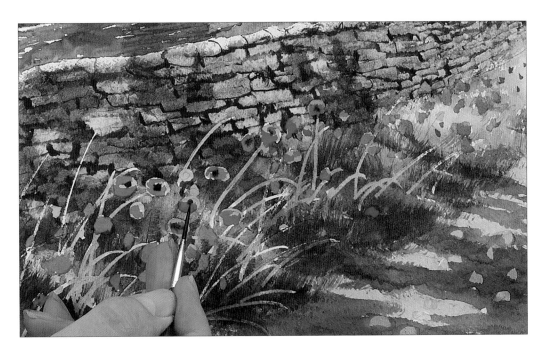

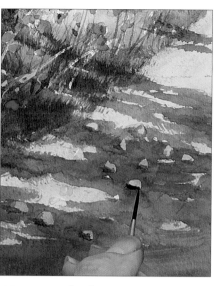

42. Use a half-rigger and midnight green to add darker grasses to the verge area.

43. Paint shadows under the stones using the half-rigger brush and ultramarine mixed with burnt umber.

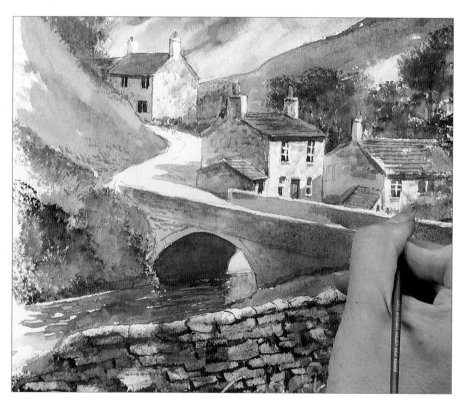

44. Use white gouache to paint highlights such as the ripples in the water and the bars in the windows.

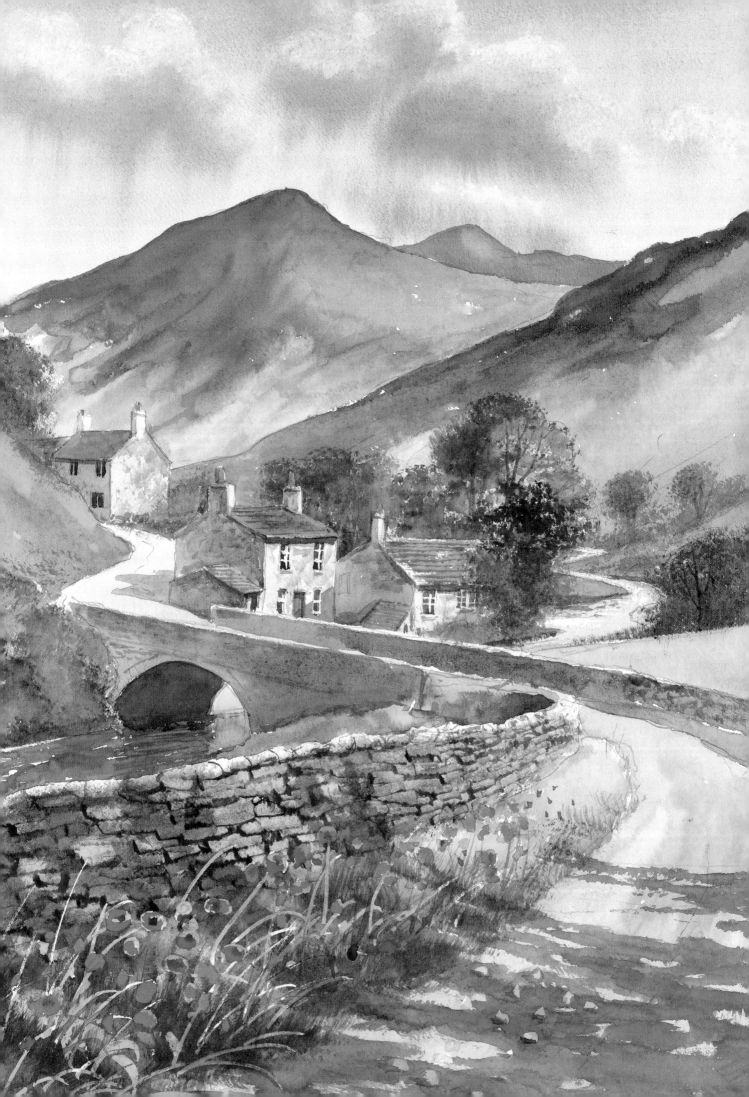

Mill Stream

There is nothing more peaceful than being beside running water. In this painting the waterfall and the overhanging tree frame the mill buildings in the background.

When choosing your subject, beware of trespassing on private property, as it turned out I was when photographing this scene. If caught, do not hesitate to apologise and beat a hasty retreat.

1. Draw the scene. Use masking fluid with a brush to mask the fence uprights, the ripples in the waterfall, the flowers on the opposite bank and the leaves in the foreground. Then use the ruling pen with masking fluid to mask the foreground grasses.

2. Wet the sky area with the golden leaf brush and paint clouds in ultramarine.

3. Mask the roofs of the mill buildings with a paper mask and stipple trees using a pale wash of sunlit green and ultramarine with the foliage brush. Remove the mask and tidy the edges using the medium detail brush.

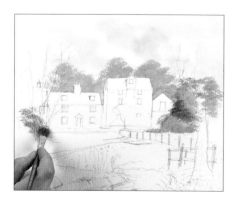

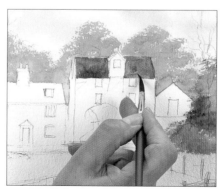

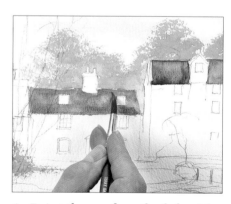

4. Stipple the trees on the right and the bush on the left with country olive and the foliage brush.

5. Paint the slate roof of the mill with the medium detail brush and a grey mix of ultramarine and burnt sienna.

6. Paint the roof on the left with burnt sienna and a touch of ultramarine. Drop in raw sienna wet in wet.

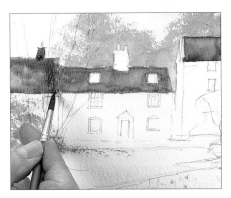 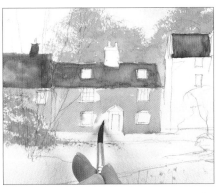 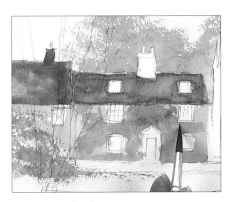

7. Paint the roof of the building on the left with burnt sienna and drop shadow in wet in wet.

8. Add cadmium red to the roof colour and water it down. Paint all the brickwork.

9. Drop shadow in wet in wet.

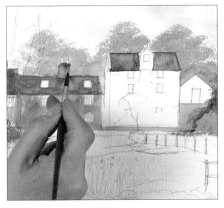 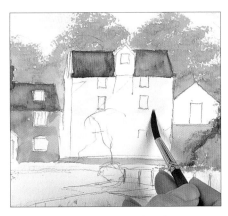 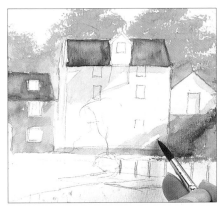

10. Paint half the building on the right with the brickwork mix, then use a thicker mix for the chimney stack on the left.

11. Paint a light wash of raw sienna on the mill and on the building on the right. Allow the paint to dry.

12. Use the medium detail brush and cobalt blue with a touch of shadow to paint the shadows under the eaves and from the gable and trees.

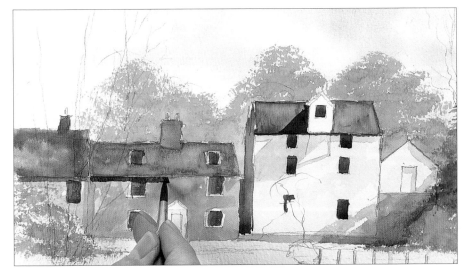

13. Use ultramarine and burnt umber to paint the shading on the mill roof, the dark windows and the shadow under the eaves of the building on the left.

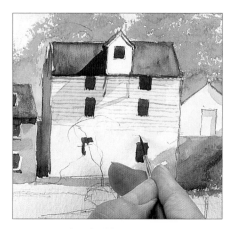

14. Use the half-rigger and a bluer mix of ultramarine and burnt umber to paint the weatherboarding on the mill.

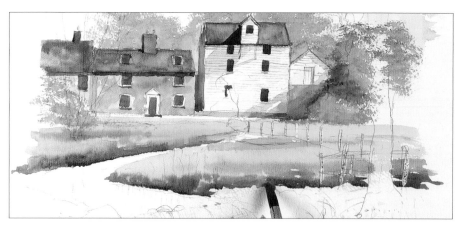

15. Make a light mix of raw sienna and sunlit green and paint the far stream bank with the large detail brush. Add a darker mix of country olive and burnt umber wet in wet as you come forwards. Paint the same succession of mixes on the right.

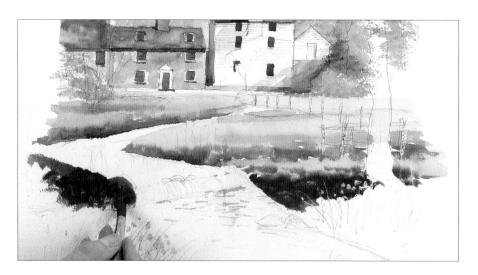

16. Add sunlit green as you come forwards, then midnight green and burnt umber at the base of the tree, up to the water's edge and on the other side of the stream.

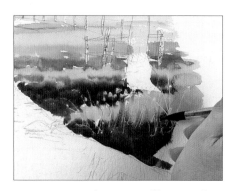

17. Paint cadmium yellow under the tree, and then take the large detail brush and flick the dark green mix up into it, wet in wet.

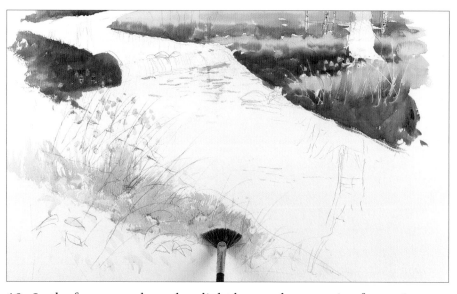

18. In the foreground, apply a light base colour, a mix of raw sienna and sunlit green, with the fan gogh brush.

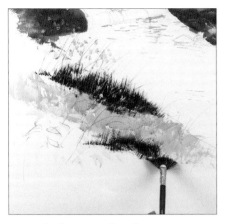

19. Flick up midnight green wet in wet into the lighter paint.

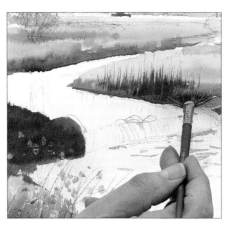

20. When the middle ground is dry, flick up grasses in midnight green, wet on dry.

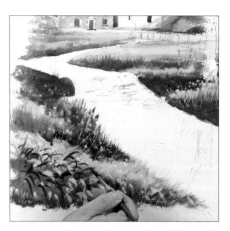

21. Use the medium detail brush to paint grasses in midnight green among the masking fluid in the left-hand foreground.

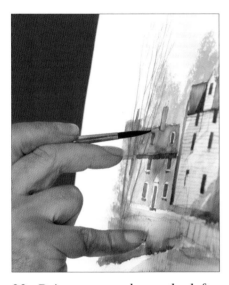

22. Paint tree trunks on the left with country olive and burnt umber. You can keep your hand still by supporting it with one finger against the easel as shown.

23. Paint in the middle tree in front of the mill in the same way.

24. Use the fan stippler and a mix of greens to paint the foliage on all the trees.

25. Take the large detail brush and a light mix of burnt umber and country olive and paint in the large tree trunk. Then use a darker mix to paint the shaded side.

26. Paint the branches using the large detail brush.

27. Then use the golden leaf brush to stipple foliage in sunlit green.

28. Stipple country olive on top when the lighter green is dry.

29. Paint the distant part of the stream using the 19mm (¾in) flat brush and ultramarine.

30. Paint a wash of ultramarine and burnt umber in the foreground, then add ripples with a darker, bluer mix of the same colours.

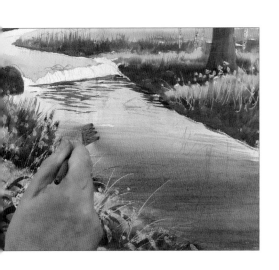

31. Paint ultramarine wet in wet over the browner mix in the foreground.

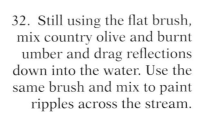

32. Still using the flat brush, mix country olive and burnt umber and drag reflections down into the water. Use the same brush and mix to paint ripples across the stream.

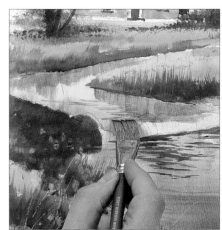

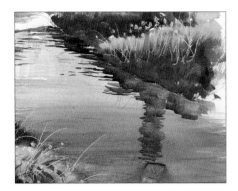

33. Still using the flat brush, paint country olive, burnt umber and ultramarine for the darks reflected from the right-hand stream bank.

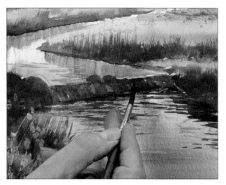

34. Use the medium detail brush and a dark mix of country olive, burnt umber and ultramarine to paint the waterfall. Allow it to dry.

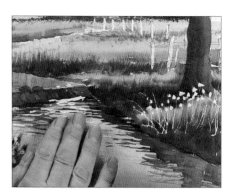

35. Remove the masking fluid over the whole area of the painting.

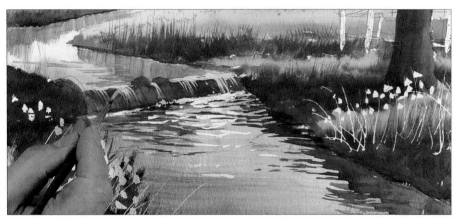

36. Mix white gouache with a touch of cobalt blue and add detail to the waterfall with a few downward strokes.

37. Paint the window bars with the half-rigger and white gouache.

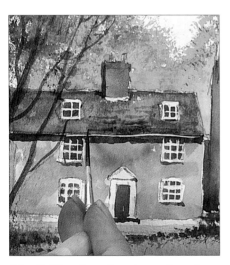

38. Still using the rigger brush, paint details on the roofs using country olive with a touch of burnt umber.

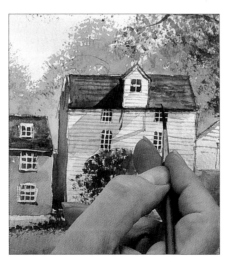

39. Paint details on the mill roof with the half-rigger and ultramarine and burnt umber.

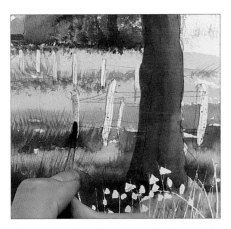

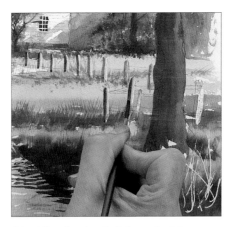

40. Paint the fence uprights with a light wash of raw sienna and country olive. Leave to dry.

41. Shade the left-hand sides with country olive and burnt umber, wet on dry.

42. Paint the horizontal bars of the fence with the same mix.

43. Apply a wash of sunlit green over the broadleaf plants in the foreground, using the large detail brush.

44. Paint raw sienna over the foreground grasses.

45. Use the medium detail brush to paint burnt sienna with a touch of cobalt blue on the building on the far right.

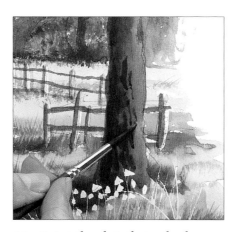

46. Paint the details in the large tree trunk using a dark mix of ultramarine, burnt umber and midnight green.

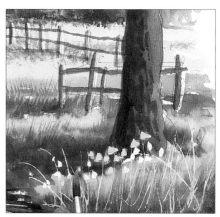

47. Paint the flowers under the tree with the medium detail brush and a wash of cadmium yellow.

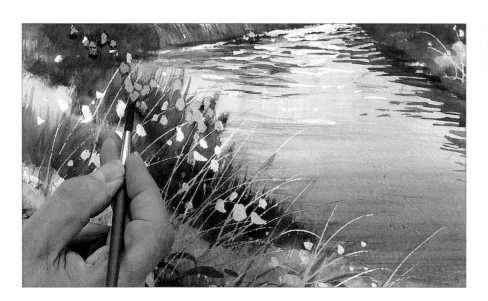

48. Paint the flowers on the left-hand bank with a thin wash of alizarin crimson.

49. Drop in a stronger mix of alizarin crimson wet in wet.

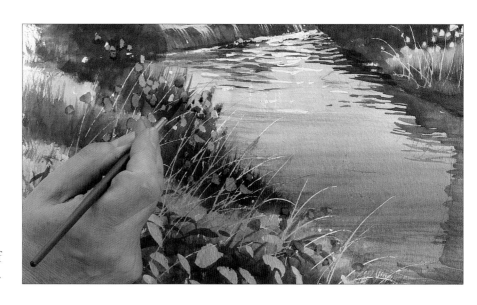

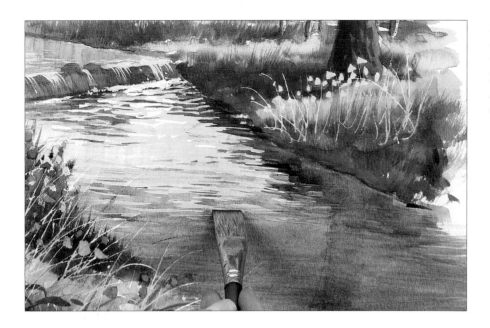

50. Make a mix of ultramarine and midnight green and wash it over the water in the foreground using the flat brush. Add ripples with a darker mix of the same colours.

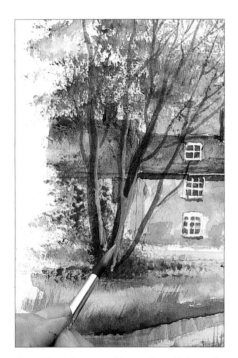

51. Use the medium detail brush to paint raw sienna mixed with white gouache on to the sunlit side of the tree on the left.

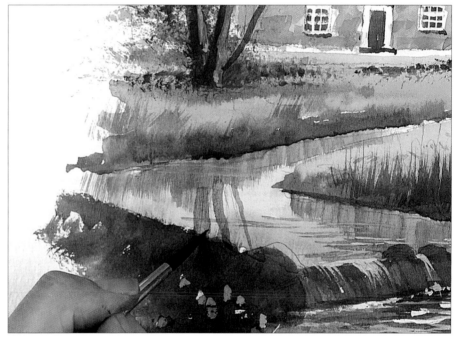

52. Add a reflection of this tree using burnt umber and country olive.

Opposite
The finished painting
370 x 510mm (14½ x 20in)
Although this painting is predominantly green, this is balanced by the warm colours of the mill house and the splash of colour in the foreground flowers.

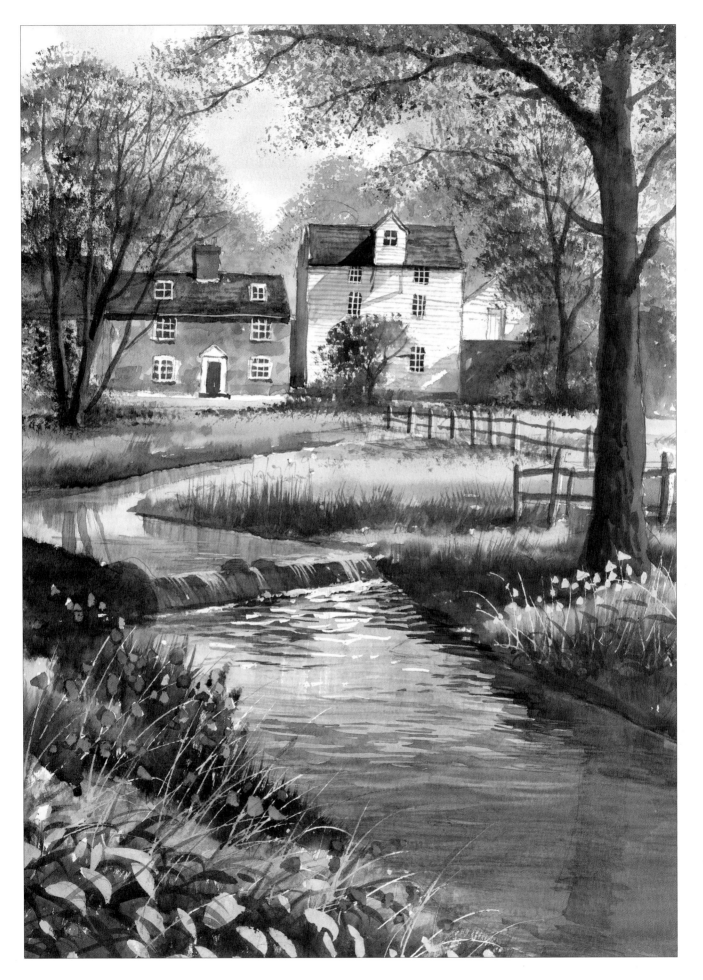

149

Sea & Sky in Watercolour

I am not the type of artist that usually has his head in the clouds, but some days you just can't help yourself – I catch myself looking skywards and thinking, 'How would I paint that?'

Skies play an essential part in any landscape, and somehow combining an atmospheric sky with the drama of the sea can create the greatest free show on earth.

I don't know why I am attracted to painting seascapes, as I do live a fair way inland. However, this liking for the sea stems back to my childhood, when my ambition at one stage was to join the Navy. This was

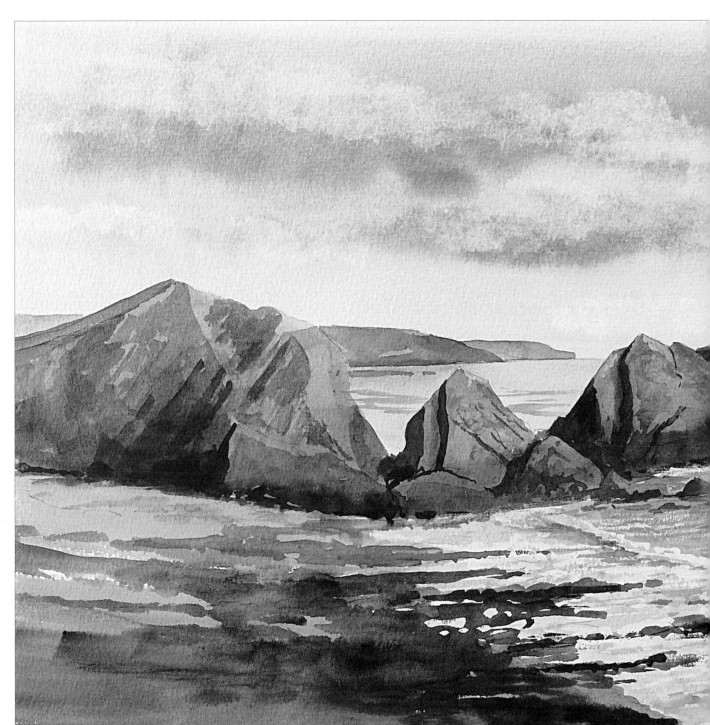

dashed after living in Germany for a couple of years and travelling on cross-channel ferries, which always seemed to result in terrible seasickness. To this day I still have the same problem with sea-going craft: for example on a recent holiday in the Mediterranean I was physically ill on a pedalo.

In this section the intention is to show you some basic painting skills to achieve certain elements of a seascape or skyscape. Hopefully by learning to master the basic elements of these subjects, you can then develop dramatic paintings of your own – creating restless, moody, powerful seas with crashing breakers and jagged rocks!

Terry Harrison

Rocky Headland
72 x 33cm (28½ x 13in)
This dramatic shoreline lends itself to a panoramic composition – long fingers of sharp teeth-like rocks stretching out into the incoming tide.

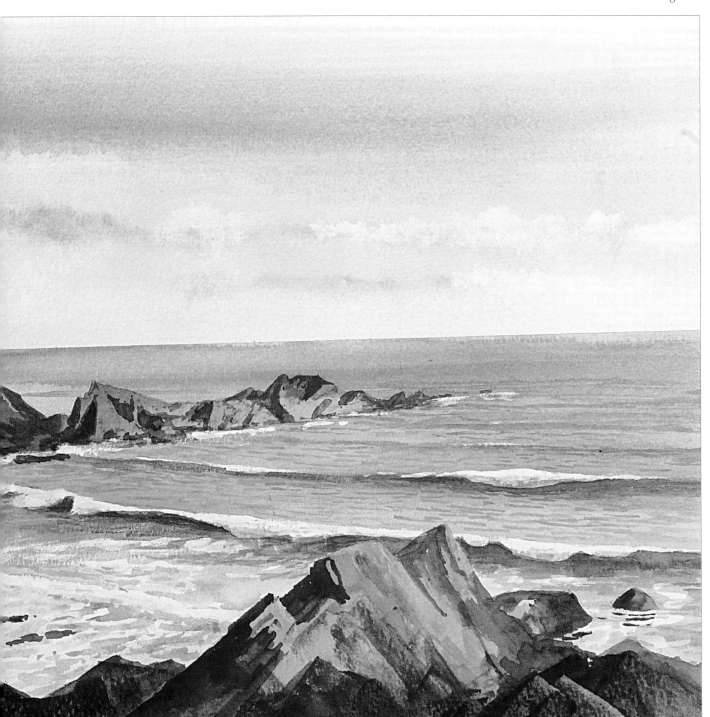

My palette

I limit myself to a fairly small range of colours, and with the range shown here I find that I can paint virtually any scene I choose. This selection includes a warm and a cool blue, three ready-made greens, one yellow, a good range of earth colours, a good strong red, permanent rose (a useful pink that is difficult to mix from other colours), alizarin crimson which is ideal for creating purple shades, and shadow which is a ready-made transparent mix that is ideal for painting shadows.

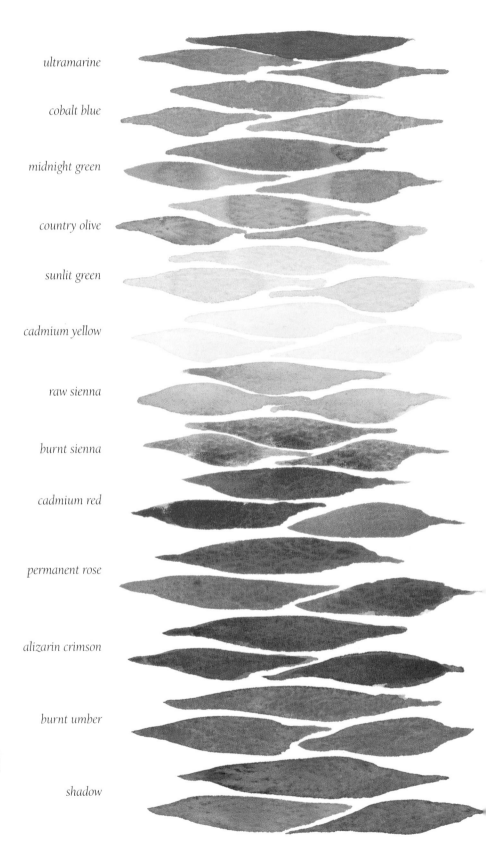

ultramarine

cobalt blue

midnight green

country olive

sunlit green

cadmium yellow

raw sienna

burnt sienna

cadmium red

permanent rose

alizarin crimson

burnt umber

shadow

Useful mixes

The following colour mixes are useful for painting seas and skies
in various different conditions.

*Ultramarine and burnt umber make a good warm grey which is
excellent for painting storm clouds.*

*Cadmium yellow and permanent rose make a good colour for a sky
at sunset.*

Ultramarine and midnight green make a good, deep sea colour.

*Cobalt blue and sunlit green mixed together make a brighter sea
colour for sunny conditions.*

Techniques

Brush techniques

You can create wonderfully realistic effects using just the range of brushes shown here.

Large detail

This brush is useful for painting rippled water. Varying the amount of pressure you apply can create different effects.

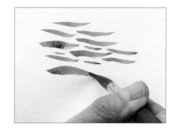

Flat brush

The 19mm (¾in) flat brush is useful for painting choppy water. Use a side to side motion with the tip of the brush.

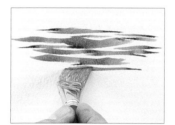

Medium detail

This is ideal for painting smaller details such as ripples on water.

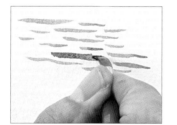

Small detail

This brush can be used to paint really small ripples on distant water.

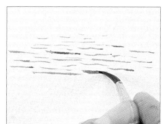

Half-rigger

The half-rigger has a really fine point but holds a lot of paint. The hair is long, though not as long as a rigger. As its name suggests, this brush is excellent for painting the rigging on boats. You can use a ruler to steady your hand to achieve a straight, even line by running the ferrule (the metal part) along the edge of the ruler.

Golden leaf

This is a large wash brush which holds lots of paint and is ideal for painting washes and wet-in-wet skies. Use it to drop clouds into a wet wash.

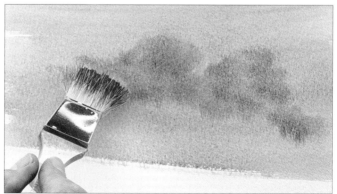

Foliage brush

This smaller version of the golden leaf brush is good for painting foam bursts or adding texture to waves. You can also use it to paint shingle.

Fan stippler

This fan-shaped version of the foliage brush is ideal for painting sea spray.

Wizard

Twenty per cent of the hair in this brush is longer than the rest, which produces some interesting effects. To create reflections, paint a wash on first, then drag the brush down.

Fan gogh

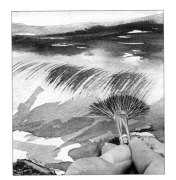

This thick fan brush is excellent for painting streaks in waves, and also for sand and grasses.

Grand Emperor

This large mop brush holds lots of paint and is good for washes and skies. It can be used for dropping a dark, stormy cloud into a wet sky wash.

Emperor extra large

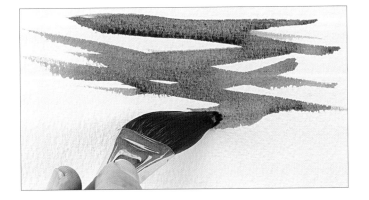

This large brush is useful for washes, but it also has a flat edge that is good for painting choppy water with a side-to-side motion.

Wet into wet

This involves putting wet paint on to a wet surface. The issue with this technique is how wet to make the initial wash. If there are puddles of water on the surface, it is too wet; the paper should just glisten. When adding paint to a wet surface, try not to overload the brush, or your paint will run away into the initial wash.

Tip

If your brush is overloaded, remove the excess moisture by dabbing it on to some kitchen paper.

Sky

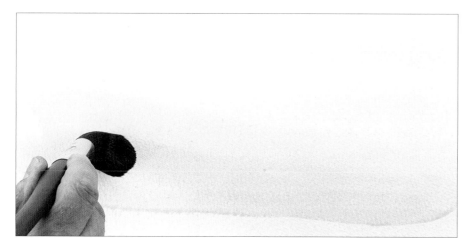

1. Wet the sky area with clean water using the Grand Emperor brush. Paint a thin wash of raw sienna on to the area near the horizon.

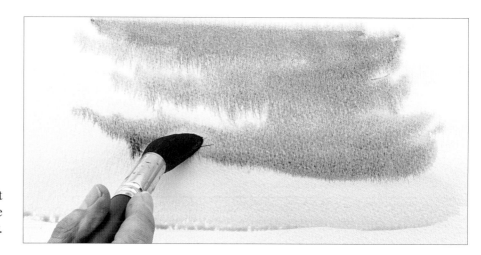

2. Mix ultramarine and burnt umber and streak it across the top of the sky.

Sea

Use the Emperor extra large brush to apply a wash of cobalt blue. Then add streaks wet into wet using a stronger mix of ultramarine and midnight green.

Wet on dry

I know this is going to sound obvious, but this technique involves putting wet paint on to a dry surface. Skies are often painted wet into wet, but using a wet on dry technique gives you the option of adding detail in a more controlled way once your sky has dried. When painting seas, you can use this technique to add details such as ripples in sharp contrast with the background colour. If you did this wet into wet, the detail would dissolve into the background wash.

Sky

1. Use the Grand Emperor brush to apply a wash of raw sienna and allow it to dry.

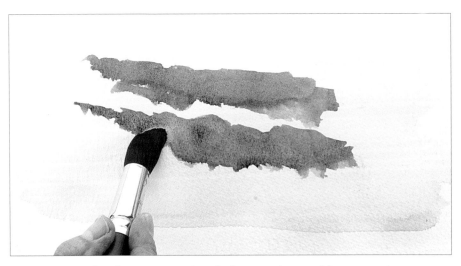

2. Paint on clouds using a mix of ultramarine and burnt umber. Painting wet on dry in this way creates harder edges.

Sea

1. Paint on a wash using the Grand Emperor brush and allow it to dry.

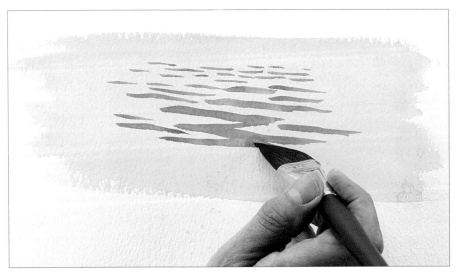

2. Paint on ripples using the tip of the Emperor extra large brush, moving it from side to side as shown.

Lifting out

This is a technique to remove surface paint using a sponge or kitchen paper while the paint is still wet.

Spray

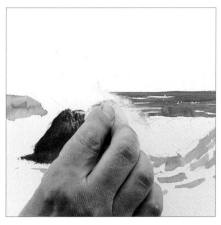

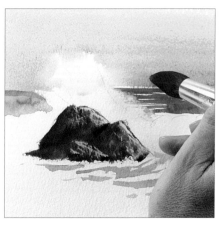

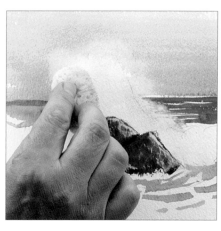

1. Use a slightly damp sponge to lift out the background sea painting to suggest spray from a wave hitting the rock.

2. Use the Grand Emperor brush to wash in the sky, leaving a gap for the spray where it will show against the sky.

3. While the sky wash is wet, use the sponge again to lift out the spray area. Allow the painting to dry.

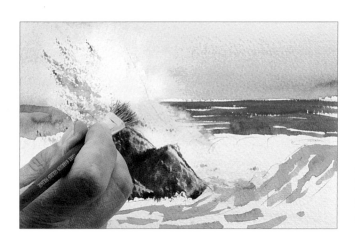

4. Use the foliage brush and a blue mix to paint in the texture of the spray.

Ripples

2. While the wash is wet, take the 19mm (¾in) flat brush, wet it and squeeze out the water. Lift out ripples with a side-to-side motion.

1. Paint on a wash for the water with the Grand Emperor brush.

Using masking fluid

Foam and ripples

1. Use an old brush and a flicking motion to mask out the foam, the ripples and the crests of distant waves.

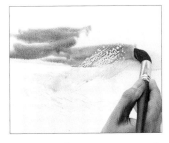

2. Paint clean water on to the sky area using the Grand Emperor brush, then apply a wash of raw sienna.

3. Mix ultramarine and burnt umber and paint in dark clouds wet into wet, going over the masking fluid.

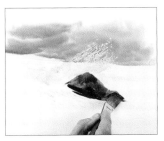

4. Use the 19mm (¾in) flat brush and a mix of ultramarine and burnt umber to paint the rock.

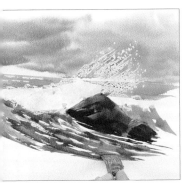

5. Paint the sea in the foreground using the 19mm (¾in) flat brush and a side-to-side motion as shown.

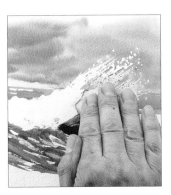

6. Remove all the masking fluid with clean, dry fingers.

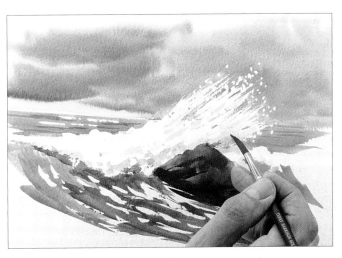

7. Use the medium detail brush and a thin mix of cobalt blue and midnight green to add detail to the foam.

Gulls

1. Use an old brush and masking fluid to mask out the gulls.

2. Use the Grand Emperor brush and ultramarine and burnt umber to paint the sky.

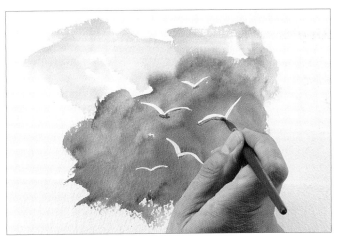

3. Rub off the masking fluid and add shading to the gulls using the medium detail brush.

Painting seas

When painting seas, the choice of brush can be important. A large mop brush can be used for large, flat areas, but a flat brush is useful for painting ripples and detail.

Calm water

1. Paint masking fluid on to the wave crests and the surf. Paint on clear water and then raw sienna for the beach using a 19mm (¾in) flat brush.

2. Paint the sea with ultramarine near the horizon, mixed with midnight green as you come forwards.

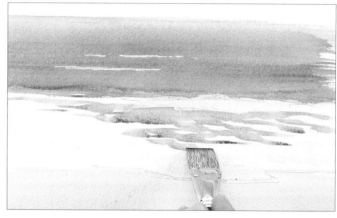

3. Use the tip of the flat brush and a side-to-side motion to paint ripples in the surf.

4. Rub off the masking fluid and use the small detail brush and ultramarine to paint distant ripples.

5. Add midnight green to the mix and paint the darker colour under the crests of the small waves. Add ripples.

6. Use cobalt blue to paint shading under the crest of the foreground wave.

7. Use the ultramarine and midnight green mix to paint darker ripples in the foreground foam.

8. Still using the small detail brush, paint a broken line of the darker blue mix under the surf on the wet sand.

Choppy water

1. Paint ripples with the 19mm (¾in) flat brush and ultramarine.

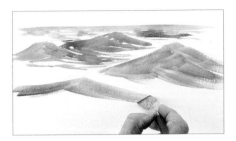

2. Using ultramarine and a touch of midnight green, paint in the peaks and troughs.

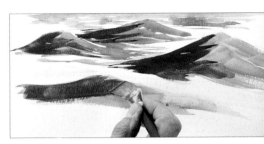

3. Add more midnight green to the mix and paint in the shaded sides of the waves.

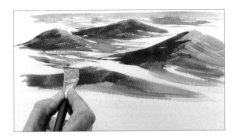

4. Use a pale wash of ultramarine and midnight green to paint ripples in the troughs between waves. This suggests a reflection of the sky.

Breaking waves

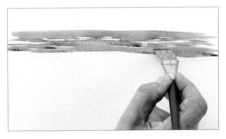

1. Take the 19mm (¾in) flat brush and paint ripples up to the top of the wave.

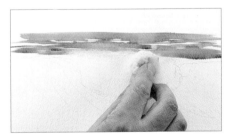

2. While the paint is wet, soften the top of the wave area using a damp sponge.

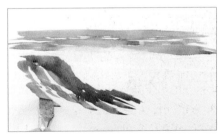

3. Paint the dark part of the wave, leaving some white streaks to imply foam.

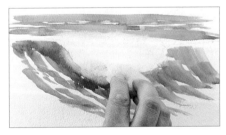

4. While the paint is wet, soften the edge of the wave using the damp sponge. Make sure the sponge is clean each time you use it.

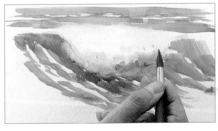

5. Using the large detail brush and a thin wash of cobalt blue, paint shading in the foam at the edge of the wave.

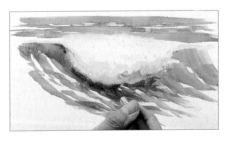

6. Allow the paint to dry. Mix ultramarine and midnight green to make a stronger blue and shade under the foam.

Crashing waves

1. Use the foliage brush to paint a thick mix of raw sienna on to the rocks.

2. Paint a strong mix of ultramarine and burnt umber on top.

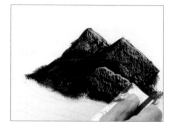

3. Use an old plastic card to scrape out rock shapes. This technique works best with rough surfaced paper. Allow to dry.

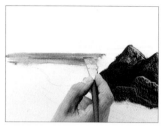

4. Use the 19mm (¾in) flat brush to paint clean water on the horizon area. Then paint on a mix of ultramarine and midnight green.

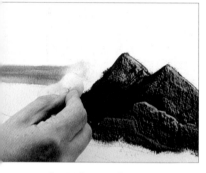

5. Lift out the area around the rock with a damp sponge to suggest spray. Allow to dry.

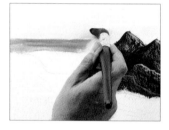

6. Use the Grand Emperor and raw sienna to paint the sky.

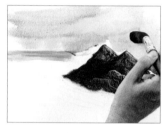

7. Paint dark clouds using a mix of burnt umber and ultramarine.

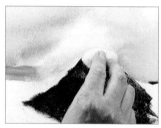

8. While the paint is wet, use the damp, clean sponge to lift out the spray around the rock.

9. Use the 19mm (¾in) flat brush and a mix of ultramarine and midnight green to paint ripples at the base of the rocks, leaving white paper to suggest foam.

10. Use the fan gogh brush and the same mix to pull streaks over from the back of the wave forwards. Allow the paint to dry.

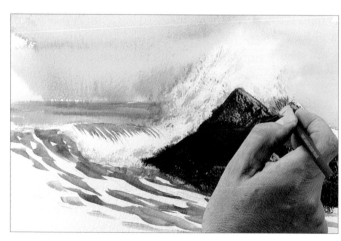

11. Take the foliage brush and use cobalt blue to add detail to the spray around the rock.

A shoreline

1. Mask the crests of the waves. Wet the sky area with clean water and use the Grand Emperor brush to paint raw sienna at the bottom of the sky.

2. Mix ultramarine and burnt umber and paint on dark clouds, wet into wet.

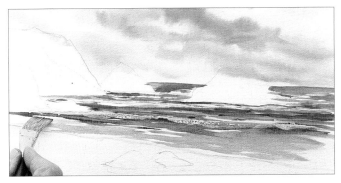

3. Use the 19mm (¾in) flat brush and ultramarine with midnight green to paint distant rippled water. Use a thinner wash of cobalt blue to paint rippled water in the foreground.

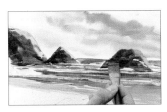

4. Paint the sunlit sides of the rocks with raw sienna. Then paint on ultramarine and burnt umber for the darker parts of the rocks.

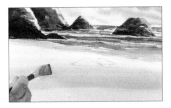

5. Wet the beach area with clean water and paint a wash of raw sienna on to the lower part of the beach.

6. Pick up the ultramarine and burnt umber mix with the flat brush and drag the colour down vertically to create reflections.

7. Clean the flat brush, squeeze water out of it and use it to lift out ripples in the water on the beach.

8. Use raw sienna, then burnt umber and ultramarine and the plastic card technique (see page 162) to paint rocks. Use the 19mm (¾in) flat brush and the dark rock mix to paint reflections.

9. Use the medium detail brush and a mix of ultramarine and midnight green to paint shadow under the crests of the waves, and a broken line under the edge of the surf.

10. Use cobalt blue to apply light texture to the foam.

The finished painting.

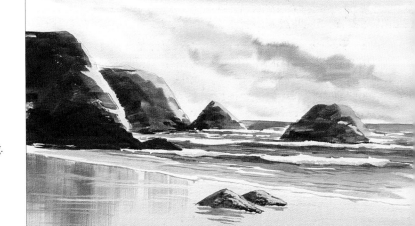

Bands of colour

1. Paint the sky and background and then paint rocks using the plastic card technique shown on page 162.

2. Use the 19mm (¾in) flat brush to paint a wash of raw sienna for the distant beach. Water down the mix towards the sea. Repeat for the foreground beach.

3. When the beach area is dry, wet the sea area with clean water and paint a wash of cobalt green deep in the background.

4. Paint with cobalt blue further forward, wet into wet.

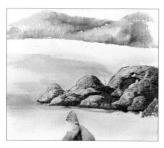

5. Paint a wash of cobalt blue and cobalt green over the foreground.

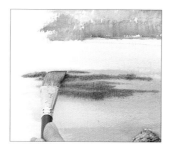

6. While the foreground is wet, paint ripples with a mid of ultramarine and midnight green.

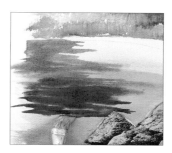

7. Add cobalt blue and cobalt green wet into wet with the flat part of the brush.

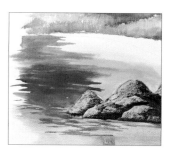

8. Use the ultramarine and midnight green mix to paint ripples in the foreground. Allow the painting to dry.

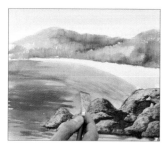

9. Wet the sea area and drag cobalt blue and cobalt green across it, following the direction of the shoreline. Allow to dry.

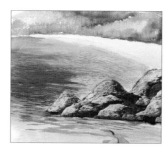

10. Use the small detail brush to add ripples with a mix of ultramarine and midnight green.

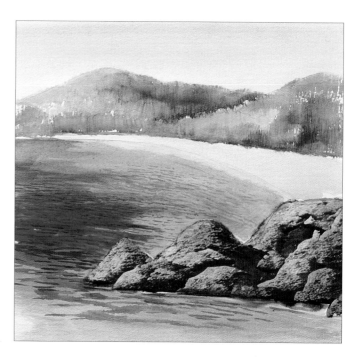

The finished painting.

The horizon

The most important thing about the sea horizon is that it must always be straight and never sloping. When applying the masking tape, put a pencil mark at one end of the horizon, then measure the same distance from the top of the paper at the other end and put a similar mark. Then you just need to join the dots!

1. Use the Grand Emperor and clean water to wet the sky area, then drop in a thin mix of ultramarine. Leave to dry.

2. Apply masking tape to the bottom of the dried sky area, with the lower edge where you want the horizon to be.

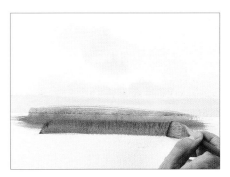

3. Use the 19mm (¾in) flat brush to paint on a mix of ultramarine and midnight green for the sea. Go over the lower edge only of the masking tape. Leave to dry.

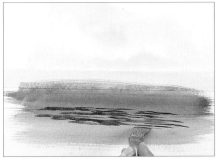

4. Make a stronger, darker mix of the same colours and paint from side to side with the flat brush to create ripples.

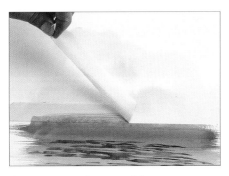

5. Remove the masking tape to reveal the straight horizon. Always pull away from the horizon line.

Tip
You can buy low-tack masking tape, which reduces the risk of tearing the surface of the paper.

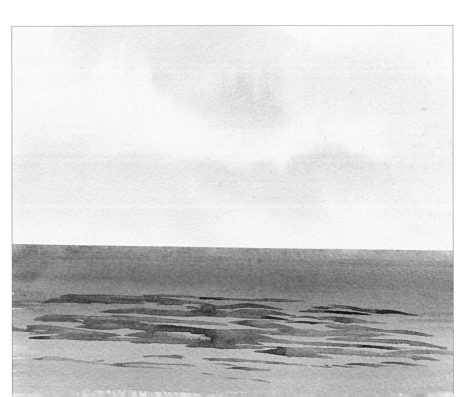

The finished horizon.

Painting skies

Many artists before me have said that to improve your skies you should paint a sky a day – I heartily concur but let's face it – who's going to do that? However, the sky will almost always play a role in any landscape or seascape – this can be a large dramatic role, or a small supporting part.

A clear sky

Most artists look for clouds or something to inspire you to get your brushes out – but sometimes the sky is just clear, so it is worth knowing how to paint a clear blue sky.

1. Wet the sky area first with clean water and the golden leaf brush. Load the brush evenly with a wash of ultramarine. Start at the top and paint from side to side.

2. As you continue down the paper, the sky gets lighter as there is less colour on the brush. The wet into wet technique disperses any streaks.

A cloudy sky

This gives you something more to get your teeth into, but sometimes if the sky is too interesting, it can detract from the rest of your picture. This is a simple cloudy sky that would look good in most paintings.

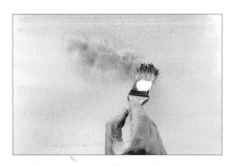

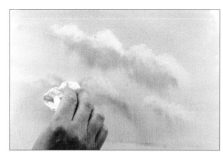

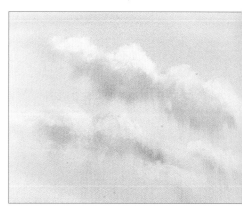

1. Wet the area first with clean water. Paint on a wash of ultramarine with the golden leaf brush. Mix ultramarine and burnt umber to make grey, and paint clouds into the wet background.

2. Use a pad of kitchen paper to lift the colour out of the tops of the clouds.

The effects will continue to develop as the sky dries.

A stormy sky

This can create atmosphere in a scene, which could be essential to the painting – for example when creating a storm at sea, or a weather front moving across the moorlands.

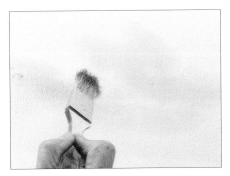

1. Paint on clean water first. Then paint on patches of raw sienna with the golden leaf brush.

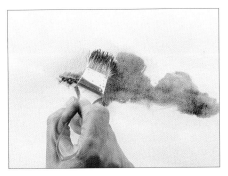

2. Paint dark clouds wet into wet using a mix of ultramarine and burnt umber.

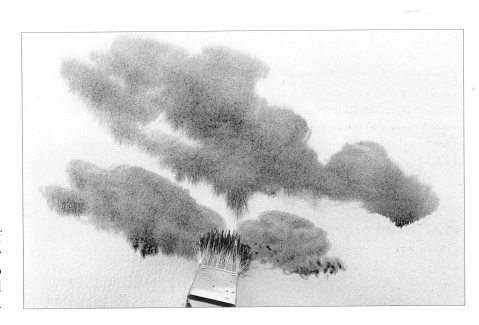

3. Use a darker mix of ultramarine, burnt umber and a touch of crimson to paint darker clouds, still working wet into wet.

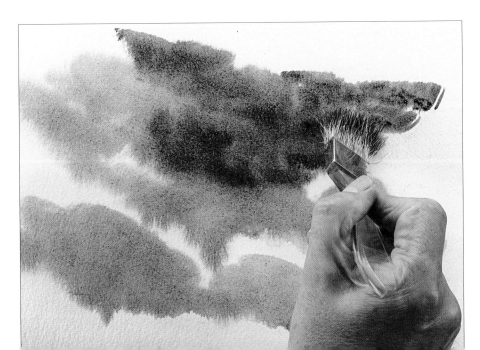

4. Add more dark clouds to finish the sky.

167

Another cloudy sky

This version of a cloudy sky also uses wet into wet and lifting out techniques, but this time the shapes of the clouds are suggested in the initial wash. This is a more controlled method of painting clouds, giving greater definition to your sky.

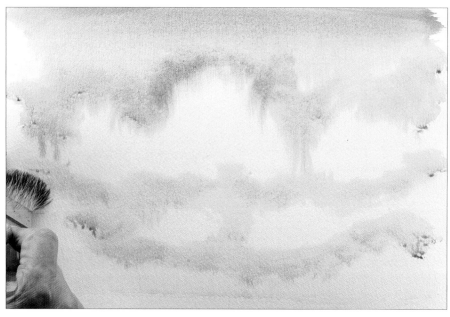

1. Wet the sky area with clean water. Take the golden leaf brush and a wash of ultramarine, and paint a sky, leaving white spaces for clouds.

2. Tidy up the edges of the clouds by lifting out colour using kitchen paper. Allow the painting to dry.

3. Wet the whole sky area again with clean water. Pick up a mix of ultramarine and burnt umber and touch in shadows at the bottom of the clouds.

4. Continue adding shadows until you are happy with the effect.

A sunset

Sunsets are very popular and because no two are ever the same. This provides endless scope for producing dramatic, atmospheric skies.

1. Wet the sky area with clean water. Use the golden leaf brush to apply cadmium yellow across the middle of the sky.

2. Paint a band of cadmium red wet into wet, under the yellow.

3. Above the band of yellow, paint alizarin crimson wet into wet, fading it into the yellow.

4. Still working wet into wet, paint cobalt blue at the top of the sky, running down into the alizarin crimson. In this way you avoid accidentally creating green by mixing the blue with the yellow.

5. Working quickly, wet into wet, drop in shadow colour to create dark clouds.

6. Create a v-shaped cloud formation, making sure that there are smaller clouds lower down the sky, as this helps to create the illusion of distance.

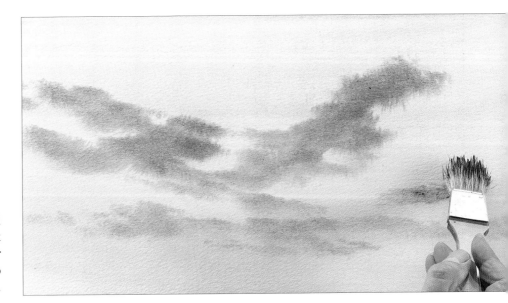

Painting reflections

The technique I am going to show you in this step-by-step demonstration is a fairly simple process, but produces more than a complete mirror image. It is easy to achieve, but very effective.

1. Paint the boat and the sky first. Paint the rigging using a half-rigger brush and a ruler as shown to achieve thin, straight lines.

2. Take the 19mm (¾in) flat brush and paint the water with a light wash of cobalt blue. Paint ripples and leave white paper to suggest reflections of the white boat.

3. Drag down the colour at the bottom of the water area.

4. Paint the reflection of the dark side of the boat using a mix of ultramarine and burnt umber and the medium detail brush. The reflection should be quite solid close to the boat.

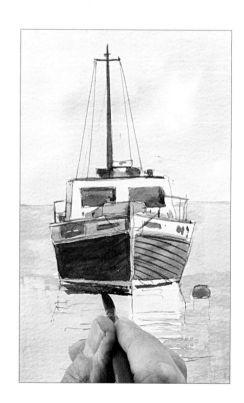

170

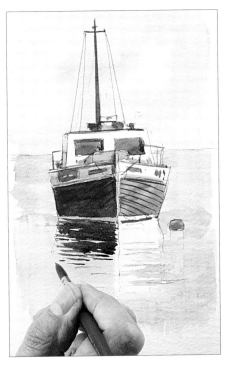

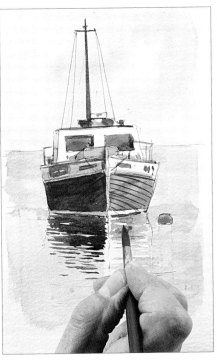

5. Further down, paint ripples as the reflection becomes less solid.

6. Use a lighter mix of cobalt blue to paint the reflection of the right side of the boat in the same way.

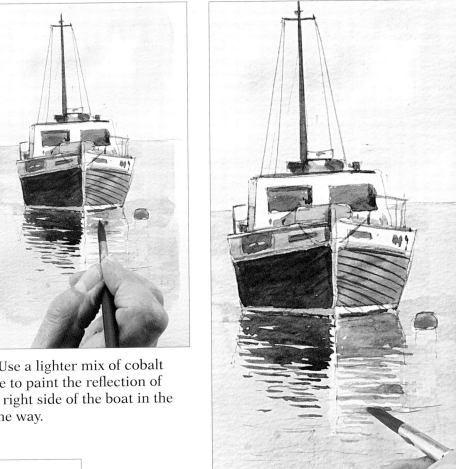

7. Paint looser, light blue ripples further down the water.

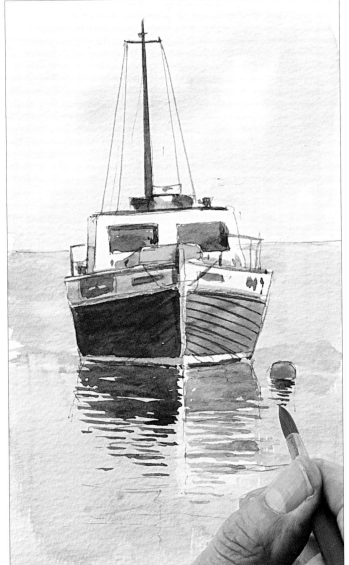

8. Finally, paint the reflection of the buoy using cadmium red.

Other elements

When painting a seascape, there is much more to the painting than just the water. Here I show you a small selection of useful techniques that will help you achieve a realistic seascape.

Rocks

This is a technique that I have recently developed. It uses a plastic card such as a credit card. The colours used in this example are quite warm, but if you want to achieve a cooler effect, use colours such as blue and grey.

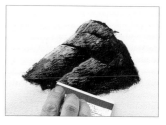

1. Paint the rock shape using a thick mix of raw sienna and the stiff-haired foliage brush.

2. Paint a dry mix of burnt umber on top.

3. Mix ultramarine and burnt umber and paint over the whole rock.

4. Use a plastic card to scrape the surface of the rock, leaving gaps as shown to suggest crevices.

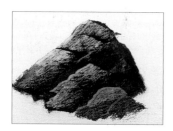

The finished rock.

> **Tip**
> *Use hardly any water with the paint for this technique. It will not work with wet paint mixes.*

Shingle

To achieve successful shingle, it is essential to create a textured effect. This is a simple technique, just using the foliage brush.

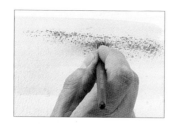

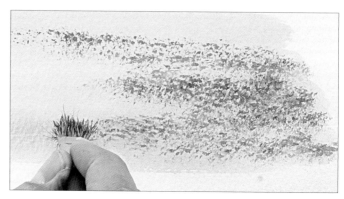

1. Paint on a thin wash of raw sienna using the foliage brush and allow it to dry.

2. Use the foliage brush to stipple on burnt umber to suggest the texture of the shingle.

3. Mix burnt umber and ultramarine and stipple this darker mix on top.

Sand dunes

The introduction of sand dunes to a painting can create interest in the foreground, which will lead you into the scene.

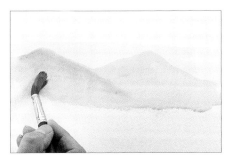

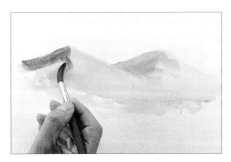

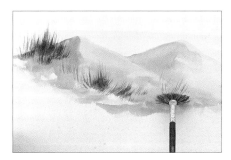

1. Paint on a light wash of raw sienna with the large detail brush, then paint in the dunes with a stronger mix.

2. Paint the shaded sides of the dunes with shadow colour, wet into wet. Allow to dry.

3. Use the fan gogh brush and midnight green to flick up grasses in the dunes.

Cliffs

Again, this uses the plastic card technique to create the different faces of the cliff.

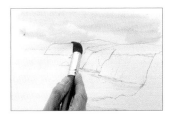

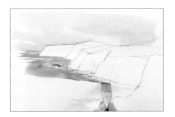

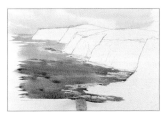

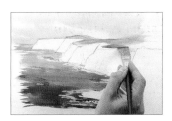

1. Mask the surf at the water's edge using masking fluid. Paint clean water in the sky area, then apply an ultramarine wash.

2. Use the 19mm (¾in) flat brush and ultramarine with midnight green to paint the sea with a side to side motion.

3. Add more midnight green towards the foreground.

4. Paint a thin mix of country olive and ultramarine on the headland, making the mix stronger in the foreground.

5. Paint thick raw sienna on the cliffs, then an ultramarine and burnt umber mix. Scrape off with a plastic card to create rocky texture.

6. Remove the masking fluid from the surf at the water's edge using a clean finger.

7. Add ripples using the medium detail brush and a strong mix of ultramarine and midnight green. The ripples should be bolder in the foreground to create perspective.

8. Add a light touch of cobalt blue in the surf to suggest shading.

A lighthouse

This step-by-step demonstration illustrates how versatile masking fluid can be. With little effort, you can create a dramatic transformation in your painting.

1. Use masking fluid to mask the lighthouse tower and the water where it meets the rock. Paint the sky with clean water, then raw sienna with the Grand Emperor brush.

2. Mix burnt umber and ultramarine to paint clouds. Go over the masked lighthouse.

3. Use the 19mm (¾in) flat brush and a mix of ultramarine and burnt umber to paint the rock formation.

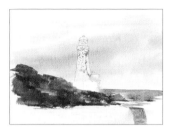

4. Paint the sea with the same brush and ultramarine and midnight green. Use a side to side motion to create ripples.

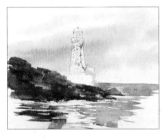

5. Use a greener mix towards the foreground. Allow to dry.

6. Remove the masking fluid by rubbing with clean fingers.

7. Take the small detail brush and a bluey mix of ultramarine and burnt umber and add details to the lighthouse.

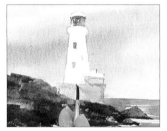

8. Shadow the right-hand side of the lighthouse base using a mix of raw sienna and cobalt blue. Then add raw sienna to the left-hand side and texture it using the shadow mix.

9. Add shadow to the right-hand side of the lighthouse using cobalt blue.

10. Add cobalt blue ripples in the water to finish the painting.

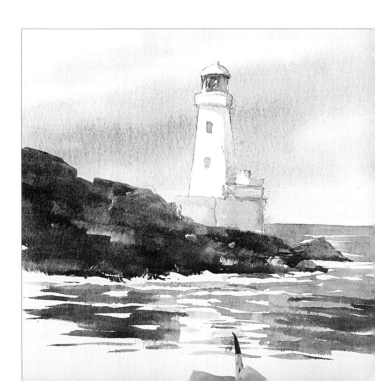

Boats

The key to painting boats successfully is to be very precise. They are not difficult, but you do need to draw what you see – not what you think you see! The example shown here relies heavily on the effect of the dark, shady sides of the boats.

1. Use the medium detail brush and raw sienna to paint the right-hand side of the boat on the right. Then add detail using a thin mix of burnt umber.

2. Paint the reflection in the same way, with raw sienna and then burnt umber.

3. Paint the dark part of the boat and its reflection using ultramarine and burnt umber.

4. Next paint the shadow inside the boat.

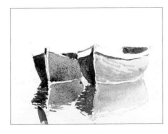

5. Paint the other boat and its reflection with burnt sienna and burnt umber, then burnt umber and ultramarine for the dark side.

6. Use the large detail brush and a very thin mix of ultramarine to paint the background sea up to the boats.

7. Paint a stronger mix coming further forwards and allow the painting to dry.

8. Use the 19mm (¾in) flat brush and midnight green with ultramarine to paint ripples.

9. Paint the pole sticking out of the water using the small detail brush with burnt umber and ultramarine.

10. Change to the half-rigger brush to paint the ropes.

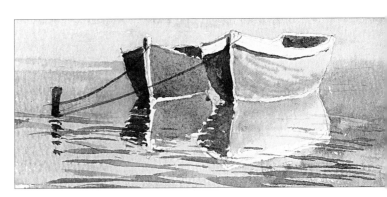

The finished boats.

Crashing Waves

This shoreline drama of crashing waves on rugged rocks is played out most days – some days with more gusto than others. This demonstration captures that moment when the wave smashes into the solid, immovable rocks on the foreshore, pushing the spray high into the sky.

1. Use masking fluid to mask the foam burst and the rivulets of water running off rocks.

2. Wet the sky area with the golden leaf brush and clean water, then apply a wash of raw sienna.

3. Paint ultramarine in sweeping, diagonal strokes across the sky, going off the top of the painting.

4. Paint clouds using ultramarine and burnt umber, sweeping across the masked foam burst.

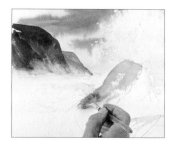

5. Use a damp sponge to remove paint around the foam burst. Allow the painting to dry.

6. Paint in the headland with the large detail brush and ultramarine with burnt umber.

7. Use a clean, damp sponge to lift out paint at the base of the headland, suggesting a sea mist.

8. Use the fan stippler and thick raw sienna to paint the sunlit sides of the rocks.

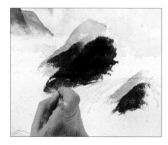

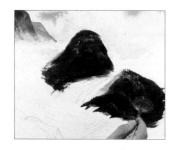

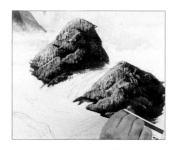

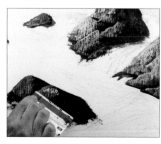

9. Paint on burnt umber on top, then ultramarine on top of that.

10. Paint a mix of ultramarine and burnt umber on top.

11. Scrape out the shape of the rocks using a plastic card.

12. Mix ultramarine and burnt umber to paint the other rocks and scrape out the texture in the same way.

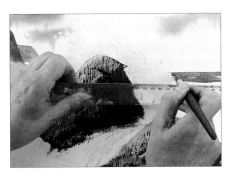

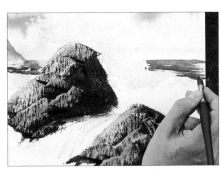

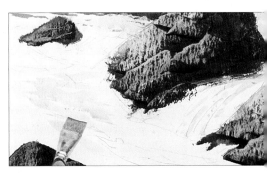

13. Take the large detail brush and paint the sea with side to side strokes to suggest ripples. Use a ruler to help you paint a straight horizon.

14. Continue painting the sea with ultramarine and midnight green as you come forwards.

15. Use the 19mm (¾in) flat brush and a thin wash of sunlit green to paint ripples.

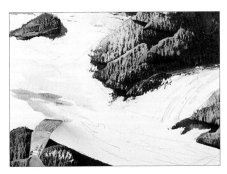

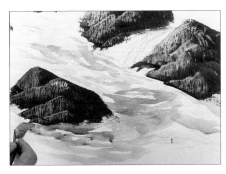

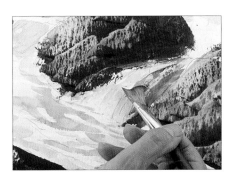

16. Add cobalt green ripples in the same way.

17. Add cobalt blue ripples towards the foreground.

18. Add cobalt blue and burnt umber over the masking fluid where water flows between the rocks.

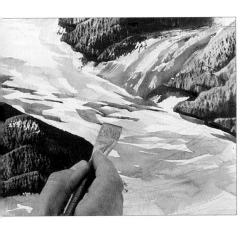

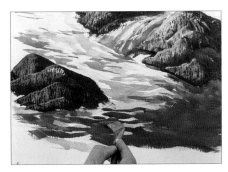

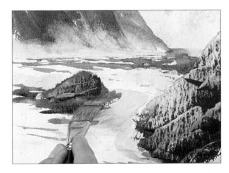

19. Paint midnight green streaks across the waves.

20. Paint larger ripples in the foreground with a mix of midnight green and ultramarine.

21. Paint round the distant rock with the same colour mix.

22. Paint very dark ripples of midnight green and ultramarine in the foreground.

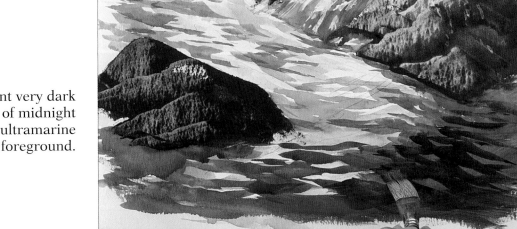

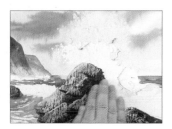

23. Rub off the masking fluid with clean fingers.

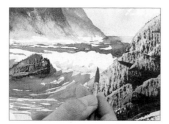

24. Use the medium detail brush and a thin mix of cobalt blue to paint shading on the foam.

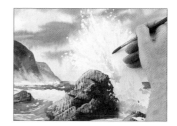

25. Using the same mix, push the brush in the direction of the foam burst.

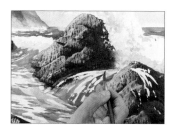

26. Shade the rivulets of water between the rocks in the same way.

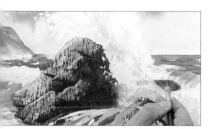

27. Use the fan gogh brush and a mix of midnight green and ultramarine to paint the crest of the wave behind the foam burst.

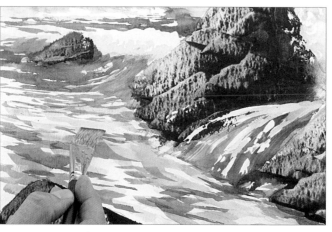

28. Take the 19mm (¾in) flat brush and paint a cadmium yellow and sunlit green mix over the water on the left of the rocks.

29. Paint over this mix wet into wet with a wash of cobalt green.

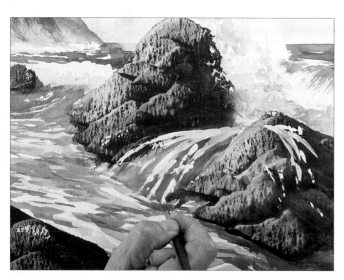

30. Pick up a little white gouache on the medium detail brush and tidy up the rivulets between the rocks.

31. Mix cobalt blue and midnight green and darken under the breaking waves.

32. Use the medium detail brush and a little white gouache to add detail to the spray in the distance.

Opposite

The finished painting. The techniques used here are very important to the success of the painting. The detail of the rocks relies heavily on the plastic card technique and the texture of the paper. The use of masking fluid helps to preserve the light of the sea spray against the dark, cloudy sky.

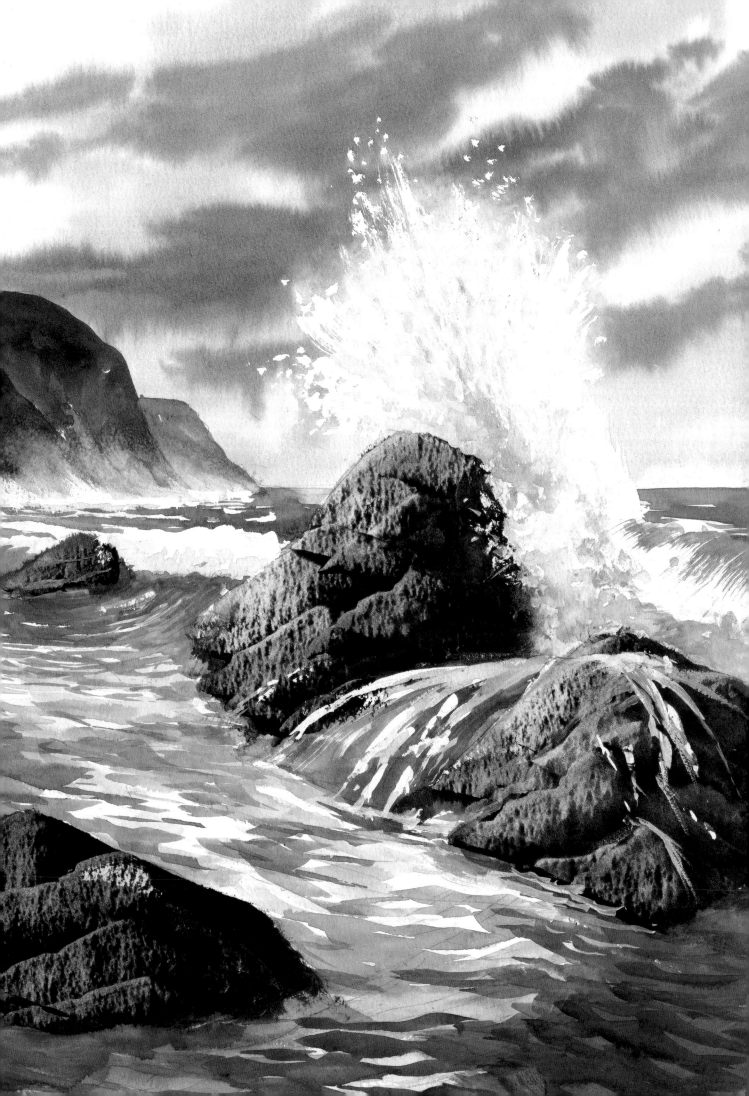

Coastal Footpath

This demonstration uses the foreground to lead you into the painting, and to add colour and interest to the picture. The path takes you round into the bay, and the sweep of the shoreline brings you out to the headland, then the clouds lead you back in the opposite direction, creating a dramatic, zigzagging composition.

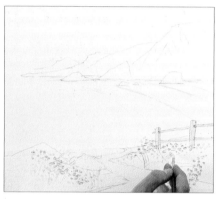

1. Use masking fluid to mask the flower heads, the fence and the edges of the water.

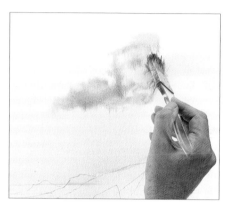

2. Wet the sky area using clean water and the golden leaf brush. Paint cloud shapes with ultramarine.

3. Mix ultramarine and burnt umber and paint dark shadows under the white of the clouds, wet into wet.

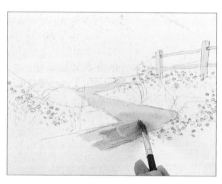

4. Take the wizard brush and paint the footpath with raw sienna. Make the colour pale towards the sea and stronger in the foreground.

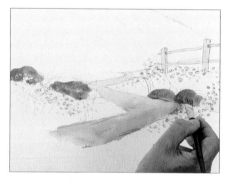

5. Paint the rocks with a thick mix of raw sienna.

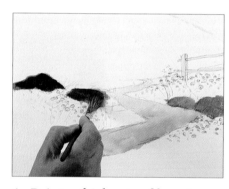

6. Paint a thick mix of burnt umber and ultramarine on top of the raw sienna.

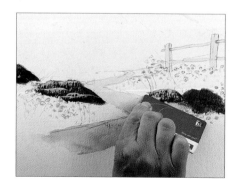

7. Scrape out the texture of the rocks using a plastic card.

8. Use the fan gogh brush and sunlit green paint to flick up grasses.

9. Add burnt sienna to the grassy area, wet into wet.

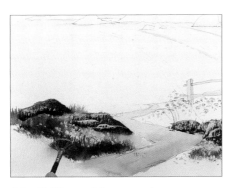

10. Still working wet into wet, paint more grasses using country olive.

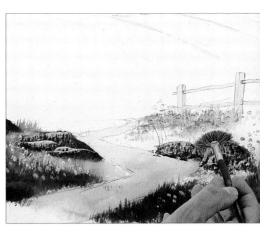

11. Paint the area nearest the fence using country olive and raw sienna. Allow to dry.

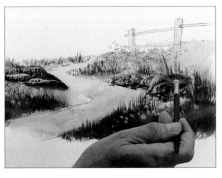

12. Flick up more grasses using the fan gogh brush, painting wet on dry on the yellowish area in front of the fence.

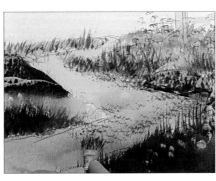

13. Using the foliage brush, stipple a mix of raw sienna and burnt umber on to the footpath.

14. Use the large detail brush and ultramarine with a touch of burnt umber to paint the distant headland.

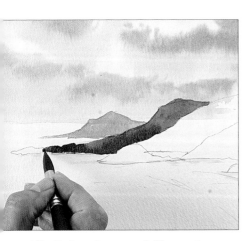

15. Paint the next hill coming forwards with a stronger mix.

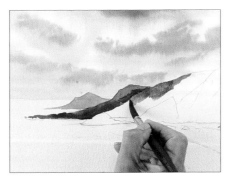

16. Mix raw sienna with ultramarine to make a warmer mix and paint the next hill coming forwards.

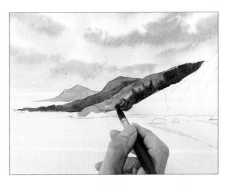

17. Drop in a darker mix of ultramarine and burnt umber wet into wet.

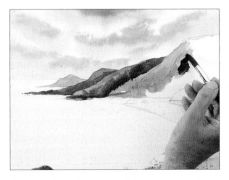

18. Paint the next hill forwards with raw sienna, then drop in ultramarine and burnt umber wet into wet to suggest crevices.

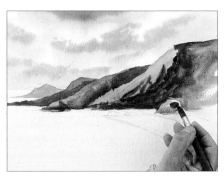

19. Paint the smaller rock on the beach in the same way.

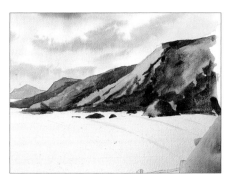

20. Paint the nearest part of the rocks with ultramarine and burnt umber and leave the painting to dry.

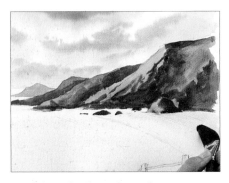

21. Wet the beach and sea area with the Emperor extra large brush and clean water. Paint on a thin wash of raw sienna for sand.

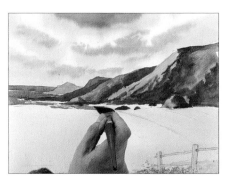

22. Use the same brush and ultramarine and midnight green to begin painting the sea.

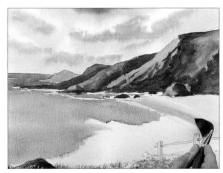

23. Add more ultramarine to the mix as you come further forwards, painting wet into wet.

24. Drop in a stronger, greener mix wet into wet.

25. Paint lines of the greener mix to suggest waves coming in to the shore.

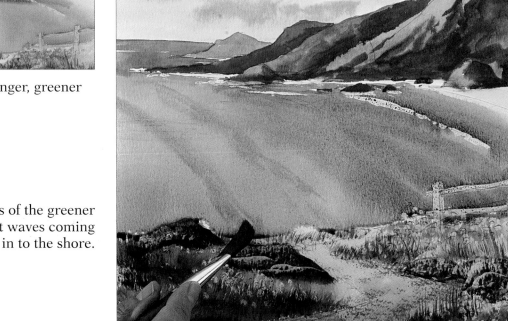

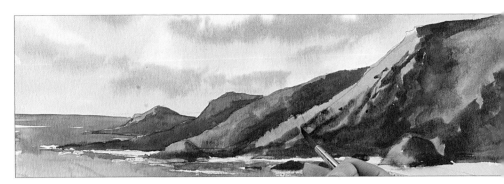

26. Take the large detail brush and darken the furthest headland with a mix of burnt umber and ultramarine. Leave it to dry.

27. Using the medium detail brush and the colour shadow, add detail and texture to the headland.

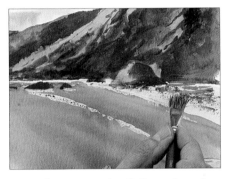

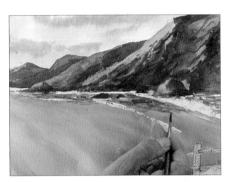

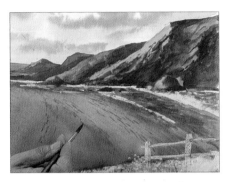

28. Change to the foliage brush and pick up shadow to paint texture on the beach.

29. Use the small detail brush and a mix of ultramarine and midnight green to paint ripples near the shore.

30. Continue painting ripples further out to sea, following the line of waves coming in to shore.

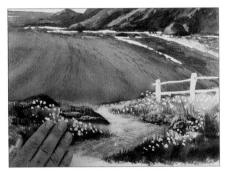

31. Rub off all the masking fluid with clean fingers.

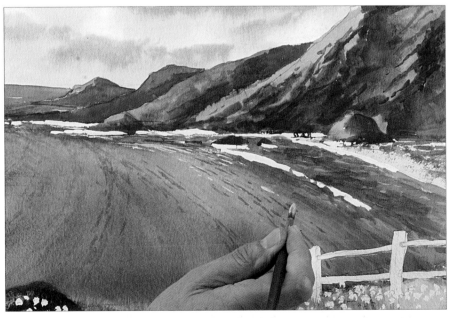

32. Mix white gouache with a touch of cobalt blue and use the medium detail brush to add highlights to ripples coming in to shore.

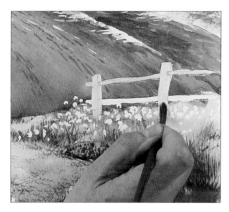 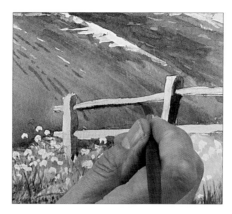

33. Paint the fence with the medium detail brush and a pale wash of raw sienna and sunlit green. Allow the painting to dry.

34. Mix country olive and burnt umber and add shading to the fence.

35. Take the small detail brush and paint a thin mix of permanent rose on the flowers.

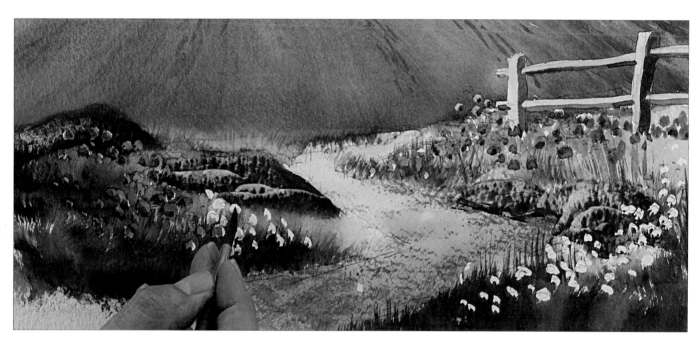

36. Paint the flowers on the left in the same way. Then paint a stronger mix of permanent rose wet into wet. Vary the strength of the pink to create variety. Leave some flowers white, and use cobalt blue to shade others.

Opposite
The finished painting. I used a half-rigger brush to do some last minute tidying, and to paint grasses in the foreground.

184

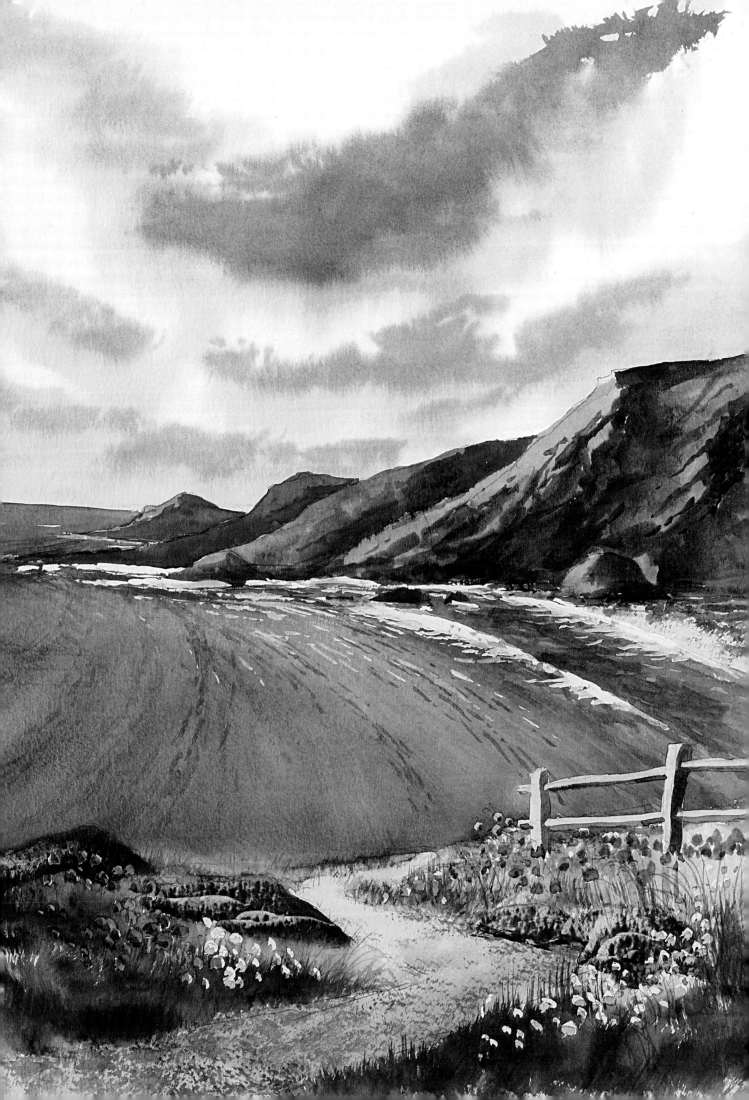

Sunset on the Sea

Watching a sunset is one of life's pleasures, and it only gets
better when it is setting over the sea. Capturing that moment in
watercolour can only enhance that feeling. This demonstration
combines a variety of techniques that you will have used earlier in
the book, for example wet into wet, lifting out, using masking fluid
and the plastic card technique.

1. Draw the scene and use
masking fluid and an old brush
to mask off the sunlit ripples in
the centre of the painting.

2. Wet the sky area with the
golden leaf brush and clean
water. Paint a wash of cadmium
yellow across the whole sky.

3. Working quickly wet into wet,
drop in a weak mix of cadmium
red from the top of the sky.

4. Then paint a wash of
cadmium red and alizarin
crimson at the bottom.

5. Lift out the area where the
sun shines through using a piece
of kitchen paper.

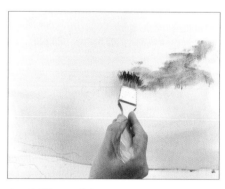

6. Still working wet into wet,
paint cloud shapes using the
colour shadow.

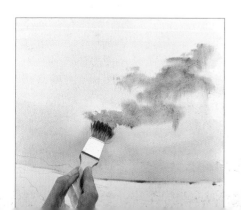

7. The clouds will naturally have
a harder-edged look where they
go over the lifted out area.

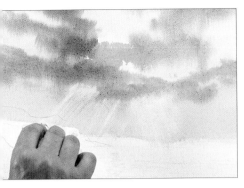

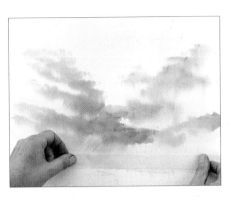

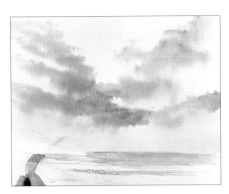

8. While the paint is still wet, take a piece of kitchen paper and lift out streaks to suggest sunlight streaming through the clouds.

9. Allow the painting to dry, then place masking tape above the line where you want the horizon to be.

10. Use the 19mm (¾in) flat brush and a mix of cobalt blue and alizarin crimson to paint the sea up to the masking tape. Sweep from side to side to create the effect of ripples.

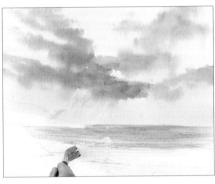

11. Paint a mix of cadmium red and cadmium yellow over the top of the blue.

12. Paint with the same orangey mix over the masked area and the foreground.

13. Lift out colour from the centre of the painting, below the sun, using kitchen paper.

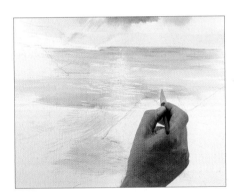

14. Use the medium detail brush to paint cadmium yellow on to the foreground to strengthen the colour there.

15. Sweep shadow colour across the horizon, towards the centre.

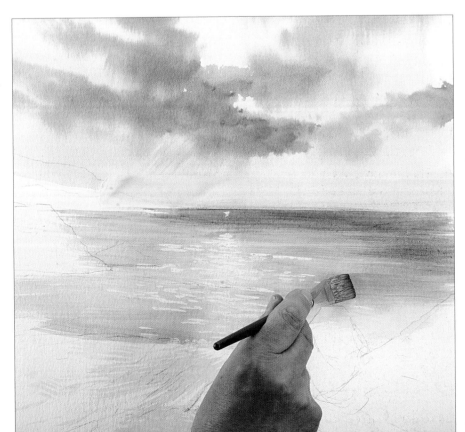

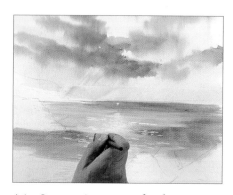

16. Sweep in more shadow colour from the left.

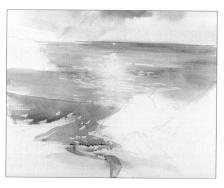

17. Darken the foreground with more shadow. Allow the painting to dry.

18. Remove the masking tape to reveal the horizon line.

19. Use the large detail brush and a mix of burnt sienna and shadow for the distant headland.

20. Mix burnt umber and shadow to darken the headland at the base.

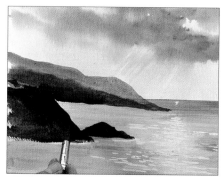

21. Use a mix of ultramarine and burnt umber for the land in the middle distance.

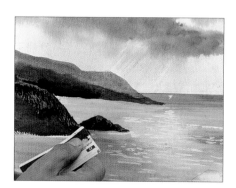

22. Scrape out the sunlit side of the land in the middle distance using a plastic card to create texture.

23. Make a thick mix of ultramarine and burnt umber and use the fan stippler to paint the rocks in the foreground.

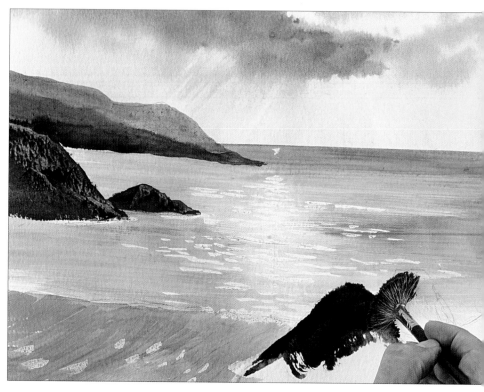

24. Scrape out the foreground rocks in the same way.

25. Add more dark rocks using burnt umber, ultramarine and the fan stippler, and scrape out texture and crevices as shown.

26. Rub off the masking fluid with a clean finger.

27. Change to the small detail brush and use shadow colour to paint rippled reflections of the rocks.

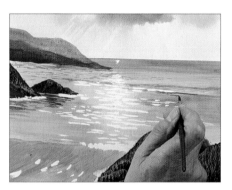

28. Continue painting ripples and shadows under the white crests of waves.

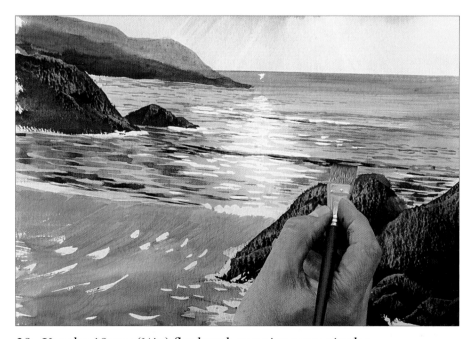

29. Use the 19mm (¾in) flat brush to paint more ripples.

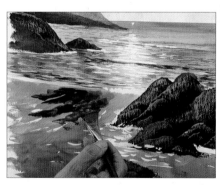

30. Darken the beach using the 19mm (¾in) brush and a mix of shadow and burnt sienna.

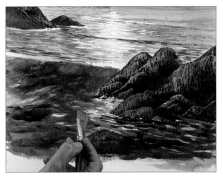

31. Mix cadmium red and cadmium yellow and paint over the dark colour of the beach, wet on dry.

32. Add more of the same orange mix in the white ripples under the rocks.

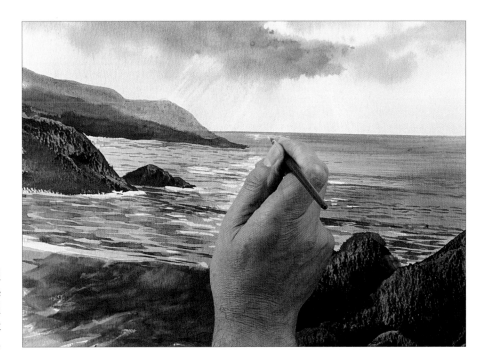

33. Add a little cadmium red and cadmium yellow to white gouache and use the small detail brush to paint the strip of light near the horizon.

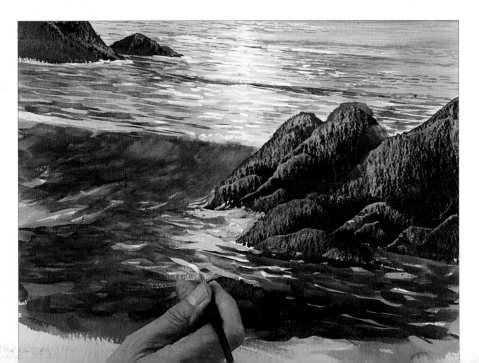

34. Use the same gouache and orange mix to paint more streaks on the water lying on the beach.

Opposite

The finished painting. After standing back to look at the painting, I noticed that the headland did not align with the horizon, so I mixed burnt umber and ultramarine to straighten it.

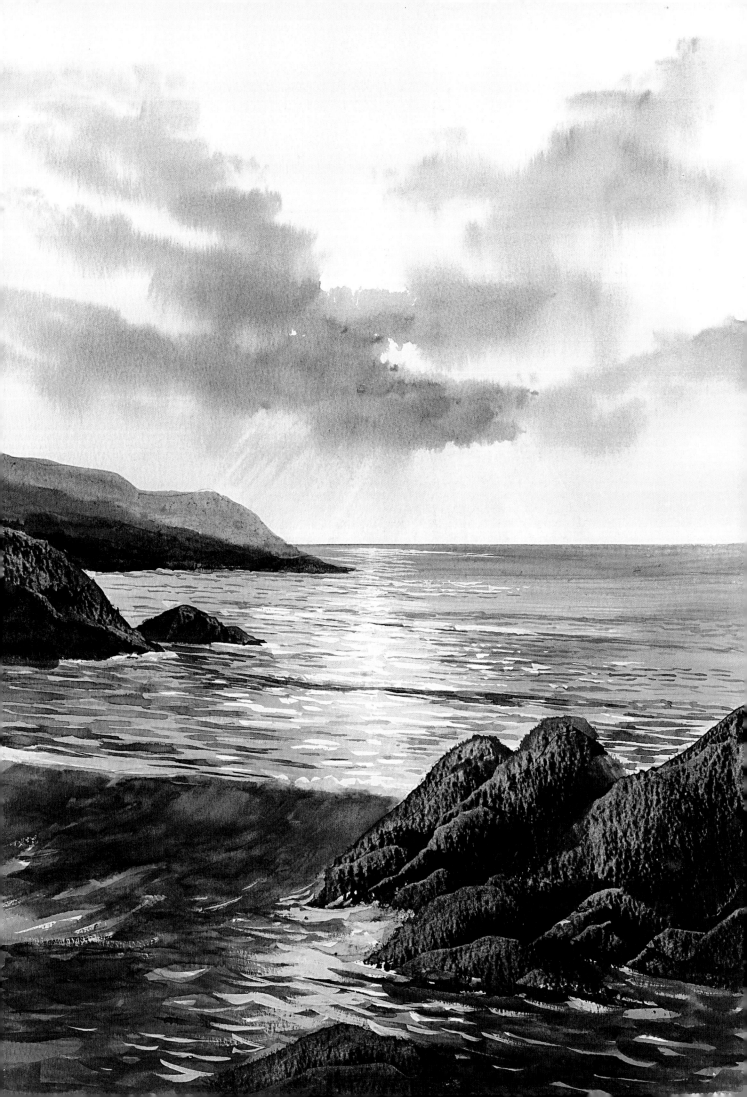

Index